Stroebel's View Camera Basics

Leslie Stroebel

D1141662

Focal Press

Boston Oxford Melbourne Singapore
Toronto Munich New Delhi Tokyo

Focal Press is an imprint of Butterworth–Heinemann
ℛ A member of the Reed Elsevier group.

∞ Recognizing the importance of preserving what has been written,
Butterworth–Heinemann prints its books on acid-free paper whenever
possible.

Library of Congress Cataloging-in-Publication Data

Stroebel, Leslie D.
 [View camera basics]
 Stroebel's view camera basics / Leslie Stroebel.
 p. cm.
 Includes bibliographical references and index.
 ISBN 0-240-80220-9 (pbk.)
 1. View cameras—Handbooks, manuals, etc. I. Title.
TR258/S697 1995
771.3'2—dc20 95-17394
 CIP

British Library Cataloguing-in-Publication Data

A catalogue record for this book is available from the British Library.

The publisher offers discounts on bulk orders of this book.
For information, please write:

Butterworth–Heinemann
313 Washington Street
Newton, MA 02158–1626

10 9 8 7 6 5 4 3 2 1

Printed in the United States of America

Contents

Contents

Contents

Contents

View Cameras

1

Modern view cameras are the descendants of many generations of large-format cameras, dating back to the birth of photography in 1839 with the introduction of the Daguerreotype process. The first commercially manufactured Daguerreotype camera, designed by Daguerre and manufactured by Giroux in 1839, was a two-part wood box with the lens mounted on the outer front box and the ground glass attached to the inner back box, which could be moved back and forth to focus the image (Figure 1–1). A pivoted disk in front of the lens served as a shutter and a 45° mirror behind the ground glass provided an upright but laterally reversed reflection of the inverted ground-glass image.[1]

The desire on the part of photographers for camera modifications to meet specific picture-making needs resulted in improvements such as substitution of a flexible bellows for the sliding boxes and the tilt, swing, and shift adjustments on the lens and ground glass that are features of modern view cameras. The desire for camera modifications also generated, over the years, a whole range of other types of cameras, including large-format cameras that could be hand-held, thanks to the addition of an optical viewfinder for composing and a coupled rangefinder for focusing, roll-film box cameras, and 35-mm cameras. Introduction of the Exakta 35-mm single-lens-reflex camera in 1936 and the Zeiss Contax 35-mm SLR with a pentaprism for eye-level viewing in 1949 combined with the continuing improvements in the graininess of 35-mm film led many to predict the demise of large-format cameras.[2] Newspaper photographers, indeed, did switch from 4×5-in. format press cameras to 35-mm SLR cameras as rapidly as they could talk management into purchasing new cameras. The 35-mm SLR cameras also became very popular with advanced amateur photographers and photojournalists, while the larger roll-film SLR cameras became popular with fashion photographers and some other professional photographers who wanted a compromise between the image quality produced with large-format cameras and the convenience of small-format cameras.

To the surprise of many, however, the popularity of view cameras, rather than declining, actually increased along with that of the smaller-format cameras. Surveys of the number of different models of view cameras that were available in the United States in 1967 and in 1993 revealed that the number of models of 4 × 5-in. view cam-

[1] Eaton S. Lothrop, Jr., *A Century of Cameras* (Rochester, NY: International Museum of Photography at George Eastman House, 1973), 1.
[2] L. Stroebel and R. Zakia, eds., *The Focal Encyclopedia of Photography*, 3rd ed. (Boston: Focal Press, 1993), 10.

Figure 1 – 1 Daguerrotype camera designed by Daguerre and manufactured by Giroux in 1839.

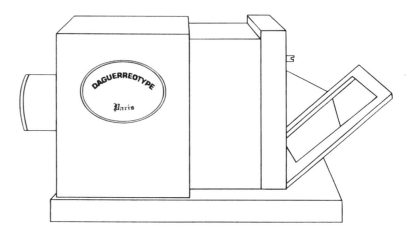

eras increased from 16 to 49, and, including smaller-format and larger-format view cameras, the total number of different view cameras increased from 34 to 90.[3,4]

During the evolution of the various types of cameras, 35-mm and roll-film cameras have borrowed some view-camera features, such as perspective-control (PC) lenses that can be shifted off center to prevent convergence of vertical subject lines, as when photographing a tall building. View cameras have also borrowed features from small-format cameras, such as roll-film adapters and various features to make the view camera more user friendly. A number of view-camera refinements will be mentioned throughout the book and a comprehensive list will be included in the final chapter—but we will start with a basic no-frills generic or Brand X view camera.

View-Camera Characteristics

It is easier, and probably more useful, to list the features generally considered to be uniquely characteristic of view cameras than to offer a dictionary-style definition. (1) View cameras are designed to be used on a tripod or other camera stand, in contrast to being hand held. (2) An inverted image is formed on a ground-glass surface where it can be examined for focusing and composing. (3) The front and back of the camera are connected with a light-tight flexible bellows. (4) Interchangeable lenses can be attached to the front of the camera. (5) The distance between the lens and the ground glass can be altered over a considerable range by changing the position of the front and/or the back. (6) Adjustments can be made in the angle and the relative vertical and horizontal positions of the lens and ground glass, such adjustments being identified as swings, tilts, and vertical and horizontal shifts. (7) The back is designed to permit a film holder to be inserted so that the film is in the plane previously occupied by the ground glass.

View cameras can generally be classified as being of either flatbed (Figure 1–2) or monorail construction. Most of the early view cameras were of the flatbed variety, although a wood monorail camera is known to have been made by 1870. In recent decades more models of monorail cameras have been marketed than flatbed cameras. Flatbed cameras are generally constructed of wood. Most can be folded into a compact self-contained carrying case, an advantage when traveling with a view camera. Monorail view cameras are generally constructed of metal and many are modular in design, which permits considerable flexibility in modifying the camera to meet special needs. An exploded view of a generic monorail view camera, with the parts identified, is shown in Figure 1–3. Not all monorail view cameras can be disassembled as completely as indicated in the exploded view, but the trend is in that direction.

In addition to the camera, a few accessories are considered to be essential. These include a tripod (or camera stand), a focusing cloth or hood to shield the ground glass from extraneous light, a focusing magnifier, a cable release, film holders, an exposure meter, and a carrying case.

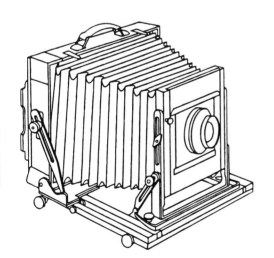

Figure 1 – 2 Flatbed view cameras typically have wood frames, are relatively light in weight, and can be folded into a compact self-contained case with a carrying handle.

[3] L. Stroebel, *View Camera Technique,* 1st ed. (Boston: Focal Press, 1967), 240.
[4] L. Stroebel, *View Camera Technique*, 6th ed. (Boston: Focal Press, 1993), 246–247.

Figure 1 – 3 An exploded view of a generic monorail view camera.

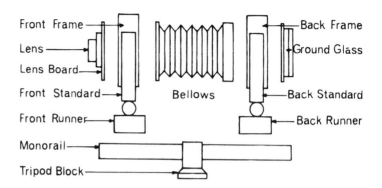

View-Camera Adjustments

The following view-camera adjustments are illustrated in Figure 1–4:

1. Focusing, which consists of changing the distance between the lens and the ground glass, is accomplished by changing the position of the front and/or back runner on the monorail. Most cameras have both coarse and fine focusing capabilities. Coarse focusing is used when setting up the camera and when substituting a different focal-length lens to quickly bring the image into approximate focus, and fine focusing is used to achieve critical focus before exposing the film.

2. Back tilt, a rotation of the camera back around a horizontal axis. The back tilt is used to control the convergence of parallel vertical subject lines, as on a building, when tilting the camera up or down. Tilting the back also alters the angle of the plane of sharp focus in object space, but the back cannot be used for this purpose if it is needed to control image shape.

3. Back swing, a rotation of the camera back around a vertical axis. The back swing is used to control the convergence of parallel horizontal subject lines, as on the side of a building that is at an angle to the camera such that one end of the building is at a greater distance from the camera than the other. In contrast to the treatment of vertical subject lines, it is seldom desirable to make receding parallel subject lines parallel in the photograph, although increasing and decreasing the rate of convergence of the parallel lines provides the photographer with some control over the apparent distance between the near and far parts of the subject.

4. Front tilt, a rotation of the lens board and lens around a horizontal axis. The front tilt is used to control the angle of the plane of sharp focus from top to bottom in vertical object space, as on the front of a tall building, or from front to back on a horizontal subject plane such as railroad tracks. Since tilting the camera back also alters the plane of sharp focus, it is important to adjust the back tilt for image shape before tilting the front to alter the plane of sharp focus.

5. Front swing, a rotation of the lens board and lens around a vertical axis. The front swing controls the side-to-side angle of the plane of sharp focus, and it should be adjusted after the swing position of the back has been established.

4

6. Front vertical shift (or front rise-and-fall adjustment), which moves the image approximately the same distance in the same direction on the ground glass. Thus, the top of a tall building could be shown on the ground glass by shifting the lens upward with the camera level, as an alternative to tilting the entire camera upward, which would require readjusting both the back and front tilt adjustments.
7. Front horizontal shift, which moves the image approximately the same distance in the same direction on the ground glass, can be used, for example, to center the image of a painting that is being copied to avoid having to readjust the back and front swings, which would be required if the angle of the camera were changed.
8. Back vertical shift (or back rise-and-fall adjustment), which in effect moves the image in the opposite direction the same distance on the ground glass. Thus, shifting the back down 2 inches is equivalent to shifting the front up 2 inches. Also, the two movements can be combined when neither the front nor back can be shifted far enough to achieve the desired effect.
9. Back horizontal shift, which in effect moves the image the same distance in the opposite direction on the ground glass. The effects of shifting the front and back in opposite directions are additive and can be used when neither can be shifted far enough to achieve the desired effect.
10. Pan-and-tilt head, which allows the entire camera to be tilted up and down, rotated clockwise and counterclockwise, and panned through a 360° circle around a vertical axis. Pan-and-tilt heads are either an integral part of the camera or are available as an accessory for approximately half of the various models of view cameras on the market. When this device is not provided with the camera, the camera is normally used with a tripod or camera stand that has a pan-and-tilt head.
11. Reversible and revolving back adjustments, which allow the ground glass and film to be placed in either a vertical or a horizontal format position. A full, or 360°, revolving back also allows angular croppings between the vertical and horizontal positions. Full revolving backs, however, require a larger bellows to prevent obstruction of light in the corners of the picture when the back is in an intermediate position.

Advantages and Limitations of View Cameras

No single type of camera is suitable for use in all types of picture-making situations, and professional photographers who do a variety of types of photography typically own two or more different types of cameras. The most obvious limitations of view cameras with respect to photographing action scenes are that the camera must be used on a tripod and there is an inherent delay between when the image is composed and focused on the ground glass and when the film can be exposed, although some view cameras have features that considerably shorten the delay. View cameras are widely used, however, for making photographs that include people, such as portraits made either in a studio or on location, and advertising photographs that include

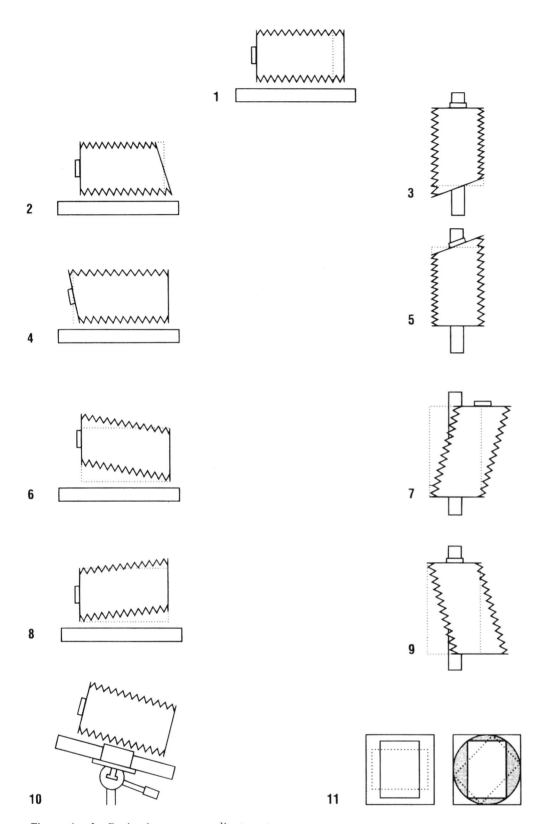

Figure 1 – 4 Basic view-camera adjustments:
(1) focusing, (2) back tilt, (3) back swing, (4)
front tilt, (5) front swing, (6) front vertical shift,
(7) front horizontal shift, (8) back vertical shift,
(9) back horizontal shift, (10) pan-and-tilt head,
and (11) reversible and revolving back.

models, in addition to the many types of photography where the field of view remains constant and it is not necessary for the camera to follow any internal movement.

Sheet film is more expensive than 35-mm film and roll film, especially in the larger-format sizes, and is not as convenient to have processed as taking 35-mm color film to a photofinisher. View cameras tend to be bulky and require the use of a tripod, which is an inconvenience when traveling, although some view cameras and tripods are compact enough to carry in a backpack.

Among the advantages of view cameras over small-format cameras are the superior image quality produced with the larger sizes of film, the precision with which images can be composed and focused on the large ground glass, and, especially, the image control that the swings, tilts, and other view-camera adjustments, combined with an unlimited choice of lenses, provide. Also, with modular-type view cameras, the camera can often be modified to meet a wide variety of picture-making needs, including the use of roll film.

Using the View-Camera Adjustments

2

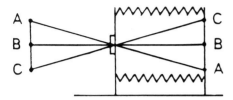

Figure 2 – 1 All points on a flat subject plane are brought into focus simultaneously when the subject plane, the lens board, and the film plane are parallel, but the image is inverted.

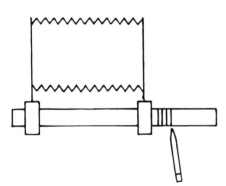

Figure 2 – 2 Focusing consistency can be checked by focusing repeatedly on the same object and noting any differences in the position of the focusing runner.

Focusing

When any camera is critically focused on a certain object distance—3 feet, for example—theoretically only object points at that exact distance will be "in focus." Fortunately, objects that are somewhat in front of and behind the distance focused on will usually appear to be acceptably sharp, a range of object distances identified as *depth of field.* When the depth of field is very shallow, however, it may appear that only a single object plane is in focus. In a closeup portrait, for example, the eyes may be in sharp focus while the nose and ears appear unsharp.

Two-dimensional subjects provide the least complicated focusing situation. With the camera aligned so that the lens board and the ground glass are parallel to the subject, as when copying paintings, photographs, and documents, focusing on any part of the image should produce satisfactory focus for the entire image even if the depth of field is very shallow, assuming that the lens is well corrected for aberrations (Figure 2–1). An experiment revealed that when photographers focused on the same target repeatedly, there were small variations in the position of the ground glass. Although the experiment was conducted using precision electronic measuring equipment, it would be worthwhile for view camera users to check their own ability to focus consistently by focusing the camera on a two-dimensional subject, placing a fine pencil mark on the camera bed to indicate the position of the focusing adjustment, moving the adjustment, and refocusing several times, each time marking the position on the bed (Figure 2–2). A significant variation in positions could be caused by any of a number of factors, including difficulty in focusing one's eyes on the ground glass at a close distance, use of a subject that has low-contrast detail, a low light level, not shielding the ground glass from extraneous light, and carelessness. It would be informative to repeat the experiment using a focusing magnifier, making sure that the focusing magnifier itself is accurately focused on the ground glass for your eyesight.

The distance between the lens and the ground glass, that is, the *image distance,* varies inversely with the object distance for in-focus images. The shortest image distances are therefore encountered when focusing on distant objects, and when the camera is focused on infinity the image distance will be the same as the lens focal length. As the camera is focused on closer objects the image distance increases, and the limit is reached when the front standard is at the front end of the camera bed and the back standard is at the back end. If the image of a small object is not as large as desired when the camera is fully extended, it is possible to focus on a closer object distance and obtain a larger image in several ways, including substituting a shorter focal-length lens, and if using a modular-type view camera, adding extensions to the bed and the bellows.

It is important to lock the focusing mechanism after focusing the camera to make sure that the focus is not accidentally changed when inserting a film holder, or due to gravity if the camera is tilted steeply up or down. Some of the newer view cameras have self-locking focusing mechanisms, making this precaution unnecessary.

While it is common practice to focus with the lens diaphragm in the fully open position to obtain the brightest image on the ground glass and then stop the lens down to obtain the desired depth of field, complications may be encountered with *soft-focus* portrait lenses when

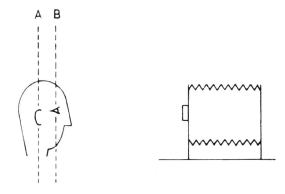

Figure 2 – 3 Plane of sharpest focus with a soft-focus lens at the maximum aperture (B) and stopped down (A).

this is done. The focus with such lenses shifts away from the camera as the diaphragm is stopped down so that if the focus is on the subject's eyes at the maximum opening, it may move back to the ears as the lens is stopped down (Figure 2–3). Lenses of this type should be focused at the aperture that will be used to expose the film.

Depth of Field

Three-dimensional subjects and scenes force the photographer to make a decision concerning which part of the subject or scene to focus on. When a shallow depth of field is appropriate, the area of greatest interest is usually selected. With studio portraits, for example, the photographer normally focuses on the subject's eyes and allows the ears and near and far shoulders to appear unsharp. When overall sharpness is desired, however, the camera must be focused on the appropriate distance so that as the lens is stopped down the increased depth of field will reach both the near and the far parts of the subject.

A commonly quoted rule of thumb states that when a large depth of field is desired, the camera should be focused 1/3 of the way into the part of the scene that is to appear sharp. Thus if the depth of field is to extend from 5 feet to 20 feet, the camera would be focused on 5 feet plus 1/3 of 15 feet, or a total distance of 10 feet. Unfortunately, this rule of thumb applies only to a limited number of situations. When the depth of field is small, as it tends to be with a long focal-length lens, a large lens aperture, or a small object distance, the camera should be focused closer to midway between the near and far parts desired to be sharp. As the depth of field increases, the point focused on must move toward the front of the subject or scene (Figure 2–4).

When it is desired for the depth of field to extend back to infinity, or in measurable units, even a mile or so, the camera should be focused on a distance that is identified as the *hyperfocal distance.* When the camera is focused on the hyperfocal distance, the depth of field extends from 1/2 the hyperfocal distance to infinity. It should be noted that in this situation the camera is focused very close to the front of the depth-of-field range, not 1/3 of the way into it. Since the hyperfocal distance changes not only with lens focal length but also with the *f*-number used to expose the film, the easiest way to determine the hy-

Figure 2 – 4 Distribution of depth of field in front of and behind the plane focused on with a shallow depth of field (*top*) and with a moderate depth of field (*bottom*).

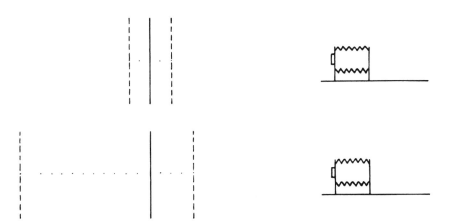

perfocal distance is to refer to a depth-of-field table for the lens being used and locate the closest distance the lens can be focused on where the depth of field extends to infinity for the *f*-number being used. View-camera depth-of-field focusing scales and guides that enable the photographer to easily determine both the depth of field and the optimum focusing distance are covered in chapter 7.

Control over depth of field by the photographer can be summarized by noting the effect that a change in each of the three major variables, *f*-number, object distance, and lens focal length, has on depth of field. (1) Depth of field is proportional to the *f*-number, so that doubling the *f*-number from *f*/8 to *f*/16, for example, doubles the depth of field. (2) Depth of field is proportional to the object distance *squared*, so that doubling the object distance from 8 feet to 16 feet, for example, increases the depth of field by a factor of 4. (3) The depth of field varies *inversely* with the focal length *squared*, so that substituting a 100-mm focal-length lens for a 200-mm lens increases the depth of field by a factor of 4. The shorter 100-mm lens, however, also produces a smaller image than the 200-mm lens. If the camera is also moved closer to produce the same image size of the object focused on, the decrease in the depth of field produced by reducing the object distance will offset the increase in depth of field produced by using the shorter focal-length lens, and the two photographs will have essentially the same depth of field.

Tilts and Swings

When the front and back tilt and swing adjustments are in their normal or zero positions—that is, the lens board and ground glass are perpendicular to the monorail—they are in the same positions as the corresponding parts on cameras that do not have tilt and swing adjustments. (All view cameras have a mechanical and/or visual indicator of the zero positions.) Many photographs are made with view cameras with the front and back in their zero positions, including typical studio portraits and landscapes. With some subjects having parallel vertical and horizontal subject lines that must remain parallel in the image, the view camera is simply set up directly in front of the subject and there is no convergence of the subject lines, as illustrated by the photograph of the test tubes and rack in Figure 2–5. The photograph of the building in Figure 2–6, in contrast, shows that tilting a camera upward causes the vertical subject lines to converge toward the top.

Making photographic copies is another situation in which there is no need to use the tilt and swing adjustments, providing that the camera is placed in the correct position with the lens board and ground glass parallel to the original that is being copied. In situations where copies must be made frequently, special equipment is commonly used whereby the camera can be placed at varying distances from the original to accommodate different-size originals without having to be concerned about aligning the camera, a prime example being the process cameras used for making copies for photomechanical reproduction where the camera and the copy board remain permanently aligned on rigid tracks. When a view camera is set up on a tripod to make an occasional copy, however, the task of aligning the camera and copy can be challenging. The task can be greatly simplified by placing

Figure 2 – 5 Parallel subject lines are imaged as parallel lines when the film plane is parallel to the subject lines. — *Jean Paul Debattice*

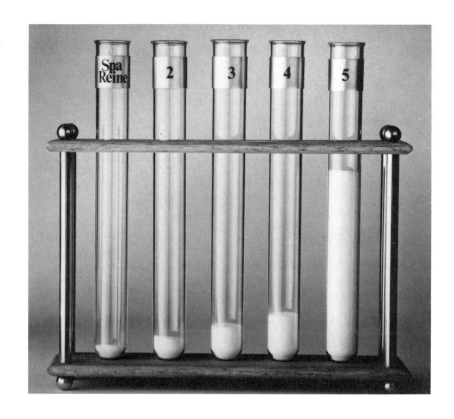

Figure 2 – 6 Tilting a camera upward causes vertical subject lines to converge toward the top of the image.

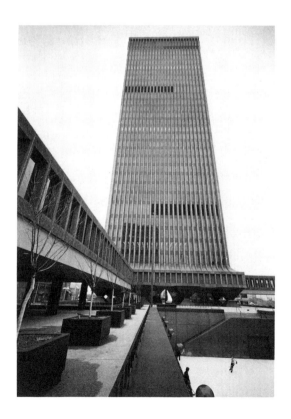

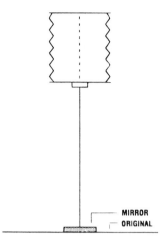

Figure 2 – 7 A mirror can be used to check camera alignment when making photographic copies.

a small mirror in the exact center of the original being copied, as illustrated in Figure 2–7. The camera will be correctly aligned when a reflection of the camera lens is located in the exact center of the ground glass. Grid lines on the ground glass are also helpful in making certain that there is no convergence of parallel subject lines in the image.

Controlling Image Shape

The effect of tilting and swinging the back of a view camera can be demonstrated by placing the camera in the copying position in front of a grid and examining the inverted image on the ground glass (1) with the back tilt and back swing both zeroed, (2) with the back tilted and the swing zeroed, and (3) with the back swung and the tilt zeroed, as illustrated in Figure 2–8. It can be observed that tilting the top of the back forward causes the vertical lines to converge toward the top of the ground glass, but that the horizontal lines remain parallel. Also, swinging the left side of the back forward causes the horizontal lines to converge toward the left side of the ground glass, but the vertical lines remain parallel. The final photograph shows that substituting a longer focal-length lens and moving the camera farther away from the subject, to obtain the same image size, results in less convergence of the horizontal lines even though the back is swung at the same angle as in the preceding photograph.

The effects of tilting the back in both directions with respect to the final photograph, rather than the inverted ground-glass image, are shown in Figure 2–9. Tilting the top of the back away from the subject causes the vertical lines to converge toward the top of the photograph. (The reason the distance between the piles of blocks is smaller at the top than at the bottom is because the rays of light from the top travel a shorter distance between the lens and the film than the rays from the bottom.) It may be noted that the effect is very similar to that produced with a conventional camera when it is tilted up from street level to photograph a tall building, where the angle of the back in relation to the building would be the same as in this illustration. Tilting the back in the opposite direction, the top of the ground glass toward the subject, reversed the direction of convergence on the photograph, so that the convergence toward the bottom of the photograph is similar to the effect produced with a conventional camera tilted down at the subject from an elevated position.

The camera is moved to an elevated position and tilted down toward the subject for the 3 photographs in Figure 2–10. With the back in the zero position in the 1st photograph, the vertical subject lines converge toward the bottom. Tilting the back so that it is parallel to the subject lines and perpendicular to the ground eliminates the convergence in the 2nd photograph. For the 3rd photograph, the back is tilted in the opposite direction, that is, the top of the back is tilted toward rather than away from the subject, and the effect is to exaggerate the convergence over that produced in the 1st photograph with the back in the zero position.

It can be concluded that convergence of vertical subject lines in photographs depends upon the relationship between the tilt angle of the camera back and the vertical subject lines, regardless of the height of the camera.

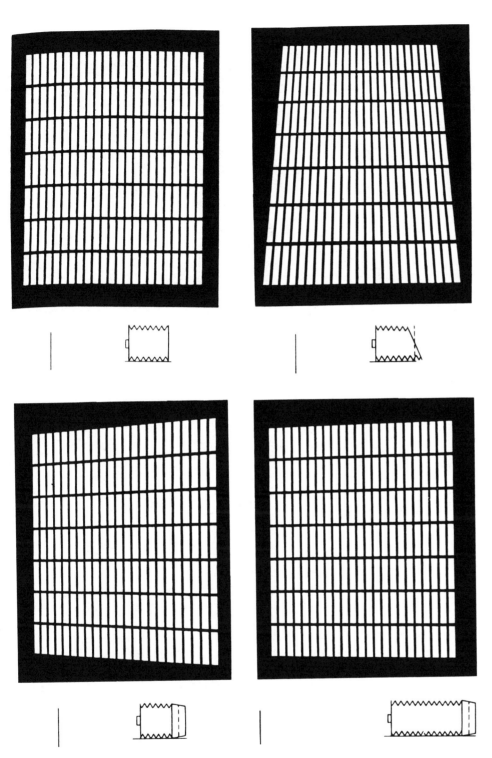

Figure 2 – 8 Inverted ground-glass images of a grid (1) with the camera back parallel to the grid, (2) with the top of the back tilted forward, (3) with the left side of the back swung forward, and (4) with the back swung at the same angle as in the preceding photograph but with a longer focal-length lens and a larger object distance.

There are no rigid rules concerning whether vertical subject lines should or should not be allowed to converge in photographs made with the camera tilted up or down at the subject, but a tradition of rendering vertical subject lines parallel has long existed among photographers and artists for certain types of subjects and target audiences. Just as different words and phrases are commonly used to express the same thought in informal spoken language and formal written communica-

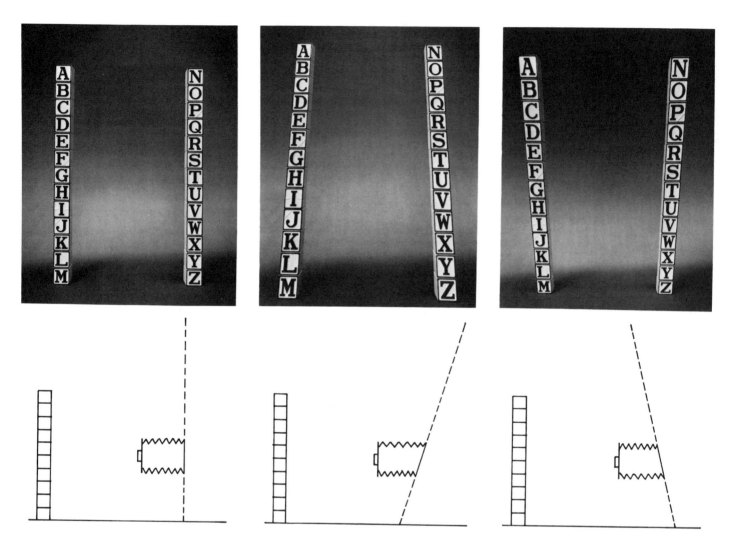

Figure 2 – 9 Photographs made with the camera level and (1) the back parallel to the subject, (2) the top of the back tilted away from the subject, and (3) the top of the back tilted toward the subject.

tion, different photographic styles are appropriate in different contexts. In any event, keeping vertical subject lines parallel represents the more formal approach that is commonly taken by photographers using view cameras, especially for architectural, commercial, and catalog-type photographs. The tradition is strong enough that perspective-control (PC) lenses have been designed and marketed so that similar effects can be achieved with 35-mm cameras.

The same relationship exists between subject plane and film plane for horizontal lines as discussed above for vertical lines, that is, the only time parallel horizontal lines will remain parallel in photographs is when the camera back is parallel to that subject plane. Fortunately, viewers are not as concerned about converging horizontal lines as they are about converging vertical lines, although there are situations where it is desirable to either reduce or exaggerate the rate of convergence, or even to entirely eliminate convergence. Altering the convergence of horizontal lines on the front of a low and long building, for example, tends to change the apparent length of the building in the photograph.

When two sides of a building or other box-shaped object are visible from the camera position it is not possible (nor desirable) to eliminate convergence of the horizontal lines on both sides simulta-

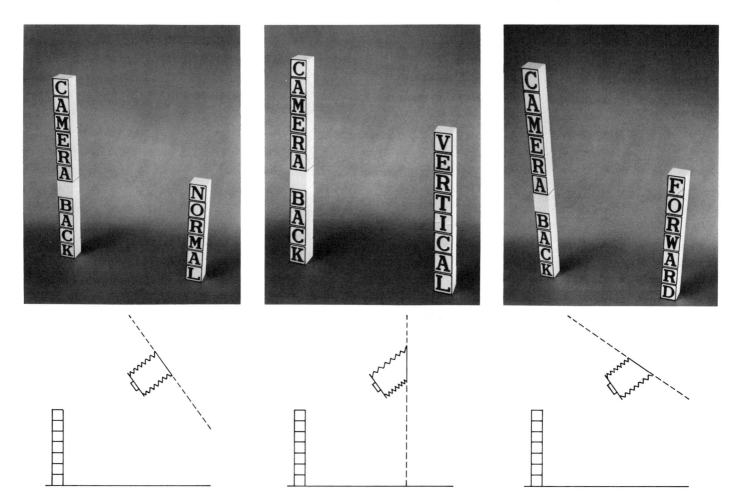

Figure 2 – 10 With the camera tilted down from an elevated position, the vertical subject lines (1) converge toward the bottom with the back in the normal position, (2) remain parallel when the back is tilted so that it is parallel to the subject, and (3) converge more strongly than in the 1st photograph when the back is tilted in the opposite direction.

neously. The 1st photograph in Figure 2–11 shows that with the swing back in the zero position the parallel horizontal lines on the left and right sides of the box-shaped object converge toward vanishing points on the left and right sides respectively. The 2nd photograph shows that swinging the back parallel to the left side of the object eliminates convergence of the parallel subject lines on that surface but exaggerates convergence on the right side. Swinging the back parallel to the right side of the object reverses the results, eliminating convergence on the right side and exaggerating convergence on the left side, as shown in the 3rd photograph.

It can be seen that the view camera offers considerable control over the convergence of both vertical and horizontal parallel lines. Slightly converging lines close to the edges of a photograph tend to be more disturbing to viewers than lines that converge more strongly, possibly because they create the impression that the convergence is due to carelessness rather than intent. With such vertical lines, there should be no hesitancy in tilting the back to eliminate the convergence. Horizontal lines on two sides of box-shaped objects allow for more flexibility of treatment. When one surface is obviously more important than the other, such as the front of a building or commercial product, or has already been given preference through choice of the camera viewpoint, eliminating convergence of the parallel subject lines on that surface will tend to be more suitable.

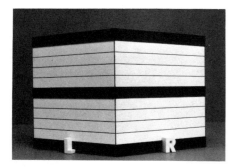 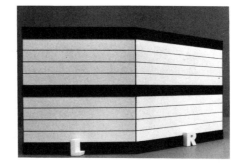 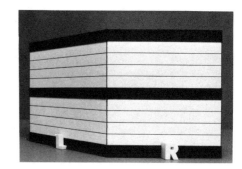

Figure 2 – 11 Three photographs made from the same position (1) with the camera back in the normal position showing convergence of the horizontal lines on both subject planes, (2) with the back swung parallel to the left subject plane, and (3) with the back swung parallel to the right subject plane.

It is possible to increase or decrease the convergence of horizontal lines simultaneously on two planes that are at right angles to each other, but this must be done by changing the distance from the camera to the subject, usually accompanied by a change in lens focal length, rather than by swinging the back of the camera. This approach will be discussed under the heading Focal Length, Object Distance, and Perspective in chapter 3.

Professional photographers make decisions concerning eliminating, reducing, or exaggerating convergence of parallel vertical and horizontal subject lines on the basis of what appears to be appropriate for each subject and the intended use for the photograph, rather than by following rigid rules. When in doubt, however, it is usually safe to keep vertical subject lines parallel and allow horizontal lines to converge normally in the photograph.

The 9 photographs in Figure 2–12 show the results of placing the tilt back in 3 different positions and the swing back in 3 different positions, with the camera tilted down from an elevated position to photograph a vertical book that is rotated slightly sideways, as indicated by the top-view and side-view diagrams under the photographs. With the back tilt and swing adjustments zeroed, there is normal convergence (as occurs in the retinal image in our eyes) of both vertical and horizontal subject lines, as shown in the 5th photograph. Tilting the back parallel to the vertical book lines and swinging the back parallel to the horizontal book lines eliminates convergence in both sets of lines, as shown in the 1st photograph.

Progressing from the 1st photograph to the 9th, only one change is made in either the back tilt adjustment or the back swing adjustment between photographs, except for the 4th and 7th photographs, where both are changed. To assist the reader in making the association between the change in the position of the camera back and the change in the image shape, the changed camera-back positions are italicized in the captions. The same rules of thumb discussed above of course still apply. Parallel subject lines *will converge* in the photograph when the camera back *is not parallel* to those subject lines. *Convergence is eliminated* by tilting or swinging the back so that it *is parallel* to the parallel subject lines and *convergence is exaggerated* by tilting or swinging the back in the *opposite direction*. Exaggeration of both vertical and horizontal book lines is illustrated in the 9th photograph, for comparison with normal convergence of both in the 5th photograph and elimination of convergence of both in the 1st photograph.

Although we have been concerned only with subjects containing parallel lines, the images of irregularly shaped objects are sim-

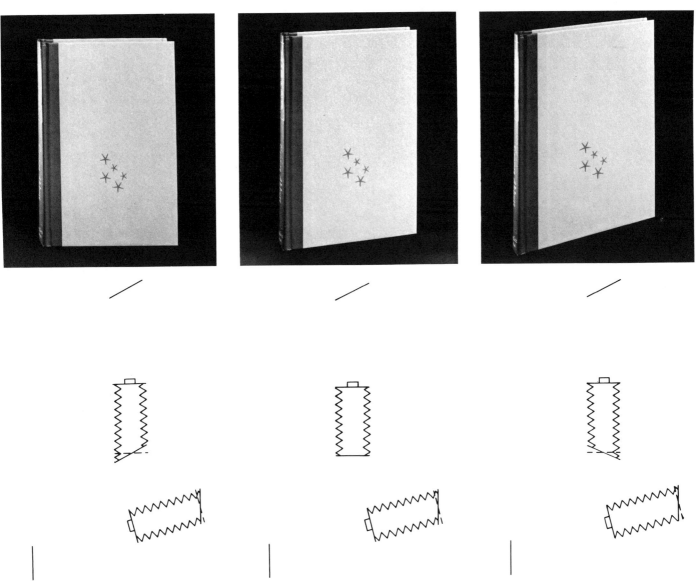

1. *Swing: Parallel to horizontal lines.*
 Tilt: Parallel to vertical lines.

2. *Swing: Zero position.*
 Tilt: Parallel to vertical lines.

3. *Swing: Opposite direction.*
 Tilt: Parallel to vertical lines.

ilarly affected by changes in the tilt and swing angles of the camera back (Figure 2–13). Casual viewers of photographs rarely notice such changes in image shape when the subject does not contain straight lines unless the changes are dramatic, but critical viewers will detect more subtle changes.

Figure 2 – 12 The 9 photographs on this and the following two pages show the variety of image shapes that can be obtained with the camera back in 3 different tilt positions and 3 different swing positions (zero position, tilted or swung parallel to the subject plane, and tilted or swung in the opposite direction). The cameras under the photographs represent a top view for the back swing and a side view for the back tilt. (Italics are used only for the swing and/or tilt adjustment that has been changed.)

Controlling the Plane of Sharp Focus

If a conventional camera (or a view camera with the front and back in the zero tilt and swing positions) is focused on the center of a flat object surface that is at an angle to the camera with the lens diaphragm fully open, the closer and more distant parts of that surface

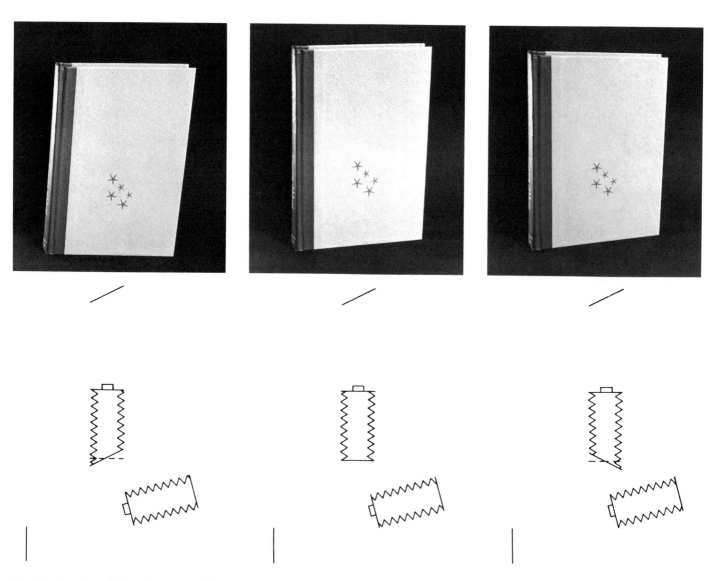

4. *Swing: Parallel to horizontal lines.*
 Tilt: Zero position.

5. *Swing: Zero position.*
 Tilt: Zero position.

6. *Swing: Opposite direction.*
 Tilt: Zero position.

will become progressively less sharp in the image (Figure 2–14-A). Stopping the lens diaphragm down will increase the depth of field, as shown in the 2nd diagram, although in some situations it will not be possible to increase the depth of field sufficiently with this control to include the closest and most distant parts of the subject. With view cameras, however, the angle of the plane of sharp focus in object space can be changed to conform to the subject plane by adjusting the angle of the front of the camera, as shown in the 3rd diagram, making it unnecessary to stop the lens down to obtain a sharp image, regardless of the length of the subject.

In addition to changing image shape, tilting and swinging the camera back also alters the angle of the plane of sharp focus, a fact that we have ignored up to now. Although the back tilt and swing can be used to control the angle of the plane of sharp focus, that task is usually assigned to the front tilt and swing adjustments so that the back

Figure 2 – 12 *(Continued)*

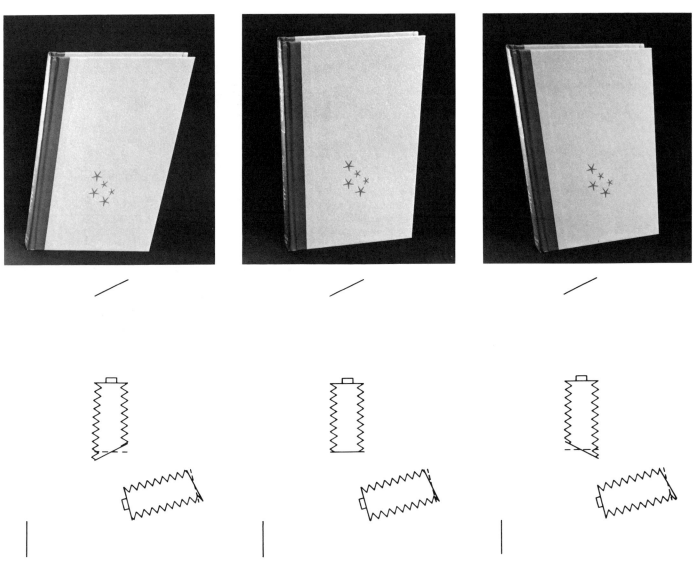

7. *Swing: Parallel to horizontal lines.*
 Tilt: Opposite direction.

8. *Swing: Zero position.*
 Tilt: Opposite direction.

9. *Swing: Opposite direction.*
 Tilt: Opposite direction.

adjustments can be reserved for controlling image shape. When both front and back adjustments are used to control both image shape and the angle of the plane of sharp focus, it is important to adjust the back first—because the back affects both image shape and sharpness whereas the front affects only image sharpness. This advice can be summarized in three general rules:

1. To control image shape when sharpness is not a factor—
 Swing or tilt the back.
2. To control image sharpness when shape is not a factor—
 Swing or tilt the front and/or the back.
3. To control both image shape and sharpness—
 Swing or tilt the back first for shape, then swing or tilt the front for sharpness.

Figure 2 – 12 (*Continued*)

Figure 2 – 13 The change in shape of the image of an object having an irregular shape as a result of swinging the camera back in opposite directions. The dashed outline represents the top photograph, the solid outline the bottom photograph.

Figure 2 – 14 (A) With a shallow depth of field, represented by the dashed lines, only the center part of the subject will appear sharp. (B) Stopping the lens down increases the depth of field. (C) Swinging the lens changes the angle of the plane of sharp focus to produce a sharp image without stopping the lens down.

17

With the camera back in the zero position, the effect that swinging the camera front has on the angle of the plane of sharp focus is shown in Figure 2–15. It is often possible for the photographer to determine the correct angle of tilt or swing for sharpness control by examining the image on the ground glass as the adjustment is being made. This trial-and-error method can be time consuming, especially when the subject does not have bold detail or when the image is dim due to a low light level. Adjustment of the camera front (or back) can be made more accurately and more rapidly by noting that optimum sharpness is obtained when either the planes of the subject, camera front, and camera back are parallel or they all meet at a common line, which appears as a point in two-dimensional drawings. The requirement that all three planes intersect at a line to obtain optimum image sharpness with angled subject planes is known as the *Scheimpflug* rule. (Theodor Scheimpflug was an Austrian army captain who studied photogrammetry and was awarded a British patent for his discussion of the theory of the relationship of the three planes.)

The drawings and photographs in Figure 2–16 illustrate how a sharp image can be obtained of an angled subject plane by swinging the camera front only, the back only, or both the front and the back. Both adjustments are used when the subject is at such an extreme angle that neither the front nor the back provides enough control, due to either physical limitations on the swing or tilt adjustments or optical limitations involving the lens covering power. The 1st photograph, made with the camera front and back swing adjustments in their zero positions, shows loss of sharpness due to the limited depth of field with the lens diaphragm fully open. Sharp images are obtained by swinging only the front in the 2nd photograph and by swinging only the back in the 3rd photograph, with the lens diaphragm still wide open. The only difference between these two images is that the convergence of the horizontal subject lines was increased by swinging the camera back away from the angle of the subject, but since the subject has very little height, the change in convergence is not obvious. For the 4th photograph, the angle of the row of blocks was increased so that it became necessary to swing both the front and back to obtain a sharp image. The original angle of the blocks is indicated by the three dashes, two of which are now unsharp.

Figure 2 – 15 The subject, lens board, and film planes must either be parallel to each other or must meet at a common line, as specified by the Scheimpflug rule, to obtain a sharp image at a large aperture.

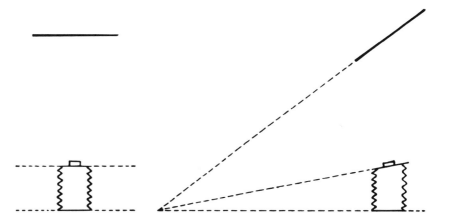

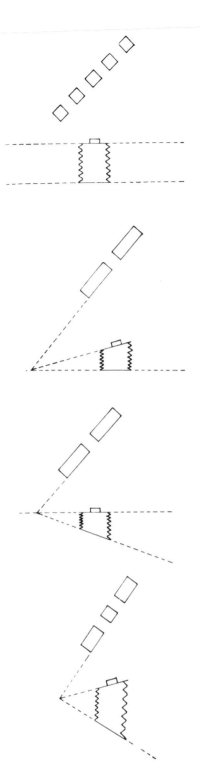

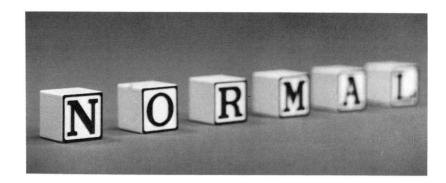

Figure 2–16 (*Top*) Only the near part of the subject appears sharp at a large aperture with the front and back swings zeroed. (*Upper middle*) A sharp image is obtained by swinging the lens toward the plane of the subject with the back in the zero position. (*Lower middle*) A sharp image is obtained by swinging the back in the opposite direction with the front in the zero position. (*Bottom*) Both the front and back swings can be used when the subject is at an extreme angle. The dashed white line in the photograph represents the maximum subject angle that could be imaged sharply using either the lens swing or the back swing.

Understanding the Scheimpflug rule helps the inexperienced view-camera user in two basic ways. First, if the front is being used to control the angle of the plane of sharp focus, it is apparent that the front is rotated in the direction of the angle of the subject, and if the back is being used, that the back is rotated in the opposite direction. Second, the rule makes it possible to determine the correct angle of rotation of the camera front and/or back to obtain optimum image sharpness. It may be difficult for a photographer to determine whether the angle of rotation is correct while standing behind the camera, but by standing where extensions of the subject plane and the camera-back

Figure 2 – 17 (*Top*) Only a narrow horizontal strip is sharp with all tilt and swing adjustments zeroed. (*Upper and lower middle*) Swinging the lens alters the angle at which the plane of sharp focus crosses the subject but does not help in achieving overall sharpness. (*Bottom*) Tilting the lens forward, with the swing zeroed, produces a sharp image of the entire subject.

plane meet, when using the front swing, it can easily be seen whether the angle of the camera front is correct, has been swung too far, or has not been swung far enough by looking down the three planes with one eye at the intersection point.

Inexperienced photographers sometimes become confused concerning whether to use a tilt or a swing adjustment to improve image sharpness in a given situation. With the camera tilted down to photograph a horizontal plane of letters with the front and back tilt and swing adjustments zeroed in Figure 2–17, the front and back rows of letters are unsharp when the camera is focused midway between them. When the front is swung rather than tilted, for the 2nd and 3rd photographs, the plane of sharp focus changes from a side-to-side direction to diagonal directions that vary with the direction in which the front was swung, leaving many of the letters unsharp. Returning the front swing to the zero position and then tilting it to the correct angle produced overall sharpness in the 4th photograph. An application of tilting the camera front to improve image sharpness is shown in Figure 2–18.

Swings and Tilts, and Depth of Field

Stopping a lens down increases the depth of field, but the shape of the depth-of-field area is drastically different when swing or tilt adjustments are used than when they are zeroed. Since the depth of field increases with object distance, the depth of field will be uniform over the entire width of a scene with the swing adjustments zeroed. Depth of field will vary from side to side, however, when a swing adjustment is used to change the angle of the plane of sharp focus, as shown in Figure 2–19 where the solid lines in object space represent the plane of sharp focus and the dashed lines represent the near and far depth-of-field limits. The camera is actually focused on different object distances when a front or back swing adjustment is used, and since depth of field increases with object distance, it will vary from side to side.

The unsymmetrical depth-of-field patterns produced when the swing and tilt adjustments are used to alter the angle of the plane of sharp focus can be useful in many picture-making situations involving three-dimensional subjects. Two adjacent walls of an interior, for example, can be imaged sharply by swinging the lens or back, so that the plane of sharp focus in Figure 2–20 includes point A, the nearest point on the wall on the left that is to be included in the photograph, and point B, a point in the center of the width of the back wall that is to be included. The dashed lines indicate the depth-of-field limits. A corresponding subject using a tilt, rather than swing, adjustment is shown in Figure 2–21. By tilting the lens or back so that the plane of sharp focus includes point A, the nearest point on the ground that is to be included in the photograph, and point B, a point that is about halfway up the vertical dimension that is to be included, everything between the dashed lines will appear sharp in the photograph.

With objects that have equal depth and height, little is gained by altering the angle of the plane of sharp focus with swings or tilts. If the back has been tilted to prevent convergence of vertical subject lines, as shown in Figure 2–22, the photographer should keep

Figure 2 – 18 Overall image sharpness was obtained by tilting the top of the lens board forward. — *Len Rosenberg*

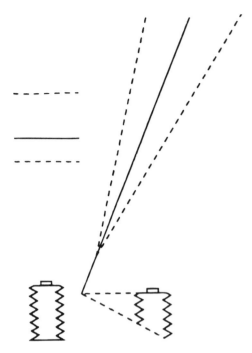

Figure 2 – 19 Shape of the depth of field area with the front and back swing adjustments zeroed (*left*), and with the back swung (*right*).

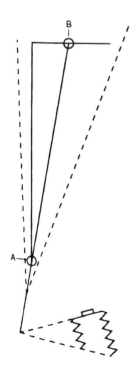

Figure 2 – 20 Use of the swing back to obtain a sharp image of two adjacent walls.

in mind that this has also altered the angle of the plane of sharp focus. When the lens is now used to focus the image, the plane of sharp focus moves up and down on the subject, rather than from front to back, as occurs with the adjustments zeroed. Consequently, rather than focusing on an appropriate point between the front and back on the top surface, it may be necessary to focus at an appropriate point between the top and bottom of the front surface if the entire object is to be included between the depth-of-field limits when the diaphragm is stopped down. A technique used by some photographers when it is difficult to know where to focus on the subject is to rack the bellows in and out to determine the minimum and maximum extensions that will produce sharp focus on any part of the subject, place a pencil mark on the camera bed for each of the two positions of the focusing adjustment, and then set it midway between the two marks. With cameras that have a linear scale on the bed, the scale markings can be used for this purpose.

Since altering the angle of the camera back affects both image shape and image sharpness, its use to control shape may either complicate or simplify the subsequent step of controlling sharpness with the camera front. Tilting a camera downward with the tilts and swings zeroed, for example, causes the vertical subject lines to converge and the plane of sharp focus to be at a different angle than the vertical plane of the subject, as shown in the 1st photograph in Figure 2–23, resulting in unsharpness in the parts of the subject that deviate from the plane of sharp focus. Tilting the back to eliminate convergence of the vertical lines causes the plane of sharp focus to intersect the vertical subject at a more extreme angle, producing even more unsharpness at the top and bottom of the subject, as shown in the 2nd photograph. To obtain agreement between the plane of sharp focus and the subject, it is now necessary to tilt the front to the vertical position so that the subject, the camera front, and the camera back are all parallel, as shown in the 3rd photograph. If, on the other hand, the photographer wanted to exaggerate the convergence of the vertical subject lines from the same camera position, the back would be tilted in the opposite direction, which would also bring the plane of sharp focus into closer agreement with the subject, as shown in Figure 2–24. There is no assurance, however, that the back would be tilted to the exact angle required for optimum sharpness, so that it might still be necessary to tilt the front to obtain a sharp image without stopping the lens diaphragm down.

Figure 2 – 21 Use of tilting adjustment to obtain a sharp image of the horizontal foreground and the vertical object.

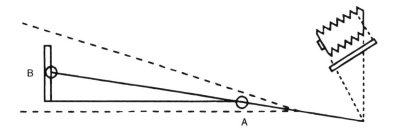

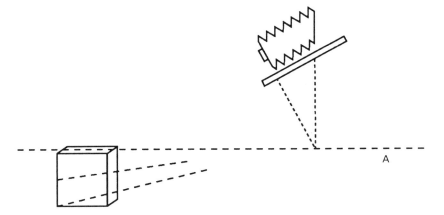

B

Figure 2 – 22 (A) Change in the plane of sharp focus as the camera focus is changed when the lens board and film plane are not parallel. (B) Type of subject where, after tilting the back to the vertical position for image shape, the optimum focus can be determined by marking the near and far limits of the focusing standard that produce sharp focus on any part of the subject and then setting it midway between the two marks. — *Len Rosenberg*

Simultaneous Use of Tilts and Swings

In practice, it is not uncommon for photographers to encounter situations that require the use of tilts and swings to control image shape and sharpness on vertical and horizontal planes simultaneously. In the 1st photograph in Figure 2–25, for example, the camera is tilted both down and sideways at the subject, resulting—with the adjustments zeroed—in convergence of the vertical and horizontal lines, and, when focused on the nearest corner, a progressive decrease in sharpness to the right and downward. In the 2nd photograph, the back has been tilted to eliminate convergence of the vertical lines, which also produced a greater loss of sharpness from top to bottom, and the front has been swung to improve image sharpness from left to right. In the 3rd photograph, the front has been tilted to improve the sharpness from top to bottom. The horizontal subject lines were allowed to converge normally.

Vertical and Horizontal Shifts

The vertical shift (or rising-falling movement) and the horizontal (or lateral) shift alter the position of the image on the ground glass and the film without affecting image shape or the angle of the plane of sharp focus. Thus, if a view camera has been set up to photograph an object and after adjusting the swings and tilts to obtain the desired image shape and angle for the plane of sharp focus the

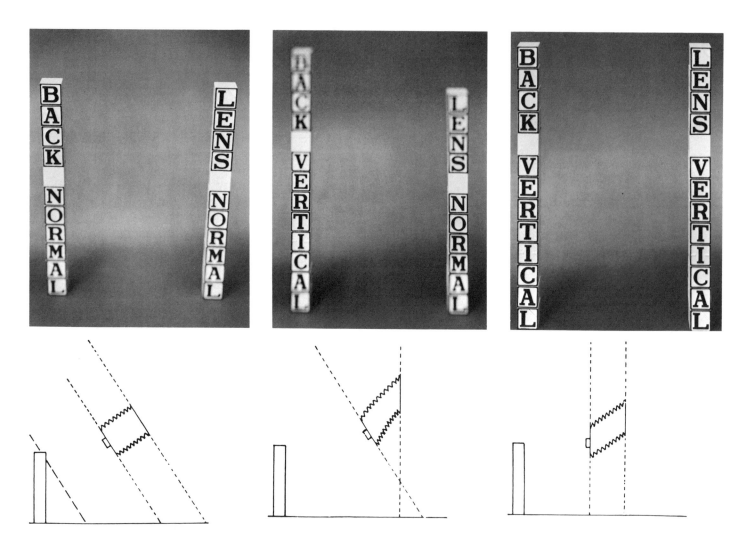

Figure 2 – 23 (*Left*) Appearance of the image with the camera tilted downward and with the tilt adjustments zeroed. (*Center*) Tilting the back to eliminate convergence of the vertical lines also reduces the area of sharpness. (*Right*) Tilting the lens board so that it is parallel to the subject and the film plane produces a sharp image at the maximum diaphragm opening.

image is not centered as desired on the ground glass, it would be better to center the image by shifting the front or back than to position the image by tilting, swinging, or moving the entire camera—which would require readjustment of the swings and tilts. When copying a painting, for example, the camera would normally be set up with the front and back parallel to the painting so that there would be no convergence of the vertical and horizontal edges of the painting, and the plane of sharp focus would conform to the plane of the painting. The vertical shift moves the image up and down and the horizontal shift moves the image from side to side, and in both situations the image moves approximately the same distance as the lens.

Shifting the lens moves the image in the same direction on the ground glass. Since the image is inverted on the ground glass, shifting the lens upward also moves the image upward on the ground glass, but in terms of the final photograph the image moves down, as shown in Figure 2–26. Similarly, shifting the lens to the left moves the image to the left on the ground glass, but to the right on the photograph. The opposite effect occurs, however, when the back is shifted. That is, shifting the back downward moves the image upward on the ground glass but downward on the photograph, and shifting the back to the right moves the image to the left on the ground

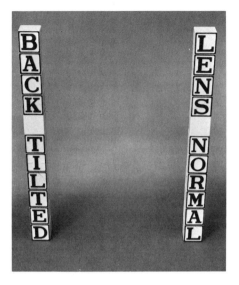

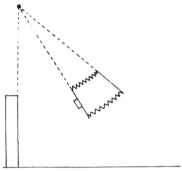

Figure 2 – 24 Tilting the back forward to exaggerate convergence will also produce a sharp image if the three planes meet at a common line.

glass but to the right on the photograph. The 2nd photograph in Figure 2–26, therefore, could have been made either by shifting the front upward and to the left or by shifting the back downward and to the right.

Since shifting the front and back of the camera in opposite directions produces the same image movement on the ground glass, it can be concluded that when mechanical limitations on the shifts prevent the desired effect from being achieved when either the front shift or the back shift is used alone, both can be used to obtain greater movement of the image by shifting them in opposite directions. When photographing a tall building, for example, if shifting the lens upward with the camera level does not move the image upward far enough to include the top of the building on the ground glass, the back could then be shifted downward. If the combination of the two changes still does not include the top of the building, the entire camera can be tilted up, followed by tilting both the front and back to vertical positions, as shown in Figure 2–27. Although there are no differences in the final image between using the vertical shift to elevate the lens with the camera level, and tilting the camera upward and then tilting the front and back to vertical positions if the displacements between the lens and the film are the same, the latter method requires three steps rather than one—tilting the camera, tilting the front, and tilting the back.

Another type of situation in which the vertical and horizontal shifts are useful is where a flat reflective surface, such as a mirror or a plate glass window, produces a reflection of the camera. For the 1st photograph in Figure 2–28, the mirror was placed on the floor to obtain a reflection of the white ceiling and the camera was placed

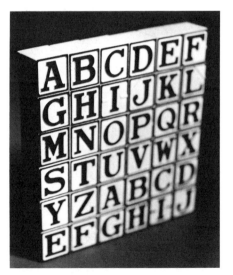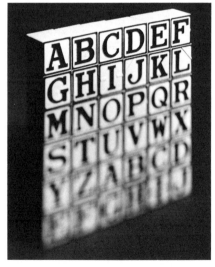

Figure 2 – 25 (*Left*) Appearance of the image with the tilt and swing adjustments zeroed. (*Center*) Effects of tilting the back to eliminate convergence of the vertical lines and swinging the lens to improve sharpness from left to right. (*Right*) Top-to-bottom sharpness obtained by tilting the lens.

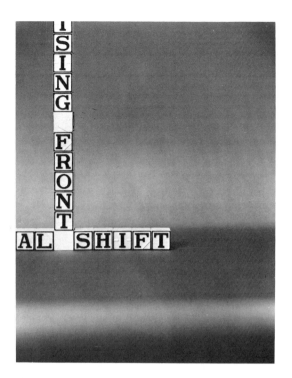

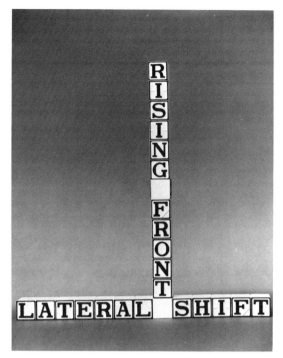

Figure 2 – 26 The front vertical and horizontal shift adjustments move the (inverted) image in the same vertical and horizontal directions on the ground glass, but in the opposite directions in terms of the erect print image.

Figure 2 – 27 Lens displacement with front vertical shift (*left*) and increased displacement also using bed, front, and back tilts (*right*).

directly over the mirror with all adjustments zeroed to obtain a rectangular image. To eliminate the reflection of the camera and tripod, the tripod was moved in the direction of the bottom of the mirror and then the front of the camera was shifted upward to reposition the image on the ground glass. If a reflection of the camera is seen on the glass covering framed artwork that is being copied on a wall, the camera could either be lowered, using the vertical shifts to reposition the image, or moved sideways, using the horizontal shifts to reposition the image. The shifts may also be useful in situations where an obstruction prevents the camera from being placed directly in front of a subject having parallel lines that are to appear parallel in the photograph.

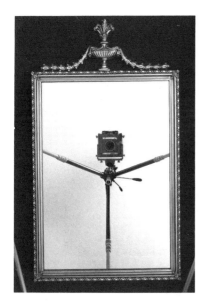

Film Rotation

When it is necessary to switch between horizontal and vertical film formats with a hand-held camera, the entire camera can easily be rotated. View cameras can similarly be rotated when using a pan-tilt tripod head that has both longitudinal and lateral tilt capabilities, or when using a ball-joint tilt attachment. Also, some view cameras having tubular monorails can be rotated about the monorail by loosening the monorail clamp. There are two disadvantages to rotating the entire camera for this purpose, however. Rotating the camera changes the center of gravity of the camera in relation to the tripod, which may result in an unstable setup, and it also changes the position of the lens in relation to the subject, which requires realignment of the camera when making closeup photographs.

View cameras have the capability of switching the ground glass and film holder between horizontal and vertical format positions without rotating the entire camera. With *reversible* backs, the back is detached from the camera, rotated, and reattached. With *revolving* backs, the back can be rotated without detaching it. With 360° revolving backs, the film can be placed in intermediate positions in addition to vertical and horizontal (Figure 2–29). The more limited type of revolving back that cuts off the image in the corners of the ground glass at the intermediate angles of rotation is used mostly where the compactness of a smaller bellows is more important than the versatility. Because 360° revolving backs require appreciably larger bellows than reversible backs, they are seldom used on the larger sizes of view cameras. Several manufacturers of 8 × 10-in. and larger view cameras offer the revolving-back feature on accessory reducing backs for smaller film sizes but not on the larger standard backs.

Figure 2 – 28 Elimination of a reflection in a mirror without altering its rectangular shape by moving the camera and tripod toward the bottom of the mirror and shifting the lens toward the top.

Figure 2 – 29 Reversible back (*top*) and 360° revolving back (*bottom*).

View-Camera Lenses

3

Almost any lens that can be attached to a lens board, including a pinhole aperture, can be used on a view camera, but for most picture-making situations lenses specifically designed for view cameras should be used. Considering the many ways in which lenses can differ, photographers often have little specific information about the lenses that they purchase and use. Not infrequently, the focal length and the range of *f*-numbers are the only quantitative information marked on the lens itself. Since relatively few photographers are prepared to conduct comprehensive lens tests, they tend to be influenced in their choice of lenses by recommendations of others and by the manufacturers' advertising claims. Although the major lens manufacturers do make testing and performance data available in their technical publications, some of the characteristics of the images formed by view-camera lenses are difficult to document in terms that are meaningful to photographers who have no knowledge of optics. A basic knowledge of image formation is also helpful in understanding the limitations of view-camera swings, tilts, and other adjustments to prevent unnecessary loss of quality of the optical image.

Some of the more significant ways in which the images formed by different lenses may vary are: image size, illumination at the maximum aperture, variation of illumination from the center to the edges of the film, image definition at the center and the edges of the film, image definition when focused on large and small object distances, and accuracy of the image with respect to shape, color, and contrast.

Image Formation

The simplest method for forming an optical image is with a pinhole in a thin sheet of opaque material. The pinhole can be thought of as transmitting only a single ray of light from each point on the subject, which, since light travels in a straight line in air, can strike only one position on a ground-glass viewing surface or piece of film placed on the opposite side to form an inverted image. The size of the image for an object at a given distance increases with the distance between the pinhole and the ground glass or film, as shown in Figure 3–1. Instead of a single ray of light, the pinhole actually transmits a very narrow beam of light, one that has the same diameter as the pinhole, from each object point. It would seem to be logical that the sharpness of the pinhole image would vary inversely with the size of the pinhole, but for a given pinhole-to-film distance there is an optimum pinhole size. If the pinhole is made larger than the optimum size, it transmits too large a beam of light, which reduces image sharpness. If the pinhole is made smaller than the optimum size, the pinhole causes the narrow beam to spread out, somewhat like water from the nozzle on a garden hose, due to a phenomenon known as *diffraction,* which also reduces image sharpness.

Because pinholes produce images with nearly uniform sharpness for objects ranging in distance from miles to inches from the camera, many photography students, amateur photographers, and others have developed an interest in experimenting with pinhole photography and have produced many fascinating photographs. The image sharpness produced with a pinhole of optimum size used with 4 × 5-in. or larger film is comparable to that produced with a professional

Figure 3 – 1 The size of the image formed with a pinhole increases with pinhole-to-film distance.

soft-focus portrait lens used at the maximum aperture. View cameras are well suited to pinhole photography since it is easy to attach a pinhole made in a small piece of thin, opaque material over an opening in a cardboard lens board. The distance between the pinhole and the film can easily be altered to change image size and angle of view, and sheet-film holders enable one to make as many different exposures as desired.

The diameter of a pinhole of optimum size varies primarily with the pinhole-to-film (or image) distance. Optimum pinhole diameters are listed in Table 3-1 for image distances from 1 in. to 16 in. The corresponding f-numbers are also listed to assist in determining exposure times. If an exposure meter is used and the f-number scale does not include such large f-numbers, the exposure time for a smaller f-number should be multiplied by 4 each time the f-number is doubled until the desired f-number is reached—for example, 1/15 sec. at f/32 corresponds to 1/4 sec. at f/64 and 1 sec. at f/128. With exposure times longer than 1 sec. it may be necessary to increase the indicated exposure time to compensate for reciprocity effects, a factor that will be discussed in chapter 4, Exposure and Exposure Meters.

Comparison pinhole images made with three different-size pinholes, optimum size, 1/2 optimum size, and two times optimum size, and an image made with a photographic lens on an 8×10-in. view camera are shown in Figure 3–2. The three pinhole prints were cropped to permit a side-by-side comparison but the images are the same size as in the uncropped photograph made with the lens. It can be observed that the pinhole image becomes less sharp when the pinhole is either larger or smaller than the optimum size. Also, although the sharpest pinhole picture has good detail, it appears soft in comparison with the image made with the lens.

Image Formation with a Simple Lens

Positive lenses produce images by refracting or changing the direction of light so that all rays of light falling on the front surface of the lens from each object point converge to a point behind the lens, as

Table 3 – 1 Optimum pinhole diameters for different pinhole-to-film distances.

(Distance) f	(Diameter) D	(f-Number) f-N
1 in.	1/140 in.	f/140
2 in.	1/100 in.	f/200
4 in.	1/70 in.	f/280
8 in.	1/50 in.	f/400
16 in.	1/35 in.	f/560

$$D = \frac{\sqrt{f}}{141}\text{(in.)}$$

$$D = \frac{\sqrt{f}}{28}\text{(mm)}$$

$$f\text{-}N = \frac{f}{D}$$

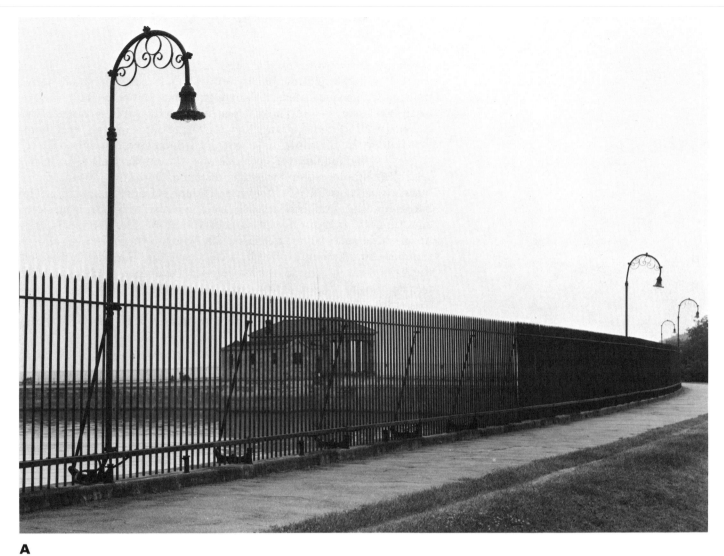

A

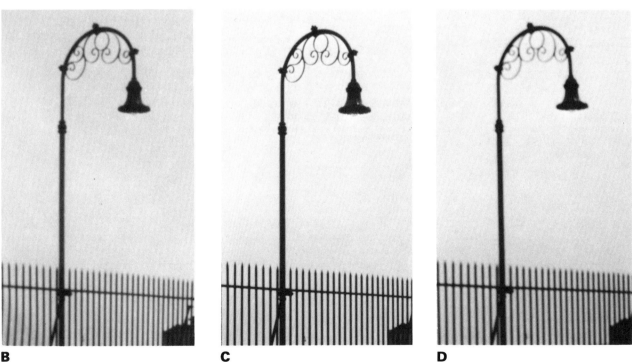

B **C** **D**

Figure 3 – 2 (A) Photograph made with a lens on an 8 × 10-in. view camera. Three additional photographs were made using different-size pinholes and an area on the left side was cropped in printing to facilitate comparing image sharpness. The pinhole sizes were (B) 1/2 the optimum diameter, (C) the calculated optimum diameter, and (D) two times the optimum diameter.

Figure 3 – 3 Image formation with a positive lens.

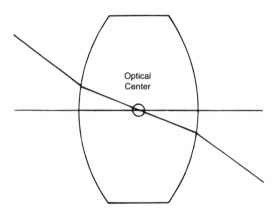

Figure 3 – 4 Any ray of light passing through the optical center leaves the lens traveling parallel to the direction of the entering ray.

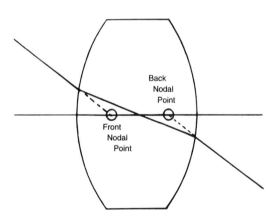

Figure 3 – 5 Using a ray of light that passes through the optical center, the nodal points can be located by extending the entering and departing segments in straight lines until they intersect the lens axis.

shown in Figure 3–3. If the object is at infinity or a very large distance, the light rays will enter the lens traveling parallel to each other, and the image point formed where they come to a focus is referred to as the *principal focal point.* For conventional photographic lenses, the approximate *focal length* can be determined by measuring the distance from the center of the lens to the principal focal point, or the distance from the center of the lens to the ground glass when a view camera is focused on a distant object.

The focal length marked on photographic lenses by the manufacturer is determined by a more precise method than the procedure just described. For every lens, whether it is a single-element lens, as shown in Figure 3–4, or a typical photographic lens that contains multiple elements, there is a point on the lens axis known as the *optical center* located so that any ray of light that passes through it enters and leaves the lens traveling in the same direction. Although the line in Figure 3–4 represents the actual path of the ray of light, extending the entering and departing rays of light to the lens axis, as shown in Figure 3–5, establishes the front (or object) *nodal point* and the back (or image) *nodal point.* Lines drawn through the nodal points, perpendicular to the lens axis, as shown in Figure 3–6, represent front and back *nodal planes.* Knowledge of the location of the nodal points and planes is important for two reasons: (1) when precise measurements are required, object distance is measured to the front nodal plane and image distance is measured to the back nodal plane, and (2) when a lens on a view camera is swung or tilted about the back nodal point, the ground-glass image remains stationary. (When the lens is tilted on a view camera that has base tilts, where the pivot is near the camera bed, the image moves vertically on the ground glass, requiring realignment of the camera.)

For most picture-making situations with conventional view-camera lenses, the errors introduced by making measurements to the center of the lens rather than the nodal planes will not be significant. It should be noted, however, that with some lenses of special design, such as telephoto lenses and reversed telephoto wide-angle lenses, which are used primarily on small-format single-lens-reflex cameras, the nodal planes tend to be located in front of the lens and behind the lens. Although lens manufacturers do not indicate the locations of nodal planes on their lenses, the location of the *back* nodal plane of any lens can be determined by focusing the lens on infinity, or a very distant object, and measuring 1 focal length forward from the ground glass. The location of the *front* nodal plane could be determined by turning the lens around and repeating the process.

Image Formation with a Multiple-Element Lens

All view-camera lenses contain multiple elements. The high-quality view-camera lens illustrated in Figure 3–7 contains a total of six positive and negative elements. For some purposes, as when comparing basic types of lenses, such as normal, telephoto, and wide-angle, and when discussing lens design with respect to lens aberrations, it is important to examine the arrangement of the individual elements in lenses. For the purpose of noting the relationships between

Figure 3 – 6 For an object point that is not on the lens axis, object and image distances are measured in a direction that is parallel to the lens axis of the corresponding nodal planes.

Figure 3 – 7 A high-quality general-purpose view-camera lens that contains six elements.

Figure 3 – 8 Image formation graphic drawings with the object at distances of 1, 2, 3, 4, and 5 focal lengths from the lens.

object and image distances and object and image sizes for a given lens or for lenses having different focal lengths, the lens diagrams can be simplified to three straight lines—a horizontal line representing the lens axis and two vertical lines representing the nodal planes. If the separation between the nodal planes is small, as it usually is, and great precision is not required, they can be combined into a single vertical line.

The simple diagram in Figure 3–8, containing only the lens axis and the combined nodal planes, can be used to show the inverse relationship that exists between object distance and image distance for a given lens—that is, as a distant object is moved closer to the camera, the distance between the lens and the ground glass must be increased to keep the image in focus. The top diagram shows an object, the arrow, placed 1 focal length in front of a lens. A mark representing the principal focal point is made an equal distance to the right of the lens since any ray of light entering the lens parallel to the lens axis will pass through the principal focal point, as shown with the upper ray in all of the diagrams. Also, a ray of light that passes through the optical center of the lens does not change direction, as shown with the lower ray in all of the diagrams. In the top diagram, the two rays of light from the object leave the lens traveling parallel to each other, which means that they never come to a focus and we can conclude that a camera cannot be focused on an object that is at a distance of 1 focal length or less from the camera.

The distance between the object and the lens progressively increases by 1 focal length between diagrams from top to bottom, and

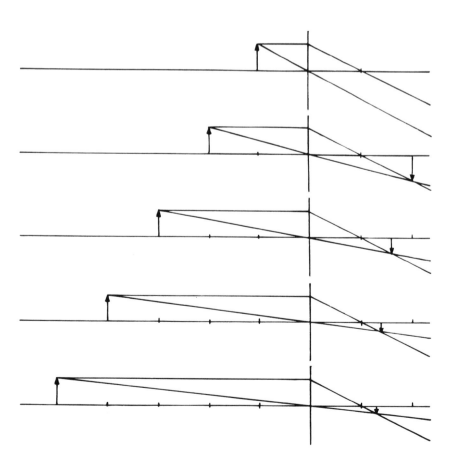

the focused image becomes smaller and moves closer to the lens. A limit would be reached when the object distance is increased to infinity, in which case the in-focus image would be located exactly 1 focal length behind the lens.

The 2nd diagram from the top is especially noteworthy since it shows that when an object is placed 2 focal lengths in front of the lens, 400 mm with a 200-mm focal-length lens, the image is formed an equal distance behind the lens and the image is the same size as the object. Thus, the range of object distances for the entire specialized field of photomacrography, which may be defined as the production of camera images at a scale of reproduction of 1:1 or larger, is represented by the change in position of the object between the top 2 diagrams. In practice, the largest image that can be produced with a given view camera and lens is determined by the camera's maximum bellows extension.

Simple ray tracings were introduced above to illustrate (1) the inverse relationship that exists between object end image distances, and (2) how image size increases as image distance increases and object distance decreases, but measurements can be made on such drawings to obtain quantitative information about distances and sizes providing that the drawings are made to a known scale. Using a 1/8 scale, for example, the principal focal points for an 8-in. focal-length lens would be located 1 in. on each side of the vertical line representing the lens, and if a 16-in. tall object is to be located 40 in. from the camera lens, the arrow would be 2 in. tall and located 5 in. to the left of the lens. The actual image distance and image size could then be determined by measuring those distances on the drawing and multiplying them by 8.

Once the basic distance and size relationships are understood, however, it is more convenient to use simple mathematics than ray tracings. With equations involving three terms, the value of any one of the three can be determined when the values of the other two are known. A few examples of how useful information can be obtained in this manner are given below. It should be noted that the same information could be obtained by focusing a view camera on an object at the specified distance and making the desired measurements, but that is more time consuming and it assumes that the appropriate focal-length lens and camera are available. It may be useful to obtain certain such information before purchasing a view camera and lenses to make sure that they will function as desired.

1. Question: What is the shortest object distance (u) that two cameras equipped with 8-in./203-mm focal-length (f) lenses can focus on if the maximum bellows extension (v) of one is 12 in. and of the other is 24 in.?

Equation: $1/f = 1/u + 1/v$

$1/8 = 1/u + 1/12$ and $1/8 = 1/u + 1/24$

$1/u = 1/8 - 1/12$ $1/u = 1/8 - 1/24$

$1/u = .042$ $1/u = .083$

$u = 24$ in. $u = 12$ in.

This same equation could be used to find the minimum object distance that can be focused on with different focal-length lenses with a given maximum bellows extension.

39

2. Question: What are the largest scales of reproduction (R) that can be obtained with 8-in./203-mm and 4-in./102-mm focal-length lenses on a camera having a maximum bellows extension of 16 in.?

Equation: $R = (v\text{-}f)/f$

$R = (16\text{-}8)/8$ and $R = (16\text{-}4)/4$

$R = 1$ $R = 3$

Thus, the largest image that can be obtained with the 8-in. focal-length lens is the same size as the object, whereas the largest image with the 4-in. lens is three times as large as the object. It should be noted that although longer focal-length lenses produce larger images when the object distance remains constant, shorter focal-length lenses produce larger images when the maximum bellows extension is the limiting factor because the shorter lens allows the camera to be focused on a shorter object distance.

Basic Differences between Lenses

At least five different brands of view-camera lenses are marketed in the United States, and one manufacturer makes more than 40 different view-camera lenses. The basic differences between lenses offered by each manufacturer include: (1) focal length (from 28 mm to 800 mm, for example), (2) covering power (for film sizes from 2 1/2 × 3 1/2 in. to 11 × 14 in., for example), (3) design type (normal, wide-angle, telephoto, for example), (4) correction for aberrations (including different levels of correction, and optimization for small, medium, and large object distances), (5) range of f-numbers ($f/4$—$f/32$, and $f/8$—$f/90$, for example), and (6) range of shutter speeds (T—1/250 sec., and T—1/500 sec., for example). Some of these lens attributes will be covered below but the last two, f-numbers and shutter speeds, will be included in chapter 4, Exposure and Exposure Meters.

Focal Length

For lenses of normal design, image size and covering power both increase as the focal length increases. In general, image size is directly proportional to focal length, so that the image formed with a 300-mm focal-length lens will be two times as tall and wide as the image formed with a 150-mm lens at the same distance from the subject. With respect to covering power, the main precaution is not to select a lens designed for a smaller film size than the film being used, such as a lens designed for 4 × 5-in. film on an 8 × 10-in. camera. There would be no problem in using a lens recommended for an 8 x 10-in. camera on a 4 × 5-in. camera, however, providing that the base and bellows are long enough to accommodate the longer focal-length lens. According to a commonly quoted rule of thumb, a normal focal-length lens for general-purpose photography is a lens that has a focal length equal to the diagonal of the film. The diagonal of 4 × 5-in. film is 6.4 in. or 163 mm, for example. It should be noted, however, that the most commonly used

focal lengths for various types of photography may deviate considerably from this generalization, such as the use of longer focal-length lenses for studio portraits and shorter focal-length lenses for interior architectural photographs. Also, somewhat longer focal-length lenses have commonly been used on view cameras for general-purpose photography to provide the additional covering power that might be needed when using tilt, swing, and shift adjustments, such as using a 210-mm focal-length lens rather than the 163-mm focal length mentioned above for 4 × 5-in. film.

Since the size of the image of an object at a given distance increases as the focal length of the lens increases, it follows that the longer lens will include a smaller area of the scene, an area identified as the field of view. For some purposes, such as making photographic copies and closeup photographs, it may be useful to specify the field of view in terms of the dimensions of the rectangular subject area included on the ground glass and film for different focal-length lenses and object distances. Generally, however, the subject area that will be included is specified in terms of the *angle of view,* which is defined as the angle formed between straight lines connecting the lens back nodal point and opposite corners of the film when the camera is focused on infinity.

An angle of view of 53° is produced when the lens focal length is equal to the film diagonal, which is a useful number to remember for comparison purposes. Unfortunately, lens manufacturers do not generally provide data on angles of view for combinations of various focal-length lenses and film sizes. (Angle of *view* should not be confused with angle of *coverage,* which is commonly provided by lens manufacturers.) The angle of view for a given lens-film combination can be determined by making a full-size scale drawing in which the length of the film diagonal is represented by a vertical line in the film position. With the lens placed 1 focal length to the left, diagonal lines are drawn from the lens center to the ends of the film line. The angle of view can then be measured at the lens with a protractor.

Changing either the focal length or the film size will change the angle of view, as shown in Figure 3–9. Decreasing the focal length increases the angle of view, an inverse relationship, but halving the focal length does not double the angle. It should be noted that the distance between the lens and the film could be increased with a given lens by focusing on closer object distances, which would also change the angle between lines drawn to the corners of the film, but such angles should be referred to as *effective* angles of view, since the definition of angle of view is based on an image distance of 1 focal length, or the lens being focused on infinity. Decreasing the film size, as by using a roll-film adapter on a 4 × 5-in. view camera, also decreases the angle of view, but again, not by the same proportions.

If one is only interested in knowing how much of a given scene will be included with a certain combination of lens and film, without determining the size of the angle of view, this can easily be accomplished by cutting an opening the size of the film in a larger piece of cardboard and holding it 1 focal length in front of one eye. The area seen will be the area recorded on the film. The distance between the mask and the eye can be varied to correspond to different focal-length lenses, as illustrated in Figure 3–10, to assist in selecting appropriate focal-length lenses for specific situations.

41

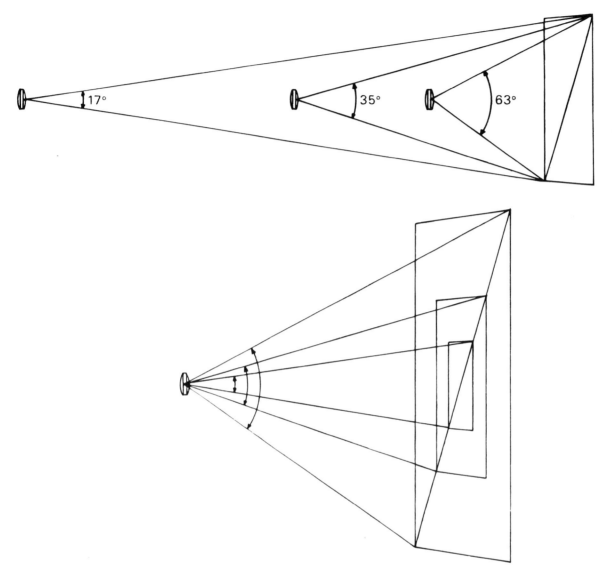

Figure 3 – 9 (*Top*) Angle of view with different focal-length lenses and constant film size. (*Bottom*) Angle of view with different film sizes and constant focal length.

Focal Length, Object Distance, and Image Size

Since image size for a given subject can be varied either by changing to a longer or shorter focal-length lens or by moving the camera toward or away from the subject, the similarities and differences of the resulting images with the two procedures should be known. With two-dimensional subjects, as when copying paintings, photographs, and drawings, the resulting images should be essentially identical if one is made with a 150-mm focal-length lens from an object distance that produces the desired image size and the other is made with a 300-mm focal-length lens from twice the distance.

There may be practical limitations on the range of image sizes that can be obtained with each of these two methods in specific situations. The largest image of a distant object that can be obtained by changing lenses depends upon the focal lengths of the lenses that are available and that can be accommodated by the view camera being used. The longest normal-type lens that can be used on a camera hav-

Figure 3 – 10 Comparison of fields of view with 90-mm, 210-mm, and 420-mm focal-length lenses on a 4 × 5-in. view camera, the same as would be seen by holding a 4 × 5-in. opening at a distance of 90 mm, 210 mm, and 420 mm from the eye at the camera position.

ing a maximum bellows extension of 20 in. is 20 in., and then only with the camera focused on infinity. With modular-type view cameras, extension monorails and bellows can be attached to dramatically increase the maximum lens-to-film distance, if the camera parts are available. Similarly, the smallest image that can be obtained of an object at a fixed distance from the camera is based on the shortest focal-length lens that is available and that has adequate covering power. With some view cameras difficulty may be encountered in reducing the lens-to-film distance sufficiently to focus the image with very short focal-length lenses without substituting a bag bellows for the conventional accordion bellows and/or using the lens with a recessed lens board. Unfortunately, variable focal-length zoom lenses are not available for view cameras as they are for 35-mm cameras—with focal-length ratios up to approximately 6:1—and video and motion-picture cameras—with ratios up to approximately 20:1.

There may also be limits on moving a view camera to obtain the desired image size with a given focal-length lens in specific situations. It may not be possible to move a camera close enough to a distant scene because of physical obstructions, or because the camera

position selected for compositional reasons does not produce as large an image as desired. When photographing very small objects, the limitation on how close the camera can be placed to the object with a given lens is the maximum bellows extension. On the other hand, it is often not possible to place the camera as far away from the subject as desired, at least with a normal focal-length lens, when making interior architectural photographs, due to the restrictions imposed on camera placement by walls and other obstructions.

Focal Length, Object Distance, and Perspective

Although identical images can be obtained of two-dimensional subjects with different combinations of lens focal length and object distance, with three-dimensional objects and scenes such variations produce differences in perspective. Perspective may be defined as the appearance of objects with respect to their distance and position. Perspective is the quality that creates the illusion of three dimensions in two-dimensional photographs. There are several factors that contribute to this illusion of depth in photographs, but the most obvious one is linear perspective, which can be defined as a change in image size or a convergence of parallel subject lines as a result of variations in object distance (Figure 3–11). The freedom of choice of lens focal length and camera position afforded by the long bellows provides view-camera users with considerable control over linear perspective.

With two objects of equal size that are located at different distances from the camera, the images will vary inversely in size with the object distances. A 1:2 ratio of object distances, for example, produces a 2:1 ratio of image sizes. (The image of the front of a long, low building that is at an angle to the camera will reveal linear perspective not only by the difference in height of the near and far ends of the building, but also by the convergence of the horizontal building lines.) Moving the camera farther away from the two objects that are at different distances will cause both images to become smaller, but not by the same amount. Since the ratio of the distances from the camera to the two objects decreases as the camera is moved away, the ratio of the image sizes will also decrease. Starting with objects at a 1:3 ratio of distances, doubling the distance from the camera to the near object increases the distance from the camera to the far object by only 1/3 of the original distance (Figure 3–12). The ratio of the object distances is now 1:2 and the ratio of the image sizes is 2:1. Moving the camera to the third position again doubles the distance to the near object but increases the distance to the far object by 1/2, producing a ratio of object distances of 1:1.5 and a ratio of image sizes of 1.5:1. Thus the images become more nearly equal in size in addition to decreasing in size as the camera is moved farther away. The camera could never be moved so far away that the two images would become exactly equal in size, but at very large object distances the difference would be insignificant.

Inexperienced photographers commonly select the camera position on the basis of factors other than perspective. The tendency is to adjust the distance between the camera and the subject to obtain the desired image size and angle of view. This casual approach will oc-

Figure 3 – 11 The appearance of depth due to the convergence of parallel subject lines and diminishing image size of objects with increasing object distance.

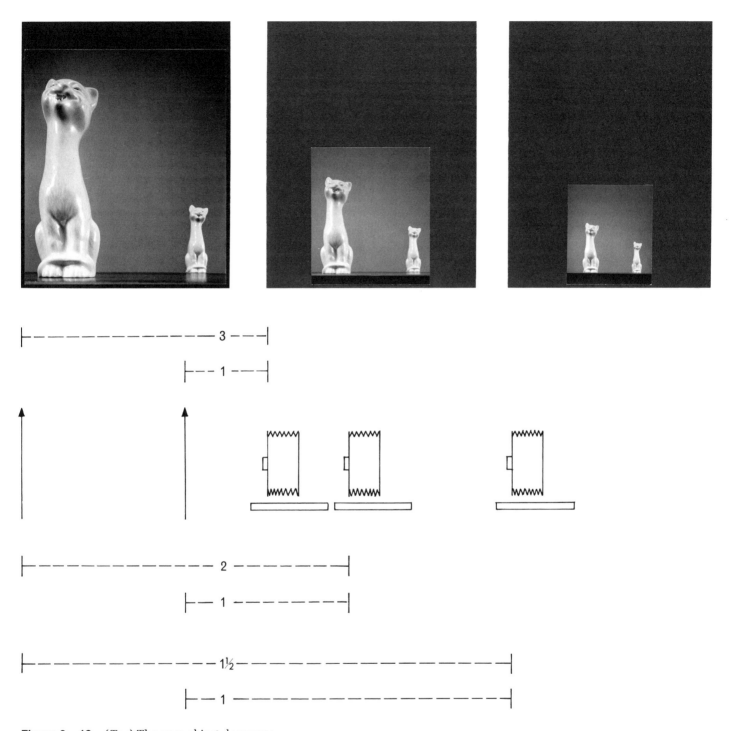

Figure 3 – 12 (*Top*) The near object decreases in size more rapidly than the far object as the camera distance increases. (*Bottom*) The decreasing ratios of the object distances as the camera is moved to the right are the same as the decreasing ratios of image sizes in the photographs.

casionally result in an obviously unfortunate perspective effect, such as the too-large nose on a closeup portrait or the compressed appearance of a subject photographed from a distance. Professional photographers learn to control perspective to obtain the desired effect, whether it be normal, strong, or weak perspective. To do this, it is first necessary for the photographer to be aware of the subtle as well as the obvious perspective effects. The camera position is then selected on the basis of the perspective desired, and, finally, a lens is selected having the focal length that will produce the desired image size.

When we look at three-dimensional objects and scenes directly from different distances we are rarely aware of a perception of either weak or strong perspective, as occurs when we look at certain photographs. This can be explained by the fact that the focal length of optics of the eyes remains constant, and when we do move closer to a three-dimensional object or scene, the stronger linear perspective is perceived as being appropriate for the close distance and it therefore appears normal. The linear perspective in photographs made with normal focal-length lenses, that is, lenses having a focal length approximately equal to the film diagonal, generally appears normal, even though we may prefer somewhat weaker or stronger perspective with certain subjects. The perspective in photographs made with very short focal-length lenses, however, tends to appear strong due to the shorter camera-to-subject distance used with such lenses to obtain the same image size of the main subject as with a normal focal-length lens, and conversely, the perspective in photographs made with very long focal-length lenses tends to appear weak due to the larger camera-to-subject distance generally used with these lenses.

Changes in linear perspective are most obvious when comparison photographs are made in which the object distance and the focal length are changed simultaneously in such a way that part of the subject remains unchanged in size in the two images. The diagram in Figure 3–13 shows a camera at four different distances from a box-shaped object. Four different focal-length lenses were used and the camera-to-subject distance was adjusted with each lens change so that the height of the far end of the box remained constant. The changes in linear perspective can be seen in the resulting photographs both in the decrease in the height of the near end of the box as the camera is moved farther away and in the change in the convergence of the horizontal subject lines from very obvious in the 1st photograph to just detectable in the last. The transition in linear perspective can be described as changing from strong, through normal, to weak. Normal perspective typically results when the focal length of the camera lens is approximately equal to the film diagonal. Normal perspective is appropriate in photographs where the objective is to present a realistic representation of the subject, but strong and weak perspective can often be used creatively to enhance the subject and make a more interesting photograph.

The 4 photographs in Figure 3–13 were made with the tilts and swings in their zero positions to demonstrate the effect of changing lens focal length and object distance on linear perspective. Since a single subject plane dominates the pictures, it should be noted that similar perspective changes could have been made with a single lens by swinging the back of the camera away from being parallel to the plane of the subject to increase convergence of the horizontal lines, and toward being parallel to decrease convergence. In most three-dimensional scenes, however, the entire subject does not conform to a single plane and the two procedures cannot be used to achieve the same effect.

Picture-Viewing Distance and Perspective

The distance at which a photograph is viewed can alter the appearance of depth in the scene even though the size relationships of the images of objects at different distances and the angle of con-

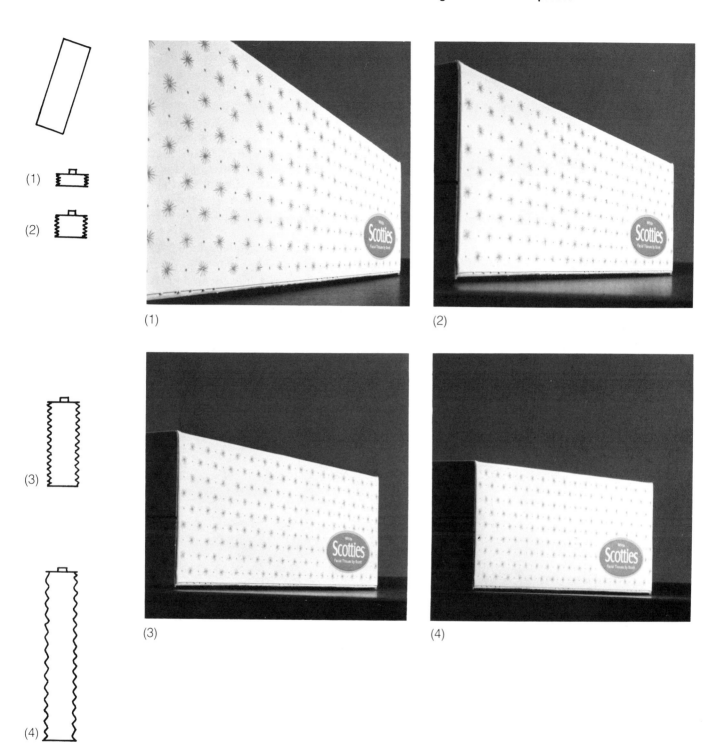

(1)

(2)

(3)

(4)

(1)

(2)

(3)

(4)

Figure 3 – 13 Simultaneous increases of lens focal length and object distance result in a progressive weakening of linear perspective. The right end of the box remains constant in size in the photographs.

vergence of parallel subject lines remain constant. The major reason why some photographs appear to have strong perspective and others weak perspective is because they are not viewed at the so-called "correct" viewing distance. For contact prints, the "correct" viewing distance is equal to the lens-to-film distance in the camera at the time the film was exposed. (Since the image distance is seldom measured when photographs are made, the lens focal length is commonly substituted and it is sufficiently accurate except when making close-up pho-

47

tographs, in which case the image distance is considerably larger than the focal length.) If an enlarged print is made rather than a contact print, the "correct" viewing distance is the camera image distance or lens focal length multiplied by the magnification from the negative to the print. Thus, an 8 × 10-in. contact print from a negative exposed with a 12-in. focal-length lens should be viewed at a distance of 12 in., and an 8 × 10-in. enlargement from a 4 × 5-in. negative (magnification of 2.0) exposed with a 6-in. focal-length lens should also be viewed at a distance of 12 in. At this distance, the images of objects on each of the 2 photographs will subtend the same angles to the eye as the original objects would have with the eye placed in the position of the camera lens, and the linear perspective in the photographs will appear normal.

Three different focal-length lenses are used on an 8 × 10-in. camera in the diagrams in Figure 3–14, a normal focal-length 12-in. lens, a 6-in. lens, and a 24-in. lens. Contact prints from the three negatives will tend to be viewed from a distance equal to the diagonal of the prints, or 12 in., indicated by the letter "A." Since this is the same distance as the lens-to-film distance for the photograph taken with the 12-in. lens, it is the "correct" viewing distance (indicated by the letter "B") for that photograph and the linear perspective in that photograph will appear normal.

With the shorter 6-in. focal-length lens on the camera, the "correct" viewing distance is shorter than the assumed viewing dis-

Figure 3 – 14 Correct viewing distance (B) and conventional viewing distance (A) with different focal-length lenses.

tance and the perspective will appear stronger than normal. With the longer 24-in. focal-length lens, the "correct" viewing distance is larger than the assumed distance and the perspective will appear weaker than normal.

Small variations in viewing distance will not produce significant changes in the perceived perspective and even large variations in viewing distance will have little effect with photographs of essentially two-dimensional subjects. Photographs that contain dominant objects in the foreground and background or strongly converging lines may change quite obviously in appearance with changes in the viewing distance.

Before leaving the subject of perspective, other methods of representing the three-dimensional world in two-dimensional photographs, in addition to linear perspective, should be mentioned. The first four of the following apply to photographs made with view cameras: (1) Overlap. When a foreground object covers up part of an object that is at a greater distance from the camera, it is obvious to the viewer that the objects are at different distances and there is no question as to which object is closer. If overlap is the only depth cue provided, however, it would not be possible to determine whether the distance separating the first and second objects is small or large, but in most situations multiple depth cues are provided. With movable objects, the objects can be arranged to obtain a desired overlap perspective effect. In other situations it is necessary to place the camera in the position that will produce the desired effect. (2) Depth of field. Use of a limited depth of field, so that the images of objects in front of and behind the distance focused on are unsharp, creates a stronger appearance of depth or perspective than when the entire scene appears sharp. Varying the f-number is usually the most convenient method of controlling depth of field, although variations in camera-to-subject distance, lens focal length, and film size also affect depth of field. In addition, view-camera swings and tilts can be used to alter the angle of the plane of sharp focus and the shape of the depth-of-field pattern. (3) Lighting. The appearance of depth can be enhanced with lighting that produces a gradation of tones on curved surfaces, a separation of tones between the planes of box-shaped objects, tonal separation between foreground objects and backgrounds, and shadows of objects on the ground or other surface. With photographs made in studios and other interior locations, the lighting can be arranged to achieve the desired effects. Outdoors, the lighting effect generally depends upon weather conditions, time of day, and camera location. (4) Aerial haze. The scattering of light that occurs in the atmosphere makes distant objects appear lighter and less contrasty than nearby objects. Thick fog and smoke can create an appearance of depth with relatively small differences in distance. (5) Motion perspective. As one approaches objects at different distances, they appear to increase in size at rates that vary with their relative distances, which produces strong perceptions of depth whether viewed directly or in a motion picture or video. (6) Stereophotography. Viewing 2 photographs taken from slightly different positions so that the left eye sees one and the right eye sees the other produces a realistic perception of depth. (7) Holography. With a single photographic image, holograms present different images to the left and right eyes, as with stereo pairs, but they also produce motion parallax for objects at different distances when the viewer moves laterally.

Covering Power of Lenses

The area within which an acceptable image is formed at the film plane of a camera is limited for all photographic lenses. This limitation can best be seen by placing a lens designed for a given film-format camera, such as 4 × 5-in., on a larger-format camera, such as 8 × 10 in. or 11 × 14 in., and examining the in-focus image of a distant scene on the ground glass. Although a satisfactory image is formed in the central area of the ground glass, the image becomes unsharp and eventually fades into darkness toward the corners. There are three basic ways of identifying the size of the usable area for specific lenses: (1) the recommended film format, (2) the diameter of the circle of good definition, and (3) the angular covering power. Manufacturers of view-camera lenses typically provide all three types of information for their lenses.

Recommended Maximum Film Format

The dimensions of the maximum film format recommended by the lens manufacturer are a useful guide in selecting a lens for a specific view camera to avoid the possibility that the lens will not cover the entire film area—at least when all of the adjustments are zeroed. This information does not help the photographer in knowing how far the tilts, swings, and shifts can be moved from the zero positions before the covering power of the lens is exceeded. Three different focal lengths of the same lens offered by one manufacturer, 120 mm, 135 mm, and 150 mm, are all recommended for use with 4 × 5-in. film, but their covering powers are not all the same, varying by about 23 percent. The amount of excess covering power provided to allow use of the view-camera adjustment can be determined, however, if the diameter of the circle of good definition is known.

Circle of Good Definition

The circle of good definition is a circular area in the image plane within which the lens is capable of forming an image having acceptable definition. There is some variation of image definition even within the circle, a decrease from the center to the edges, but this is generally not apparent except when a magnified image is examined critically. The diameter of the circle of good definition only needs to be as large as the diagonal of the film when the camera has no tilt, swing, or shift adjustments, or with view cameras when it will not be necessary to use any such adjustment for a certain type of photography, as for copying. If adjustments are to be used, however, the circle of good definition should be appreciably larger. Shifting the lens or back vertically or horizontally, or tilting or swinging the lens, will move the circle of good definition off center relative to the film, and image definition will not be satisfactory on any part of the film that is located outside the boundaries of the circle (Figure 3–15). Tilting and swinging the back of the camera do not appreciably alter the relative positions of the circle of good definition and the film. The only condition under which the circle of good definition is actually circular in shape

Figure 3 – 15 Positions of the circle of good definition in relation to the film (A) with the lens adjustments zeroed, (B) with the lens raised, and (C) with the lens tilted.

in the film plane is when the lens board and the film plane are parallel to each other. When they are not parallel, the "circle" of good definition becomes elliptical in shape.

To determine the amount of excess covering power a specific lens has with a given film format it is necessary to compare the diameter of the circle of good definition, which is provided in the manufacturer's literature, with the diagonal of the film format. This task is made more difficult by the fact that film dimensions are usually specified in inches, such as 4 × 5 in., where it is left up to the photographer to determine the length of the diagonal, and lens focal lengths are usually specified in millimeters. The diagonals of the conventional view-camera film formats, in inches and millimeters, are:

2.25 × 2.75 in.	3.55 in.	90 mm
4 × 5 in.	6.4 in.	163 mm
5 × 7 in.	8.6 in.	218 mm
8 × 10 in.	12.8 in.	325 mm
11 × 14 in.	17.8 in.	452 mm

Thus, if a 150-mm focal-length lens that is recommended for use with 4 × 5-in. film has a circle of good definition of 214 mm, subtracting the 163-mm film diagonal from the 214-mm circle diameter leaves a difference of 51 mm, or 2 in. Since only half of this difference is distributed on each side of the film, however, it would only be possible to shift the lens or back 25 mm or 1 in. and still keep the film entirely within the circle of good definition. If additional covering power is needed, either a wide-angle-type lens of approximately the same focal length or a longer focal-length normal-type lens could be used.

Four factors affect the size of the circle of good definition: (1) With lenses of normal design, the diameter of the circle of good definition is approximately equal to the focal length of the lens with the diaphragm set at the largest opening (Figures 3–16, 3–21). (2) Stopping a lens down increases the size of the circle of good definition somewhat with most lenses (Figures 3–16, 3–18). A 210-mm (8.25-in.) focal-length normal-type lens that has a circle of good definition of approximately that diameter at the maximum diaphragm opening might have a circle with a diameter as large as 300 mm (11.8 in.) with the diaphragm stopped down. It should be noted that lens manufacturers typically specify the covering power of their lenses with the diaphragm set at *f*/22, so an ap-

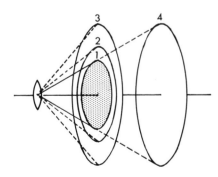

Figure 3 – 16 Four ways to increase the size of the circle of good definition: stop the diaphragm down (1 and 2), focus on a closer object (1 and 4), substitute a wide-angle lens having the same focal length (1 and 3), and substitute a longer focal-length normal-type lens (1 and 4).

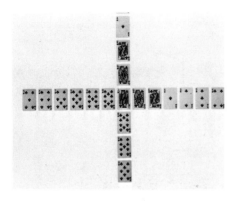

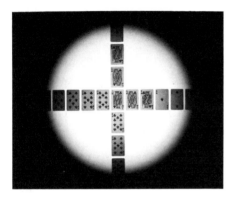

Figure 3 – 17 (Top) Photograph made with a lens having a sufficiently large circle of good definition to cover the entire film area. (*Bottom*) Photograph made with a lens having a much smaller circle of good definition.

propriate allowance should be made for somewhat less coverage when the lens is used at a larger opening. (3) The type of design of the lens can dramatically alter the ratio of the diameter of the circle of good definition to the focal length. The ratio is significantly larger than 1:1 with wide-angle lenses and smaller than 1:1 with telephoto lenses, such as 2.8:1 for a wide-angle lens and 0.6:1 for a telephoto lens, for example (Figure 3–16). (4) Since the usable light transmitted by a lens is projected toward the film in the form of an expanding cone of light, the farther the image is formed behind the lens the larger the circle of good definition will be (Figures 3–16, 3–19). Thus, a 210-mm (8.25-in.) focal-length lens that has a circle of good definition with a diameter of 210 mm when photographing distant scenes, will have a circle of good definition with a diameter of 420 mm (16.5 in.) when photographing a closer object that requires double the bellows extension.

Angle of Coverage

The angle of coverage of a lens is the angle formed by lines connecting the image nodal point with opposite sides of the circle of good definition, or the angle of the cone of *usable* light that is transmitted by the lens (Figure 3–20). The angle of coverage and the diameter of the circle of good definition are both measures of the covering power of lenses, but the angle of coverage is altered by only two of the four factors that determine the size of the circle of good definition. Changes in lens-to-film distance, due either to a change in focal length or a change in subject-to-lens distance, do not affect the angle of coverage.

Since the standard angle of *view* when the focal length is equal to the film diagonal is 53°, the angle of coverage of a lens intended for general-purpose photography must be at least that large, and larger if camera adjustments that alter the position of the lens axis in relation to the film are to be used. Information concerning the angle of coverage is generally provided by lens manufacturers, but it should be noted that it also is determined with the diaphragm stopped down to $f/22$, and it will be somewhat smaller at larger diaphragm openings.

Circle of Illumination

The circle of illumination is the circular area in the image plane formed by the entire cone of light transmitted by the lens, not just the usable cone of light. Although the circle of illumination is always larger than the circle of good definition, the difference in size of the two circles varies with lenses, and as a given lens is stopped down (Figure 3–21).

Types of Lenses

Most view-camera lenses can be classified as being one of three basic types—normal, wide-angle, or telephoto. Normal lenses are designed for general-purpose photography. In some respects they are

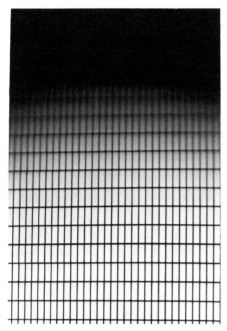

Figure 3 – 18 Edges of the circles of good definition and illumination with the lens diaphragm wide open (*top*) and stopped down (*bottom*).

compromises in that they are intended to perform adequately in a variety of situations rather than ideally in more specialized situations. Although the minimum focal length generally recommended for normal-type lenses is approximately equal to the film diagonal, there is no limit on how long the focal length of normal-type lenses can be—except that if the focal length approaches the maximum camera bellows extension in length it will only be possible to focus the camera on large object distances. Normal-type lenses having focal lengths considerably longer than the film diagonal are commonly referred to as *long-focus* lenses. The same lens, however, could be considered to be a normal focal-length lens for an 8 × 10-in. view camera and a long-focus lens for a 4 × 5-in. camera. Normal-type lenses having focal lengths considerably shorter than the film diagonal will not have sufficient covering power to cover the entire film when the camera is used for general-purpose photography. When a camera is used to photograph small objects close up, short-focus lenses not only have sufficient covering power but they also have the advantage that they provide a larger scale of reproduction than a longer focal-length lens at the same lens-to-film distance. When photographing a small object at a 1:1 scale of reproduction, for example, a 105-mm (4.1-in.) focal-length lens will have the same-size circle of good definition as a 210-mm (8.2-in.) focal-length lens that is used to photograph distant scenes because the lens-to-film distance for the closeup photograph will be double the focal length of the shorter lens and equal to the lens-to-film distance of the longer lens focused on a large object distance.

Some lens manufacturers offer two normal-type lenses of the same focal length, the difference between them being in the number of elements and the design with respect to correcting lens aberrations, the *f*-number of the maximum diaphragm opening, and the price.

Telephoto Lenses

Telephoto lenses are characterized by having a shorter lens-to-film distance than a normal-type lens of the same focal length. This is the only advantage telephoto lenses have over conventional lenses. If two negatives are made under identical conditions, one with a 254-mm (10-in.) focal-length normal-type lens and the other with a telephoto lens having the same focal length, superimposing the negatives would reveal that the two images are identical, assuming no significant aberrations in either lens.

Long focal-length lenses of normal construction are sometimes incorrectly referred to as telephoto lenses. Long focal-length lenses are used when a larger image is desired than is produced with a shorter focal-length lens from a given camera position. It is not necessary to switch to a telephoto-type construction when substituting a longer focal-length lens unless the increased lens-to-film distance required with the conventional lens cannot be accommodated due to length limitations of the camera bed or bellows, or because of objection to the increased bulkiness of the camera with the bellows extended.

Telephoto lenses have a classic basic structure, as shown in Figure 3–22, that results in the image or back nodal plane being located in front of the lens rather than within the body of the lens (Figure 3–23). A positive element is always located in front of a negative element sep-

Figure 3 – 19 Three photographs made with a 2-in. focal-length lens on a 4 × 5-in. view camera with the camera moved progressively closer to the subject. Since the circle of good definition increases in size as the image distance is increased to keep the image in focus, the circle was large enough to cover the entire film area for the 2nd photograph and was large enough to have used moderate tilt, swing, or shift adjustments if needed for the 3rd photograph.

arated by a space. Additional elements are used to minimize aberrations. Both the front and back components may contain a positive and a negative element, as shown in Figure 3–24, but the front component must have a positive (converging) effect and the back component a negative (diverging) effect. Image definition with early telephoto lenses was inferior to that of conventional lenses but the better modern telephoto lenses are of comparable quality.

When it is necessary to know the location of the image (or back) nodal plane of a telephoto lens it can easily be determined, as with any type of lens, by focusing the lens on infinity or a distant object and measuring 1 focal length forward from the ground glass (Figure 3–25). The distance the nodal plane is located in front of the lens or the lens board should be recorded for future reference, as that relationship will remain constant regardless of changes in lens-to-film distance when focusing on objects at different distances from the camera. Whenever it is necessary to measure object distance or image distance with a telephoto lens, as when calculating the scale of reproduction of an image or determining the exposure factor for a closeup photograph, the distance separating the nodal plane and the reference point should be subtracted from the distance between the subject and the reference point for the object distance, and added to the distance between the reference point and the ground glass for the image distance.

Although telephoto lenses are generally designed and used for photographing objects at moderate to large distances from the camera, the telephoto design has been used for some macro lenses. The advantages of the telephoto design for photomacrography are (1) that a longer focal-length lens can be used at a larger distance from the subject to obtain the same image size, which allows more room for lighting the subject without casting a shadow of the camera on the subject, and (2) when the bellows is fully extended to obtain the maximum scale of reproduction, the image distance (the distance from the back nodal plane of the lens to the film) is larger with the telephoto lens than with a normal lens of the same focal length, which produces a larger scale of reproduction.

It should be remembered that the covering power of telephoto lenses is smaller than that of normal-type lenses of the same focal length. One 360-mm (14-in.) focal-length telephoto view-camera lens, for example, has a circle of good definition with a diameter of 230 mm, which is considerably smaller than the focal length, but it is still larger than the 220-mm diameter circle produced by a 150-mm (5.9-in.) focal-length normal-type lens made by the same manufacturer and recommended for use on 4 × 5-in. view cameras.

Wide-Angle Lenses

Wide-angle lenses are characterized by having greater covering power than normal-type lenses of equal focal length. Since covering power is measured in terms of the diameter of the circle of good definition and the angle of coverage, values for both of these will be larger than with normal lenses having the same focal length. One 120-mm (4.7-in.) wide-angle lens, for example, has a 288-mm diameter circle of good definition and a 100° angle of coverage, compared to a 179-mm diameter circle and a 72° angle of coverage with a normal-type

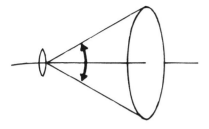

Figure 3 – 20 Angle of coverage and circle of good definition.

lens of the same focal length made by the same manufacturer. The angles of coverage of most wide-angle lenses now being marketed for use on view cameras are in the 100° to 110° range, but a specific minimum angle for a lens to be classified as a wide-angle lens has not been established. In the past some lenses having angles of coverage considerably smaller than 100° have been identified as wide-field or wide-angle lenses by the manufacturer.

There is no basic arrangement of positive and negative elements in wide-angle lenses as there is for telephoto lenses except for *reversed-telephoto* wide-angle lenses designed for small-format single-lens-reflex cameras, which require a certain minimum distance between the lens and the film plane to permit the mirror in the viewing system to swing out of the way before the film is exposed.

Lens designers are faced with more severe problems in designing wide-angle lenses than normal, or even telephoto, lenses. These problems include controlling the falloff of illumination from the center of the film toward the corners, which can be objectionably severe with very short focal-length lenses, and maintaining acceptable image definition over the larger angle of view. A cross-section view of a modern wide-angle view-camera lens is shown in Figure 3–26. Uniformity of illumination at the film plane is improved by increasing the size of the elements in both directions away from the diaphragm and by using negative elements at the front and back surfaces. A total of nine elements were used in this lens to improve uniformity of illumination and overall image definition. It is difficult to satisfy these two objectives and also to make a fast lens, that is, one with a small *f*-number at the maximum diaphragm opening. It is not necessary, however, to stop a short focal-length lens down as far as a longer lens to obtain the same depth of field, other factors being equal. A 90-mm focal-length lens, for example, will produce essentially the same depth of field at *f*/8 as a

Figure 3 – 21 The diameter of the circle of good definition of normal-type lenses can be assumed to be as large as the focal length with the diaphragm wide open and somewhat larger when stopped down.

Figure 3 – 22 Basic telephoto lens design.

Figure 3 – 23 Location of the image nodal plane with a telephoto lens.

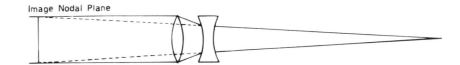

Image Nodal Plane

Figure 3 – 24 Cross-section of a modern telephoto lens. The positive elements dominate the group of elements on the left and the negative element dominates the pair of elements on the right.

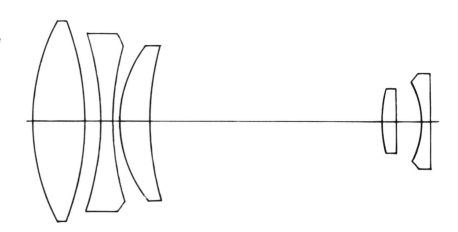

180-mm lens at f/32 at the same distance from the subject. This advantage will disappear, however, if the camera is moved closer with the shorter lens to obtain the same-size image of the object focused on.

Wide-angle lenses are used in preference to normal-type lenses for various reasons, including the following: (1) The normal lens does not have sufficient covering power to produce an acceptable image to the edges of the film when the camera adjustments are used, in which case a wide-angle lens having the same focal length would provide more covering power. (2) A smaller image and wider angle of view are desired from a certain camera position than are produced with the normal lens, and a shorter focal-length normal-type lens will not cover the entire film, in which case a shorter focal-length wide-angle lens should be substituted.

Short focal-length wide-angle lenses are required in situations where the camera cannot be placed far enough from the subject to include the desired subject area with a longer lens, which is typical with interior architectural photographs and not uncommon with exterior views. The stronger perspective produced by placing the cam-

Figure 3 – 25 Determining the position of the image nodal plane with a telephoto lens by focusing on a distant object and measuring 1 focal length forward from the film plane.

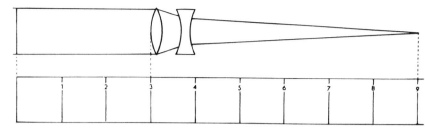

Figure 3 – 26 Cross-section of a modern wide-angle lens.

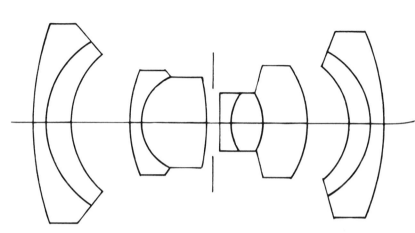

era closer to the subject with a short focal-length wide-angle lens may produce a more dynamic picture with some subjects. With interior architectural photographs, the stronger perspective makes rooms appear larger, which is usually considered to be desirable, even though it misleads the viewer. The 2 photographs in Figure 3–27 show how use of a shorter focal-length wide-angle lens made it possible to eliminate objectionable objects that appear in the foreground of the photograph taken with a longer focal-length normal-type lens from a greater distance.

Copying and Closeup Lenses

Normal-type lenses that produce excellent images with objects at moderate to large distances may not produce satisfactory images when used to photograph objects at closer distances. This is especially true when the lens designer is required to increase the speed of a general-purpose lens by increasing its diameter, thereby reducing the *f*-number at the maximum diaphragm opening—an important factor for lenses that are to be used on small-format cameras. The top photograph of a small object in Figure 3–28 was made with such a general-purpose camera lens at the maximum aperture. The increasing unsharpness toward the corners is due to curvature of field, which would not be present in photographs of objects at moderate to large distances. The bottom photograph was made with a macro lens that was designed to be used at small object distances.

Small-format camera lenses designed for closeup photography are identified as *macro* lenses, and typically are 1 to 3 stops slower

Figure 3 – 27 Elimination of distracting foreground objects by moving the camera closer to the building and substituting a shorter focal-length wide-angle lens.

than comparable general-purpose lenses. Lenses designed for use on the large-format process cameras in the graphic arts field for photomechanical reproduction are identified as *process* lenses. Such lenses are also designed to be used at relatively close object distances and they produce flat-field, distortion-free, high-definition images. Typically, process lenses have long focal lengths in relation to the film diagonal to provide uniform illumination, and they tend to have larger *f*-numbers at the maximum aperture than comparable view-camera lenses. Process lenses are well suited to be used on view cameras providing that the camera has sufficient bellows extension to accommodate the long focal lengths with moderate to small object distances.

Several manufacturers of view-camera lenses offer macro lenses and lenses having the characteristics described above for process lenses, and they commonly specify the scales of reproduction for which the lenses have been optimized, such as 1:10 to infinity, 1:1, and from 2:1 to 12:1.

Figure 3 – 28 Photographs of a small object made with a normal-type camera lens (*top*) and a macro lens (*bottom*), both at the maximum diaphragm openings.

Soft-Focus Lenses

Photographers do not always require or want overall sharpness in their photographs. Various methods have been employed to limit sharpness, either overall or in selected parts of the image, such as by using a diffuser on the camera or enlarger, exposing at a large aperture to obtain a shallow depth of field, exposing at a slow shutter speed to obtain a blurred image due to subject or camera movement, and using a soft-focus lens. Soft-focus lenses have been used extensively for portraits and occasionally for other types of subjects (Figure 3–29). Since the soft-focus effect with this type of lens results from spherical aberration, the degree of diffusion can be controlled by adjusting the aperture. The attractiveness of images produced with soft-focus lenses is attributed to the fact that they consist of an unsharp image superimposed on a sharp image, and highlight subject areas are surrounded by halos in the picture.

Figure 3 – 29 Effective use of a soft-focus lens. — *Dick Faust*

Supplementary Lenses

It has been noted that a general-purpose view-camera lens may not produce the desired results in some situations, such as producing unsharpness in closeup photographs of small objects, and too strong a perspective with head-and-shoulder portraits. If the photographer does not have access to other view-camera lenses, the addition of an inexpensive positive or negative supplementary lens to the general-purpose lens may produce more acceptable results. Positive (converging) supplementary lenses decrease the focal length of the camera lens and negative (diverging) lenses increase the focal length. A 203-mm (8-in.) focal-length lens can be converted to the equivalent of a shorter 127-mm (5-in.) or a longer 533-mm (21-in.) lens by the addition of positive or negative 330-mm (13-in.) supplementary lenses, respectively.

For closeup photography, the best image definition is obtained by focusing the camera lens on infinity, so that the image distance is 1 focal length, and then adding a positive supplementary lens

Figure 3 – 30 (*Top diagram and left photograph*) The largest scale of reproduction that can be obtained with an 8-in. focal-length lens on a camera having a maximum bellows extension of 16 in. is 1:1. (*Bottom diagram and right photograph*) Addition of a 4-in. focal-length positive supplementary lens makes it possible to focus on a shorter object distance to obtain a larger image and a scale of reproduction of approximately 5:1.

of the proper focal length to produce an in-focus image at a small object distance—which will be a distance equal to the focal length of the supplementary lens. The 1st photograph in Figure 3–30 shows the largest image that could be obtained with the normal view-camera lens and the camera bellows fully extended, and the 2nd photograph shows the image produced by adding a positive supplementary lens and moving the object closer until it came into sharp focus. Single-element supplementary lenses can be expected to introduce aberrations, but stopping the camera lens down minimizes such effects.

Supplementary lenses are commonly calibrated in diopters. The focal length in millimeters can be found by dividing 1000 by the diopters. A 1-diopter lens, for example, has a focal length of 1000 mm (39 in.), a 5-diopter lens 200 mm (7.9 in.), and a 10-diopter lens 100 mm (3.9 in.).

Enlarger Lenses

The image quality obtained by using a good camera lens can be sacrificed by using an inferior lens on the enlarger. Enlarger lenses vary over a considerable range in price and performance, and, like camera lenses, produce the best images when stopped down 1 to 3 or 4 stops—more with inexpensive lenses than with top-of-the-line lenses. Stopping down also increases the depth of focus, which reduces unsharpness due to focusing errors.

Lens Shortcomings

Even though it was convenient to ignore most lens shortcomings in the preceding discussion of lenses and image formation, it should be recognized that no lens is capable of forming a perfect image.

It could be argued that if a lens is capable of making a photographic copy that when viewed at the normal viewing distance cannot be distinguished from the original, it has for all practical purposes made a perfect image. Although this can be done, and although most of the photographic images being produced in a wide variety of situations by professional photographers are satisfactory, photographers have not been freed from the problems of lens shortcomings. Sometimes it is necessary to have more information in a photograph than is revealed by viewing it at the so-called normal viewing distance, as when it becomes necessary to enlarge and crop a portion of a negative or transparency, or to examine a photograph at a close distance or with a magnifier. Also, while we think of the task of minimizing lens aberrations as being the responsibility of the lens designer, the photographer has a surprising amount of control over the effects the aberrations and other lens shortcomings have on the photographic image. By understanding the basic lens shortcomings, the photographer can avoid their ill effects either by selecting the most appropriate lens for a given type of picture-making situation or by controlling the conditions of use of a given lens.

Lens shortcomings that affect five attributes of the photographic image—image definition, image shape, image color, uniformity of illumination, and image contrast—will be considered here.

Image Definition

The ability to produce images having good definition is the lens attribute that photographers seem to be most concerned about. Many lens aberrations can affect image definition, in addition to miscellaneous factors such as inaccurate focus and vibration or movement of the camera during the exposure. Spherical and chromatic aberrations affect all parts of the image field, while coma, lateral color, astigmatism, and curvature of field do not affect the on-axis image but become progressively worse toward the edges of the circle of good definition. Lens designers have considerable control over aberrations, but they are hampered by the necessity of making some compromises. Aberrations can be minimized quite effectively for a specific object distance—large for aerial-camera lenses, smaller for process-camera lenses, and very small for macro-type lenses. One manufacturer of view-camera lenses offers different lenses that are optimized for infinity focus, 1:10 scale to infinity focus, 1:1 scale focus, and several different scales larger than 1:1. Less than optimum image definition can be expected when even an expensive high-quality lens is used at an object distance that produces a dramatically different scale of reproduction than the lens was optimized for. Definition may also suffer when the lens designer is required to increase the angle of coverage beyond that of normal-type lenses, or to increase the speed of the lens, or to reduce the cost of production, or when any of various other special conditions are imposed.

Spherical aberration is characterized by the difference in focus for light rays that are transmitted through the central portion of the lens and the rays passing through the outer zones. As illustrated in Figure 3–31, the marginal rays come to a focus closer to the lens than do the axial rays. Lens designers can control spherical aberration in various ways, including by (1) altering the radii of curvature of the

Figure 3 – 31 Spherical aberration. (A) Position of best focus (the smallest bundle of all the rays of light) with the diaphragm wide open. (B) Position of best focus (central three rays) with the diaphragm stopped down.

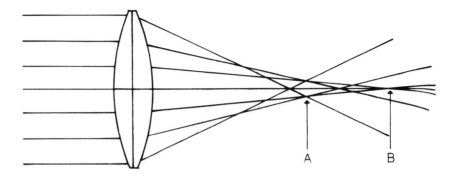

spherical lens surfaces, (2) restricting the diameter of the lens and, therefore the maximum aperture, (3) combining two or more elements having appropriate shapes and optical characteristics, and (4) using aspherical (non-spherical) lens surfaces.

It may be apparent to the reader that if a lens does have a considerable amount of spherical aberration, the photographer can still reduce it by stopping the lens down to a smaller diaphragm opening, thereby progressively eliminating the rays of light passing through the outer zones of the lens. Soft-focus portrait lenses normally achieve their soft-focus effect with spherical aberration that has purposely been undercorrected or left uncorrected. Since the spherical aberration is reduced as the lens is stopped down, the photographer can control the amount of softness between the limits that are determined by the minimum and maximum *f*-numbers, as shown in Figure 3–32. Some soft-focus lenses produce images with excellent definition at the smaller diaphragm openings, but it is necessary to focus at the *f*-number that will be used to expose the film, since the position of best focus changes as the lens is stopped down. Arrow A in Figure 3–31 identifies the position of best focus with the lens wide open, that is, the position where the diameter of the entire bundle of cones of light transmitted by the different zones of the lens is at a minimum. Arrow B identifies the position of best focus when the diaphragm has been stopped down to eliminate all but the central three rays of light. If a portrait photographer focused a lens of this type on the eyes of the subject and then stopped the lens down to expose the film, the point of sharpest focus in the photograph would be behind the eyes, possibly on the ears. Except for soft-focus lenses, spherical aberration is generally minimized sufficiently by combining positive and negative elements that have the aberration in opposite directions so that they tend to cancel out, making it unnecessary to stop the lens down to the shooting aperture when focusing the image.

Curvature of Field

Curvature of field is an aberration whereby a flat object surface, as when making photographic copies, is imaged as a curved surface. If a camera equipped with a lens having curvature of field is focused on the center of a flat surface, the corners will be out of focus, and vice versa. The curved image surface will be shaped like a saucer,

Figure 3 – 32 Photographs made with a soft-focus portrait lens at relative apertures of *f*/6 (*top*), *f*/8 (*center*), and *f*/32 (*bottom*).

with the concave side facing the lens. Lens designers can minimize curvature of field by combining positive and negative elements having curvature in opposite directions. Photographers can minimize the effect, when using lenses having curvature of field, by focusing approximately midway between the center and the corners of the ground glass and then stopping the lens down to a small opening.

Astigmatism is similar to curvature of field, but rather than having a single curved image surface, there are two—one for the images of radial subject lines and one for the images of tangential subject lines. Radial lines are lines that radiate out from the point where the lens axis intersects the object plane, and tangential lines are lines at right angles to the radial lines. The corrective action for the photographer is the same as for curvature of field.

Whereas stopping a lens down actually reduces spherical aberration, it does not reduce curvature of field or astigmatism. It only makes these aberrations less objectionable by reducing the size of the blur circles of images of object points in much the same way that stopping down increases depth of field by reducing the size of the blur circles of images of object points located in front of and behind the object focused on.

This does not mean that image definition is always better with small lens openings. Diffraction, which causes a loss of definition with a pinhole aperture when it is made too small, also affects the image produced by a lens when the opening is very small. Two opposing actions occur as a lens is stopped down—the smaller opening tends to improve definition by minimizing the aberrations, and at the same time it tends to worsen the definition by increasing the diffraction. Most lenses can be expected to produce the best compromise at some intermediate opening, with the best definition obtained with poorly corrected lenses by using small openings, and with well-corrected lenses by using larger openings. The situation is somewhat more complex than indicated, since the best compromise is not reached simultaneously over the entire field, and other factors that affect definition of the image, such as accuracy of focusing and depth of field, have not been considered here.

Image Shape

Distortion is a lens aberration that affects the shape of the image without affecting the definition. It is most apparent when the subject contains straight lines that are imaged close to the edges of the film, as distortion causes the ends of the lines to curve either toward or away from the center of the field. With a single-element lens, the ends of the lines curve inward (barrel distortion) if the diaphragm is placed in front of the lens and curve outward (pincushion distortion) if it is placed behind the lens (Figure 3–33). The distorted shape of the image results from variations in the scale of reproduction of the image from the center to the edges of the field. Stopping the lens down does not affect distortion.

Photographers have little control over distortion except in their choice of lenses. Lenses that have a modest amount of distortion may be entirely satisfactory for photographing subjects devoid of long straight lines, such as portraits and landscapes. Extremely high distortion correction is required for certain types of photography, such as mapping, copying, and some industrial, technical, and scientific ap-

Figure 3 – 33 (*Top*) Barrel distortion. (*Bottom*) Pincushion distortion.

plications. The lens designer's best control over distortion is placing the diaphragm in the optimum position between lens elements that are approximately symmetrical in shape and spacing rather than in front of or behind the lens. It should not be assumed that all expensive lenses are distortion free. Pincushion distortion is evident in photographs made with a 254-mm (10-in.) professional-quality telephoto lens designed for use with 4 × 5-in. film (Figure 3–34). The 1st photograph (A) was made with a 216-mm (8.5-in.) conventional view-camera lens on a 4 × 5-in. view camera and does not show any evidence of distortion. The 2nd photograph (B) was made with the telephoto lens on an 8 × 10-in. view camera, which is a larger film format than the lens was designed for, to show as much of the field of coverage of the lens as possible. At this object distance the telephoto lens covered the 8 × 10-in. film with only moderate loss of definition and illumination in the corners, but the pincushion distortion is obvious along the outer edges of the image. When the photograph is cropped down to the 4 × 5-in. area for which the lens was designed, the pincushion distortion is much less obvious.

Whereas pincushion distortion is associated with telephoto lenses and zoom lenses set at the longest focal length, barrel distortion is associated with wide-angle lenses and zoom lenses set at the shortest focal length. Impressive progress has been made in reducing lens aberrations in recent years by using computer-aided design of lenses, and the better-quality view-camera lenses being marketed now are capable of producing images of excellent quality. With respect to barrel distortion in wide-angle lenses, one lens manufacturer states that its 90-mm (3.5-in.) wide-angle lens that is designed to cover 5 × 7-in. film has only 0.5% residual barrel distortion, which means that at a distance of 100 mm from the center of the film, with the adjustments zeroed, an image point would be displaced only 1/2 mm from its correct position.

As the angle of coverage of wide-angle lenses is increased, it becomes more difficult to keep barrel distortion within acceptable limits, and at this time an angle of coverage of 120° is the upper limit. In the class of wide-angle lenses referred to as *fisheye* lenses, the attempt to limit distortion is abandoned in order to achieve angles of coverage of 180° or larger. An example of the barrel distortion produced with this type of lens is shown in Figure 3–35. Despite the strong curvature of most of the subject lines in pictures made with fisheye lenses, any straight subject lines that cross the lens axis at any angle, or corresponding image lines that pass through the center of the image field, will be imaged as straight lines.

Color Aberrations

Color aberrations are commonly classified as being either longitudinal chromatic aberrations or lateral chromatic aberrations. *Longitudinal* chromatic aberration is characterized by a difference in focal length for light of various colors. White light is dispersed by lenses having this aberration, and the component colors are brought to a focus at varying distances behind the lens. Of the visible radiation, blue light comes to a focus closest and red light farthest. Ultraviolet radiation, to which most films are highly sensitive, and infrared radiation, to which films can be specially sensitized, create special problems when the focal points for these wavelengths are at different distances behind the

Figure 3 – 34 (A) Distortion-free photograph made with a 216-mm (8.5-in.) focal-length general-purpose-type view-camera lens on 4 × 5-in. film. (B) Pincushion distortion produced with a 254-mm (10-in.) focal-length telephoto lens on 8 × 10-in. film. (C) Use of a 4 × 5-in. film area, which is the size recommended for use with the telephoto lens, eliminates the more obvious distortion near the edges of the 8 × 10-in. area, but curved image lines can still be detected near the edges of the smaller film format.

A

B

C

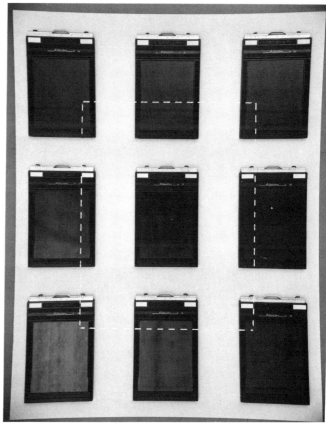

lens than the focal point for white light. Under these circumstances, the photographer must adjust the lens-to-film distance after focusing visually. Longitudinal chromatic aberration produces color halos around image points on color photographs and causes a loss of definition on both color and black-and-white photographs.

Figure 3 – 35 An example of barrel distortion produced by a 7.5-mm fisheye lens having an angle of coverage of 180°. Note that the distortion does not affect straight subject lines that pass through the center of the image, such as the horizon line and the center line on the center vertical bar.

Lateral chromatic aberration is evidenced by images that vary in size according to color, producing color fringing that becomes progressively worse near the edges of the field. Lens designers cannot completely eliminate the two color aberrations, but they can reduce them to very acceptable levels by using positive and negative elements made of different types of glass having appropriate characteristics. Stopping down will minimize the effects of longitudinal but not lateral chromatic aberration.

Lenses can also influence image color by selectively absorbing different wavelengths from white light—that is, acting like a very pale color filter. The effect the lens has on the color balance of the transmitted light depends upon the absorption characteristics of the glasses used, whether the lens elements have been treated with antireflection coatings, and, if coated, upon the nature and thickness of the coatings. There have been enough variations in these factors among lenses so that two color transparencies exposed through two different lenses may appear considerably different in color balance even though all other factors were identical. Such differences in color are of no importance in black-and-white photography, but they can be troublesome on color transparencies, especially when the transparencies are to be viewed side by side. Even with color negatives, where there is considerable control over color balance in the printing process, significant variations of this type complicate the problem of producing prints of consistent color quality.

A comparison study of the transmittance characteristics of photographic lenses made before 1960 revealed that the greatest difference was in the absorption of ultraviolet radiation. Even though ultraviolet radiation is not visible, it affects the color balance of color transparencies and negatives, due to variations in absorption by cam-

era lenses, and of color prints, due to variations in absorption by enlarger lenses. During the intervening years lens manufacturers have made changes to increase the absorption of ultraviolet radiation in their lenses, and also to decrease the variability of the color balance of transmitted light by their various lenses. The American National Standards Institute (ANSI) has specified the color transmittance characteristics of a standard camera lens in an effort to reduce the variability between lenses made by different manufacturers. The standard lens has approximately the same effect on the color balance of white light as a CC-05Y (yellow) color-compensating filter, a value arrived at by averaging the characteristics of approximately 60 medium- and high-priced camera lenses.

Uniformity of Illumination

With a subject having uniform luminance, such as an evenly illuminated white or gray wall, the illumination at the film plane decreases from the center of the film toward the corners. This occurs even with a pinhole aperture. Three factors cause this variation in illumination: (1) the distance from the pinhole to the corners is larger than to the center of the film, (2) the light reaching the corners falls on the film at an oblique angle, compared to a right angle in the center, and (3) less light is transmitted through the elliptical hole, as viewed from a corner of the film, than through the circular hole, as viewed from the center. Falloff due to these three factors also occurs with photographic lenses, plus there is additional falloff due to vignetting at the corners due to the obstruction of oblique rays of light by the lens barrel.

A moderate amount of falloff of illumination is of little consequence in conventional photography. Prints are often burned-in around the edges because the effect is considered to be attractive with many subjects, an effect that is obtained automatically with normal focal-length lenses unless it is canceled out by a similar action on the part of an enlarger lens. A minimum amount of falloff of illumination is required for certain types of photography, such as photographic copying. Greater uniformity of illumination can be achieved by selecting a relatively long focal-length lens to reduce the angle of view, and by using a relatively small diaphragm opening to reduce vignetting, both of which are inherent attributes of process lenses, which are specifically designed for copying.

Illumination falloff is most severe with short focal-length wide-angle lenses. One method that has been used to improve the uniformity of illumination at the film plane with such lenses is to place a graduated neutral-density filter that is denser in the center than at the edges in front of the camera lens. The major disadvantage of this method is that it reduces the effective speed of the lens by as much as 2 stops. Lens designers have been able to achieve a moderate reduction in the falloff of illumination in wide-angle lenses by using a large negative element on each side of a symmetrical group of positive elements.

Use of the view camera tilt, swing, and shift adjustments can also affect the uniformity of illumination at the film plane with any lens, but especially with shorter focal-length lenses. Since the circle of illumination is symmetrically positioned around the lens axis at the film plane, any change in the relative positions of the lens and the film

or the angle of the lens will alter the position of the film within the circle of illumination, and with extreme changes may place part of the film outside the circle.

Lens Flare

A considerable amount of light reaches the film in a camera in addition to the light that forms the desired image. This is non-image-forming light, and it originates primarily from light that reaches the film after multiple reflections from lens surfaces and from light that is reflected by the internal parts of the lens mount and the bellows. The non-image-forming light that reaches the film may be in the form of generally uniform flare over the entire film surface, localized areas of flare, or identifiable shapes called ghost images that resemble the shape of the diaphragm opening. Uniform flare is the least obvious of the three, but it reduces image contrast, especially in the shadow areas. An average amount of overall flare is taken into consideration by film and paper manufacturers in arriving at their recommendations for exposure and development of black-and-white film and choice of contrast grade of printing paper, and in controlling the contrast of color films and papers during manufacture.

Modern view-camera lenses typically have two or three layers of antireflection coatings on all the air-glass surfaces to reduce the amount of flare light and to increase transmittance of image-forming light and therefore the effective speed of the lens. Since each surface of uncoated glass reflects over 4 % of the incident light, the total amount of light reflected in a lens containing multiple uncoated elements can be quite large. The balance of light and dark areas in the scene being photographed also affects the amount of flare light that reaches the film, and the difference between using a white background and a black background for a studio photograph can produce a noticeable difference in image contrast. A significant amount of flare light reaching the film can also complicate the problem of correctly exposing film with films that have little exposure latitude.

A precaution that should be taken by the photographer to prevent unnecessary flare is to use an efficient lens shade that protects the lens from direct light from sources that are outside the angle of view of the lens. With view cameras this is best done with an adjustable bellows-type lens shade that has a rectangular opening that can be moved toward and away from the lens until it just clears the image area—after all camera adjustments have been made. It is also important to keep the lens clean.

Lens Testing

Photographers who inquire about testing a lens are commonly advised to do so by making photographs of the same type that they expect to be making with the lens in the future, and to leave the analytical testing to lens designers, manufacturers, and others who have the training and the sophisticated equipment necessary for that task. It makes sense that a photographer should not worry about shortcom-

ings in the imaging capabilities of a lens if the effects are not apparent in photographs made with the lens. On the other hand, many photographers use their normal lens in a variety of picture-making situations, and certain lens shortcomings may appear in one photograph and not in another. Thus the subject matter and the conditions for even a practical test of this type must be carefully controlled.

To test for image definition, the following conditions should be observed:

1. The test subject should conform to a flat surface that is parallel to the lens board and the film plane.
2. The subject should exhibit good detail with local contrast as high as is likely to be encountered but not of a single hue such as red bricks.
3. The subject should be large enough to cover the angle of view of the camera-lens combination at an appropriate distance.
4. A test should also be made with the subject at the closest distance that is likely to be used in the future.
5. Tests should be made at the maximum, minimum, and at least one intermediate diaphragm opening.
6. Care should be taken to be certain that the optimum image focus is at the film plane, which may require bracketing the assumed best focus.
7. Care should be taken to avoid any camera vibration or movement while exposures are being made, such as can result from wind or careless tripping of the shutter.

If the same subject is to be used to test for pincushion and barrel distortion, it should have straight parallel lines that will be imaged near the edges of the film.

A test for uniformity of illumination at the film plane requires a flat surface of uniform tone, evenly illuminated, and large enough to cover the entire field of view.

Tests for flare and ghost images require other subject attributes. We can conclude that a practical test cannot be overly simple if it is to provide the desired information about the lens. In any event, evaluation of the images is easier and more meaningful if a parallel test is done on a lens of known quality for comparison, and differences tend to be more obvious when the lenses are compared at their maximum apertures.

Practical tests such as these are not really lens tests but rather are systems tests since they include subject, lens, camera, film, exposure, and development, and if prints are made they include the enlarger lens and other printing factors. The advantage that such tests have of being realistic is somewhat offset by the disadvantage that tests of a system reduce the effect of variations of one component, such as the lens, even if all of the other factors remain exactly the same. For example, if two lenses that have resolving powers of 200 and 100 lines/mm are used with a film that has a resolving power of 100 lines/mm, the resolving powers of the lens-film combinations would be approximately 67 and 50, a much less dramatic difference than the 200 and 100 values of the lenses obtained by testing only the lenses.

The influence of other factors in the system can be eliminated by examining the optical image directly, either on a finely textured ground glass or by removing the ground glass and examining the

aerial image with a good-quality magnifier or a low-power microscope. An artificial star, made by placing a light bulb behind a small hole in thin, opaque material, is commonly used to check image definition by noting how the image deviates from an ideal point image. Since the ideal is seldom approximated closely, it is again better to evaluate the lens by comparison with a lens of known quality than by judging it alone. By placing the artificial star at an appropriate distance on the lens axis, the effect of stopping down on spherical aberration and longitudinal chromatic aberration can be seen. Any chromatic aberration can then be removed by placing a green filter behind the hole to observe spherical aberration alone. Moving the star laterally so that the image appears near a corner will reveal off-axis defects such as lateral chromatic aberration.

Regardless of whether any practical tests of lenses are conducted, a photographer contemplating the purchase of one or more view-camera lenses should study the descriptive literature published by the various lens manufacturers. Even though some of the graphs and technical information might be difficult for the novice photographer to interpret, the literature typically provides considerable useful factual information about the lenses, such as (1) a list of available focal lengths for each type of lens, (2) the maximum recommended film format for each lens, (3) the range of f-numbers, (4) the angular covering power, and (5) the diameter of the circle of good definition. The manufacturers' literature may also include information about the object distance or the scale of reproduction for which the lenses have been optimized and information concerning soft-focus and other special-purpose lenses.

Exposure and Exposure Meters

4

Camera Exposure

The term *camera exposure* refers to the combination of shutter speed and *f*-number used to expose film in a camera, such as 1/60 sec. and *f*/11. The term *photographic exposure* refers to the quantity of light received in a unit area of photographic film or paper and is calculated by multiplying the illuminance of the light falling on a small area of the film or paper by the exposure time, such as 30 mc (metercandles) × 1/30 sec. = 1 mcs (metercandle second). Photographic technicians use the relationship between the photographic exposure received by light-sensitive materials and the resulting density to prepare film and paper characteristic curves that reveal the tone-reproduction characteristics of these materials and how they respond to changes in exposure and development.

Assuming that a camera shutter is accurate, the shutter setting is a measure of the exposure time, but the *f*-number setting is not a measure of the illuminance. In a typical picture-making situation the film receives many different photographic exposures in different areas corresponding to variations in lightness of different parts of the scene being photographed. Opening the diaphragm by 1 stop doubles all the different illuminances that constitute the light image on the film. Thus the *f*-number and shutter-speed settings on a camera lens enable the photographer to control the photographic exposures received by the film even though the quantitative values of those exposures are not known. The function of exposure meters is to indicate a combination of *f*-number and shutter-speed settings that will produce a negative or transparency having the optimum densities for the full range of subject tones, taking into account the amount of light falling on the subject, reflected by the subject, or reaching the film plane, and the speed of the film being exposed.

f-Numbers

Relative aperture is another name for *f*-number. The word *relative* indicates that the value of the relative aperture or *f*-number depends upon two things, namely, the *focal length* and the *effective aperture*. The effective aperture is defined as the diameter of the entering beam of light that will just fill the opening in the diaphragm of a camera lens—whereas the *aperture* refers to the diameter of the opening in the diaphragm. When the diaphragm is located in front of a lens, the effective aperture is the same as the aperture, as illustrated by the solid lines in Figure 4–1. Rarely is the diaphragm located in front of a photographic lens, which makes it necessary to take into account any change in direction of the light rays between where they enter the lens and where they pass through the diaphragm opening. Since a positive lens compresses the entering beam of light into a converging cone, a diaphragm with a fixed aperture will transmit more light when it is positioned behind the lens than in front, as illustrated by the dashed lines in Figure 4–1.

Calculating *f*-Numbers

Since manufacturers of photographic lenses calibrate the diaphragm openings in terms of *f*-numbers it is not necessary for the photographer to calculate the *f*-number in most picture-making situations,

Figure 4 – 1 The effective aperture is larger when a diaphragm is located behind a lens than in front.

but knowing how *f*-numbers are determined will help in understanding why the *f*-numbers marked on lenses are completely accurate only when the camera is focused on infinity and how to compensate for the inaccuracy when photographing objects at short distances.

f-Numbers are calculated by dividing the lens focal length by the effective aperture. If the focal length of the lens in Figure 4–1 is 203 mm (8 in.) and the diameter of the diaphragm is 51 mm (2 in.), the *f*-number with the diaphragm in front of the lens equals 8/2, or *f*/4. When the diaphragm is between elements, as it normally is, a different method of measuring the effective aperture is required. It is possible to measure the width of the diaphragm opening as it appears to the eye when the lens is viewed from the front with a light surface behind the lens because the elements in front of the diaphragm magnify the size of the opening by an appropriate amount, but if the diameter is measured by laying a ruler across the front of the lens, the eye must be shifted the width of the apparent opening when aligning the end of the ruler with one edge and measuring the diameter at the opposite edge. A more reliable method is to place a point source of light 1 focal length behind the lens so that the beam of light emerging at the front of the lens is restricted by the diaphragm to the same size as an entering beam that just fills the diaphragm opening, as shown in Figure 4–2.

Whole Stops

It is useful for photographers to be familiar with the *f*-numbers that represent consecutive whole stops: *f*/0.7, 1.0, 1.4, 2.0, 2.8, 4, 5.6, 8, 11, 16, 22, 32, 45, 64, 90, 128. The series can be extended in either direction by noting that the factor for adjacent numbers is the square root of 2, or approximately 1.4. Also, by remembering any two adjacent numbers, the series can be extended by noting that alternate numbers vary by a factor of 2, with a small adjustment between 5.6 and 11, and between 22 and 45, to compensate for the cumulative effects of rounding decimals.

Each time the diaphragm is stopped down 1 stop, as from *f*/8 to *f*/11, the amount of light transmitted is divided by 2 and the exposure time required to obtain the same photographic exposure is multiplied by 2.

Maximum Diaphragm Openings

The *f*-number range on most camera lenses is approximately 7 stops (8 *f*-numbers). A typical 35-mm camera lens may have a range, for example, from *f*/1.4 to *f*/16 (7 stops) and a typical view-camera lens may have a range from *f*/5.6 to *f*/64 (7 stops). There has been a constant demand over the years for lens designers to make faster lenses, especially for small-format cameras, and lenses as fast as *f*/0.7 are now mass produced for 35-mm cameras.

The need to make photographs under very low light levels, such as moonlight and even starlight for surveillance and other purposes, has led engineers to explore alternatives to the difficult task of further increasing the speed of lenses and films. The most successful are *image intensifiers,* which can electronically amplify the light image formed by the camera lens by as much as 30,000 times. To achieve the

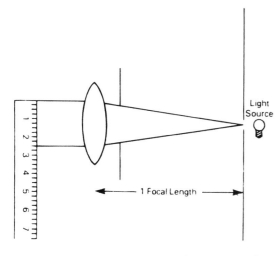

Figure 4 – 2 A procedure for determining the effective aperture is to place a point source of light 1 focal length behind the lens and measure the diameter of the beam of light that emerges from the front of the lens.

same effect by designing a lens faster than *f*/0.7 would require an *f*-number of *f*/0.004, which represents an increase in speed of approximately 15 stops. To achieve the same effect by increasing film speed would require the film to have an ISO (International Standards Organization) speed of 12,000,000/72°. With image intensifiers that are now available, it is necessary to trade off considerable resolution of fine detail for the increase in speed.

There is less need for fast view-camera lenses than for fast small-format camera lenses but there have been modest increases in the speed of some view-camera lenses in recent years, especially wide-angle and telephoto lenses. The maximum aperture on some early wide-angle lenses was recommended to be used only for focusing purposes due to the loss of definition. Image definition improves for most lenses for both small-format and large-format cameras when the lens is stopped down from 1 to 3 stops—more so for fast lenses and lower-price lenses than for moderate-speed and top-of-the-line lenses.

Minimum Diaphragm Openings

Since depth of field increases and some lens aberrations decrease as a lens is stopped down, it would seem desirable to mark *f*-numbers down to very small openings on all lenses. In 1932 a West Coast group of photographers that included Ansel Adams, Imogen Cunningham, and Edward Weston formed an organization called Group *f*/64, with the name implying that they favored making photographs in which everything was sharp.[1] Stopping down, unfortunately, also increases the adverse effects of the diffraction of light, which become apparent as a decrease in image sharpness and definition. With a lens stopped down to *f*/64, the maximum resolving power that can be obtained—no matter how good the lens and accurate the focusing—is approximately 28 lines/mm. For an 8 × 10-in. camera this is quite good because 10 lines/mm is considered adequate in a print viewed at a distance of 10 in. Stopping a 35-mm camera down to *f*/64 would produce the same resolving power of 28 lines/mm in the negative, but since the negative image must be magnified eight times to produce an 8 × 10-in. print, the resolving power in the print would be only 28/8, or 3.5 lines/mm. Lens manufacturers normally do not calibrate lenses for 35-mm cameras for openings smaller than *f*/22 because at that opening the diffraction-limited resolving power is approximately 80 lines/mm in the negative or 10 lines/mm in an 8 × 10-in. print, the minimum value that is considered adequate. The diagram in Figure 4–3 shows the relationship between diffraction-limited resolving power and *f*-number for a 4 × 5-in. camera and a 35-mm camera in terms of 8 × 10-in. prints. The horizontal line is located at the minimum acceptable value of 10 lines/mm, which corresponds to *f*/90 for 4 × 5-in. cameras and *f*/22 for 35-mm cameras.

Intermediate *f*-Numbers

Sometimes it is necessary to know the *f*-numbers of divisions smaller than whole stops, such as 1/3, 1/2, or 2/3 stop larger or smaller than a given *f*-number. (Some lenses have click-stops to obtain

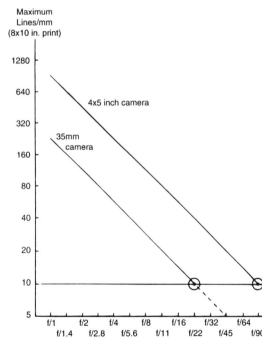

Maximum
Lines/mm
(8x10 in. print)

4x5 inch camera

35mm
camera

Figure 4 – 3 The sloping lines show that the diffraction-limited resolving power decreases as a lens is stopped down. A just-acceptable resolving power of 10 lines/mm is reached at *f*/22 with a 35-mm camera and at *f*/90 with a 4 × 5-in. camera. The resolving power values are based on 8 × 10-in. prints, which represent a magnification of 2 for 4 × 5-in. negatives and 8 for 35-mm negatives.

[1] B. Newhall, *The History of Photography* (New York: Museum of Modern Art, 1984), 128.

1/2-stop settings, and most exposure meters have 1/3-stop markings on their scales and calculator dials, although some electronic exposure meters indicate tenths of a stop between whole stops.) Intermediate values can be determined easily on instruments having *interval* scales, such as thermometers, rulers, and balances for weighing chemicals, by measuring or estimating between markings or numbers. The *f*-number series of whole stops, on the other hand, is a *ratio* scale in which each number is determined by multiplying or dividing the preceding number by a constant factor, which is the square root of 2 (approximately 1.4) for whole stops. For 1/2 stops the factor is the square root of 1.5 (1.22). For 1/3 stops the factor is the square root of 1.33 (1.15), and for 2/3 stops the factor is the square root of 1.67 (1.29). Multiplying *f*/8, for example, by these factors to determine *f*-numbers that represent stopping down by 1/3, 1/2, 2/3, and 1 stop, the *f*-numbers are *f*/9.2, *f*/9.76, *f*/10.32, and *f*/11. The factor for 1/10 stop is the square root of 1.1 (1.049).

Limitations of the *f*-Number System

f-Numbers quite accurately indicate changes in the amount of light transmitted by a lens and, therefore, changes in the exposure received by the film in the camera. Stopping down 1 whole stop, from *f*/11 to *f*/16, for example, reduces the exposure of all parts of the image to 1/2 the original values. *f*-Numbers have two inherent shortcomings, however, that can lead to inaccurate exposures if not recognized and taken into account. The most obvious shortcoming is that the *f*-number system is based on the focal length of the lens. The only time the film is located 1 focal length from the lens is when the camera is focused on infinity, and cameras are rarely focused on infinity.

As a result, it is necessary to make an exposure adjustment when the image distance is larger than 1 focal length—that is, when the camera is focused on objects that are closer than infinity. In practice, it is usually not necessary to make any exposure adjustment until the camera is focused on a distance equal to 10 times the lens focal length or closer. At an object distance of 10 focal lengths the exposure error would be 23%, or about 1/4 stop if no adjustment is made. With short focal-length lenses 10 focal lengths is a small distance—only 20 in. with a normal 50-mm (2-in.) focal-length lens on a 35-mm camera. With a corresponding normal 163-mm (6.4-in.) focal-length lens on a 4×5-in. view camera, however, an object at a distance of 10 focal lengths is more than 5 feet from the camera, and with a normal 326-mm (12.8-in.) focal-length lens on an 8 × 10-in. view camera, 10 focal lengths is almost 11 feet, distances that wouldn't seem off hand to be close enough to have to worry about but that should be compensated for when correct exposure is critical.

There are various methods for making the adjustment when photographing objects closer than 10 focal lengths. One method is to calculate the *effective f*-number, and then determine the exposure time for that number rather than the *f*-number at which the lens diaphragm is set. The effective *f*-number is found by multiplying the marked *f*-number by the ratio of the image distance to the focal length, or:

Effective *f*-n = *f*-n × image distance/focal length

With lenses of normal design, the approximate image distance is found by measuring the distance from the center of the lens to the film plane after focusing the camera. (With telephoto lenses, where the image nodal plane is typically in front of the lens, and with any lens, the position of the image nodal plane can be determined by focusing on a very distant object and measuring 1 focal length forward from the ground glass.) Thus if the image distance for a close-up photograph with a 4 × 5-in. view camera equipped with a 203-mm (8-in.) focal-length lens is 406 mm (16 in.), the effective *f*-number when the diaphragm is set at *f*/11 is: Effective *f*-n = *f*/11 × 16/8 = *f*/22. When an exposure meter reading is made, the exposure time is determined for *f*/22 rather than *f*/11. Since the difference between *f*/11 and *f*/22 is 2 stops, the exposure meter will indicate that the corrected exposure time is four times the uncorrected time (Figure 4–4).

An alternative method for determining the exposure correction is to divide the image distance by the focal length and square the result. In the example above, the *exposure factor* = $(16/8)^2$ = 4. The correction factor can be applied either by using the indicated exposure time and opening the diaphragm 2 stops from *f*/11 to *f*/5.6, or by multiplying the exposure time indicated for *f*/11 by 4.

The graph in Figure 4–5 can be used to determine the exposure increase required when focusing on objects at distances of 10 times the focal length of the lens from the camera and closer. After focusing the camera, the number found by dividing the image distance by the focal length is located on the bottom row of numbers. Alternatively, the scale of reproduction (labeled magnification), found by dividing the length of an image by the length of the object, can be located on either of the two rows of numbers directly under the graph. Drawing a vertical line up to the curved line and then a horizontal line to the left side reveals the required exposure increase both in terms of the number of stops the diaphragm should be opened and as an exposure factor that can be applied to either the exposure time or the diaphragm opening. The example provided shows that when the image distance is two times the focal length, the scale of reproduction or magnification is 1 (the image is the same size as the object) and the exposure increase required can be obtained either by opening the diaphragm 2 stops or by multiplying the indicated exposure time by 4. The graph covers the range of object distances that produce images that vary in size from 1/8th to 8× the size of the object.

Closeup photography and *photomacrography* both refer to making photographs of small objects at larger than usual scales of reproduction. When a distinction is made between the two terms, the dividing line is commonly made at a scale of reproduction of 1:1. Thus closeup photography covers the range of object distances from 10 times the focal length, where it first becomes necessary to increase the indicated exposure to compensate for the increased lens-to-film distance, to two times the focal length, where the image is the same size as the object, which corresponds to the left half of the graph in Figure 4–5. Photomacrography, then, covers the range of object distances between 2 focal lengths and 1 focal length and scales of reproduction larger than 1:1, which correspond to the right side of the graph—but not limited to the 8× magnification shown at the right edge.

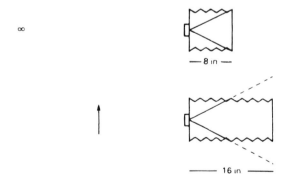

Figure 4 – 4 (*Top*) *f*-numbers are based on an image distance of 1 focal length. (*Bottom*) Doubling the image distance to photograph a small object produces an effective *f*-number that is double the marked *f*-number, such as *f*/16 for a lens set at *f*/8.

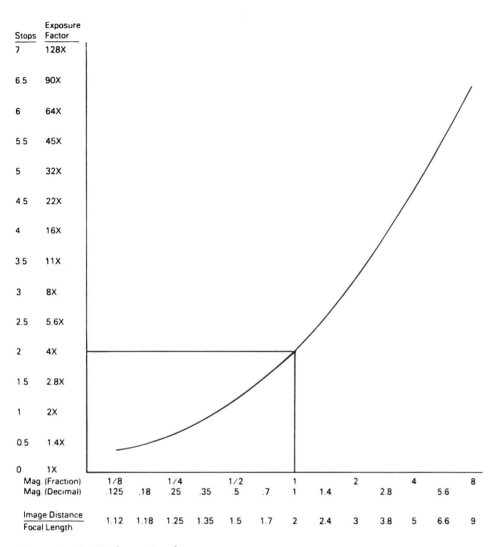

Stops	Exposure Factor
7	128X
6.5	90X
6	64X
5.5	45X
5	32X
4.5	22X
4	16X
3.5	11X
3	8X
2.5	5.6X
2	4X
1.5	2.8X
1	2X
0.5	1.4X
0	1X

| Mag. (Fraction) | 1/8 | | 1/4 | | 1/2 | | 1 | | 2 | | 4 | | 8 |
| Mag. (Decimal) | .125 | .18 | .25 | .35 | .5 | .7 | 1 | 1.4 | | 2.8 | | 5.6 | |

| Image Distance / Focal Length | 1.12 | 1.18 | 1.25 | 1.35 | 1.5 | 1.7 | 2 | 2.4 | 3 | 3.8 | 5 | 6.6 | 9 |

Figure 4 – 5 To determine the exposure increase required when the camera is close to the subject, locate magnification (scale of reproduction) or the ratio of the image distance to the focal length on the horizontal axis and read the exposure increase on the vertical axis.

Supplementary Lenses and Effective *f*-Numbers

It was noted in the section on supplementary lenses that the addition of a positive or negative supplementary lens to a general-purpose view-camera lens is an inexpensive way of achieving the basic advantage of using a shorter focal-length macro lens or a longer focal-length lens when those view-camera lenses are not available. With respect to the effect that the addition of a supplementary lens has on exposure, it should be noted that the supplementary lens significantly affects the image illuminance at the film only if there is an accompanying change in the lens-to-film distance. Adding a positive supplementary lens to make a closeup photograph after the camera has been focused on a distant object does not require any refocusing if the object is placed at a distance of 1 focal length of the supplementary lens in front of the supplementary lens. If the distance between the camera lens and the ground glass is changed, either increased or decreased, the *effective f*-number can be calculated as described above, that is:

Effective *f*-n = *f*-n x image distance/focal length

or the exposure factor can be calculated with the formula:

Exposure factor = (image distance/focal length)², where focal length refers to the camera lens, not the combination.

The top diagram in Figure 4–6 shows a view-camera lens focused on a distant object and the remaining 4 diagrams show supplementary lenses used under varying conditions. In the 2nd diagram a positive supplementary lens has been added, which produces a shorter focal-length combination, and the camera has been refocused on the distant object. Since the lens-film distance has been halved, the *f*-number is also halved, from *f*/8 to *f*/4. This should *not* be considered as an inexpensive way of obtaining a fast wide-angle lens, however, as the combination would not have a large enough circle of good definition to cover the film. In the 3rd diagram the object has been placed at an object distance of 1 supplementary-lens focal length, which in this illustration is the same as the focal length of the camera lens. Since the lens-film distance is the same as with the camera lens alone in the top diagram, the effective *f*-number is the same as the marked *f*-number, *f*/8. Moving the object even closer, as shown in the 4th diagram, would require the lens-film distance to be increased, and if it is doubled the effective *f*-number will also be doubled, from *f*/8 to *f*/16. The bottom diagram shows that a negative supplementary lens will increase the effective focal length of the camera lens, requiring

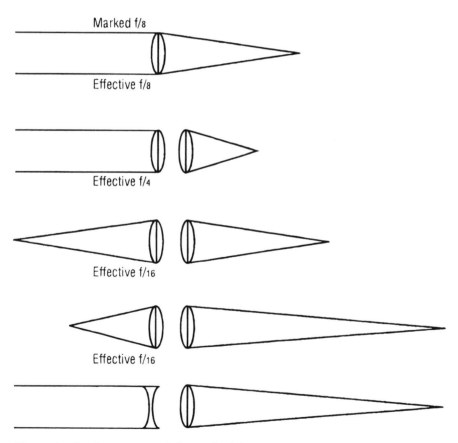

Figure 4 – 6 Comparison of the marked *f*-number and the effective *f*-number with a positive supplementary lens (with the subject at three different distances) and with a negative supplementary lens.

an increase in the lens-film distance even when focused on a distant object. Again, if the lens-film distance is doubled, the effective *f*-number will be doubled.

Lens Transmittance

A second shortcoming of *f*-numbers is that they do not take into account differences between lenses with respect to the amount of light lost due to absorption and reflection by the lens elements. The introduction of antireflection coating of lenses, a procedure that first became practical in 1935 but has been dramatically improved over the intervening years, has reduced but not completely eliminated variability between lenses with respect to the proportion of light transmitted at the same *f*-number. The problem of variations in the transmittance of lenses increases with the number of elements. Early zoom lenses for motion-picture and small-format still cameras, which contained many elements, lost a considerable amount of light and were effectively considerably slower than the *f*-numbers indicated. The practice was introduced of calibrating lenses for professional motion-picture cameras with both *f*-numbers and T-numbers, where the T-numbers are determined by the actual transmittance of the lens. The T-numbers are used for exposure control and the *f*-numbers for depth-of-field calculations, and on some lenses the two can differ by a whole stop or more.

Exposure Time

The other factor that determines photographic exposure besides image illuminance is exposure time, which with view-camera lenses is controlled by a shutter located within or close to the lens, identified as a *between-the-lens* shutter or *lens* shutter—as distinct from *focal-plane* shutters, which are located in front of and close to the film. Traditionally, each type of shutter has had certain advantages over the other. It has been easier to synchronize electronic flash with the shutter opening at higher shutter speeds with lens shutters than with focal-plane shutters, for example. Lens shutters also expose the entire film simultaneously whereas focal-plane shutters expose the film sequentially from one edge to the opposite edge, which can distort image shape with rapidly moving objects. On the other hand, it has been much easier to obtain shutter speeds shorter than 1/500 sec. with focal-plane shutters, and with cameras designed to use interchangeable lenses it is less expensive to provide a single focal-plane shutter in the camera body than to equip each lens with its own shutter. Universal behind-the-lens shutters are available to be used with view-camera barrel-mounted lenses without shutters, but the top speeds of such shutters do not match those of focal-plane shutters.

There is one other shortcoming of lens shutters that can cause overexposure of film in some situations if it is ignored and not compensated for, the fact that the effective exposure time at a given shutter-speed setting actually *increases* as the diaphragm is stopped down. This increase in exposure time is negligible at slow shutter-speed settings, but the effective exposure time can nearly double when the di-

Figure 4 – 7 On the right are the diaphragm openings for the whole stops on a typical lens. On the left are the positions of the shutter blades at which the diaphragm openings are just completely uncovered. Since the smaller openings are uncovered sooner and stay uncovered longer, the effective exposure time is longer than with a larger opening and the same shutter setting.

aphragm is stopped down in combination with high-speed settings. The reason for this increase is that lens shutters are calibrated with the diaphragm in the wide-open position, the smallest f-number setting, but when the diaphragm is stopped down the smaller opening is completely uncovered sooner and remains completely uncovered longer by the shutter blades, which open from the center outward, as shown in Figure 4–7. At the higher shutter speeds with the diaphragm in the fully open position the shutter blades no sooner uncover the outer edges of the lens than they again cover them at the beginning of the closing operation. Thus the center of the lens is uncovered for a longer time than are the edges, and the total amount of light that is supposed to be transmitted by a lens is actually transmitted only during the time that the diaphragm opening is completely uncovered by the shutter blades. If the amount of light transmitted by the lens during the opening and closing movements is plotted against time, the graph would resemble the dashed line in Figure 4–8.

If lens manufacturers calibrated shutters from the time they start to open until they are completely closed again, the loss of light during the opening and closing parts of the cycle would lead to underexposure. In other words, the *effective* exposure time would be shorter than the total exposure time. To avoid this problem, shutters are calibrated from the half-open position to the half-closed position with the diaphragm in the fully open position, as indicated by the dashed arrows in Figure 4–8. Since the smaller opening with the lens stopped down is fully uncovered sooner, the effective exposure time from half-open to half-closed is longer, as shown by the solid arrows. Since this increase in effective exposure time (and, therefore, exposure) is predictable, it can be compensated for by simply stopping down an appropriate amount beyond the f-number previously selected. Table 4-1 provides the corrections needed for different combinations of f-numbers and shutter speed settings. For example, if a lens with a maximum diaphragm opening of $f/4$ is stopped down 3 stops to $f/11$ and the shutter is set at 1/250 sec., the diaphragm should be stopped down another 1/2 stop (between $f/11$ and $f/16$) to compensate for the increase in the effective exposure time.

Types of Lens Shutters

There are three basic types of shutters with respect to power and timing—*mechanical, electromechanical,* and *electronic.* With typical mechanical lens shutters the power to open and close the shutter is provided by a spring that is placed under tension and the timing is controlled with a gear train similar to those in spring-powered clocks and watches. Most mechanical shutters have a separate cocking lever that applies tension to the spring before the shutter release lever (or cable release) is pressed to expose the film. Some mechanical shutters, however, are self-cocking so that pressing a single lever or cable release first cocks the shutter and then trips it. Although self-cocking shutters are more convenient to use, and one cannot forget to cock the shutter, more pressure is required to cock and trip the shutter in one operation than to just trip a previously cocked shutter.

The power to activate electromechanical shutters is also provided by a spring, but the timing is controlled electronically by clos-

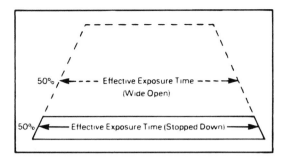

Figure 4 – 8 The dashed-line graph represents the relative amount of light transmitted by a lens from where the shutter blades start to open until they are completely closed again with the diaphragm wide open. When the diaphragm is stopped down (solid-line graph), the smaller opening is uncovered sooner and remains uncovered longer, increasing the effective exposure time from half open to half closed.

ing a circuit connecting a battery and a capacitor to start to charge the capacitor when the shutter opens. When the capacitor is filled the shutter closes. A variable resistor provides the different exposure durations.

With electronic shutters, the power to open and close the shutter is provided by solenoids and the timing is controlled by current flowing through a variable resistor to a capacitor. Mechanical shutters tend to be less accurate than shutters that are timed electronically, especially older mechanical shutters that have received considerable use and the parts have become worn or dirty. Professional camera-repair technicians can test, clean, and adjust shutters that malfunction.

Other Exposure Controls

In addition to controlling exposure with the *f*-number and shutter-speed settings, it is also possible to alter the exposure by increasing or decreasing the illumination on the subject in a studio and some other interior environments. Many electronic-flash units provide an adjustment over the light output, for example, from full power to 1/64th full power, the equivalent of a 6-stop change in *f*-numbers. Since camera shutter speeds do not provide a useful means of controlling exposure of the film with electronic flash due to the short duration of the light emission, control over the intensity of the light source provides the photographer with greater flexibility in selecting an appropriate *f*-number based on depth-of-field considerations.

Table 4 – 1 (Top) Chart for determining the number of stops between a given *f*-number and the *f*-number at the maximum diaphragm opening. (Bottom) The reduction in exposure (in stops) required to compensate for the increase in the effective exposure time for various combinations of *f*-numbers and shutter speeds. An *f*/5.6 lens stopped down 2 stops to *f*/11 with a shutter speed of 1/500 sec., for example, should be stopped down an additional 3/4 stop.

Maximum Aperture	Stopped Down								Stops
	1	2	3	4	5	6	7	8	
f/1.4	*f*/2	*f*/2.8	*f*/4	*f*/5.6	*f*/8	*f*/11	*f*/16	*f*/22	
f/2	*f*/2.8	*f*/4	*f*/5.6	*f*/8	*f*/11	*f*/16	*f*/22	*f*/32	
f/2.8	*f*/4	*f*/5.6	*f*/8	*f*/11	*f*/16	*f*/22	*f*/32	*f*/45	
f/4	*f*/5.6	*f*/8	*f*/11	*f*/16	*f*/22	*f*/32	*f*/45	*f*/64	
f/5.6	*f*/8	*f*/11	*f*/16	*f*/22	*f*/32	*f*/45	*f*/64	*f*/90	
f/8	*f*/11	*f*/16	*f*/22	*f*/32	*f*/45	*f*/64	*f*/90	*f*/128	
Exposure Time[a]									
1/60	0	0	0	0	0	0-1/4	0-1/4	0-1/4	
1/125	0-1/4	1/4	1/4	1/4	1/4	1/4	1/4	1/4	
1/250	1/4	1/4	1/2	1/2	1/2	1/2	1/2	1/2	
1/500	1/2	3/4	1	1	1	1	1	1	

[a]Additional stopping down required to compensate for changes in shutter efficiency with between-the-lens shutters.

Another exposure control that can be used with any type of light source, including daylight, consists of placing a neutral-density (ND) filter on the camera lens. A 0.3 density filter will reduce the amount of light entering the lens by 1/2, the equivalent of stopping the diaphragm down 1 stop. Each additional 0.3 in density corresponds to another stop. Neutral-density filters provide the photographer with greater freedom in using a large diaphragm opening to obtain a shallow depth of field or a slow shutter speed to obtain an intentionally blurred image of a moving object without overexposing the film.

Underexposure and Overexposure Effects

Assuming that in each picture-making situation there is a combination of f-number and shutter speed that produces the optimum level of exposure, photographers should know what will happen to the image quality if the level of exposure is either decreased or increased. It is optimistic to think that all of the various factors calibrated to determine the "correct" exposure are 100% accurate—film-speed rating, exposure meter, shutter, and f-number—and that there is no human error involved in the process, but for now the assumption will be made that there are no such inaccuracies. The range over which the exposure can be decreased and increased from the optimum level and still produce acceptable results is known as the exposure latitude. The magnitude of the exposure latitude depends upon a number of factors, including the scene contrast, the type of film being used, and the criticalness of the viewer.

As the exposure is decreased from the optimum level the darker or shadow areas of the scene will be the first to lose contrast and then detail with both negative and reversal film materials, even though negative films become thinner and reversal films denser with underexposure. As the exposure continues to be reduced contrast and detail will be lost in progressively lighter areas of the scene, from the shadows to the midtones to the highlights, and eventually there will be no image (Figure 4–9).

An increase in exposure above the optimum level results in an increase in detail and contrast in the shadow areas of the scene, which with reversal color films is accompanied by a loss of detail and contrast in the highlight areas, since these films have little exposure latitude. With negative films, which have much more exposure latitude, moderate overexposure does not alter the contrast in the highlight areas, so that the increase in contrast in the shadow areas also produces a small increase in the overall contrast of the negative. With low-contrast scenes, intentionally overexposing by a stop or so can be a useful way to increase image contrast with both black-and-white and color negative films. The curve in Figure 4–10 shows the relationship between camera exposure and overall negative contrast. It can be seen that the curve continues to rise with a moderate amount of overexposure before leveling off and then sloping downward.

The loss of overall negative contrast with larger amounts of overexposure is first due to a loss of contrast in the highlight areas, which then progressively moves down through the midtones to the shadows with extreme overexposure. Overexposure of negative films

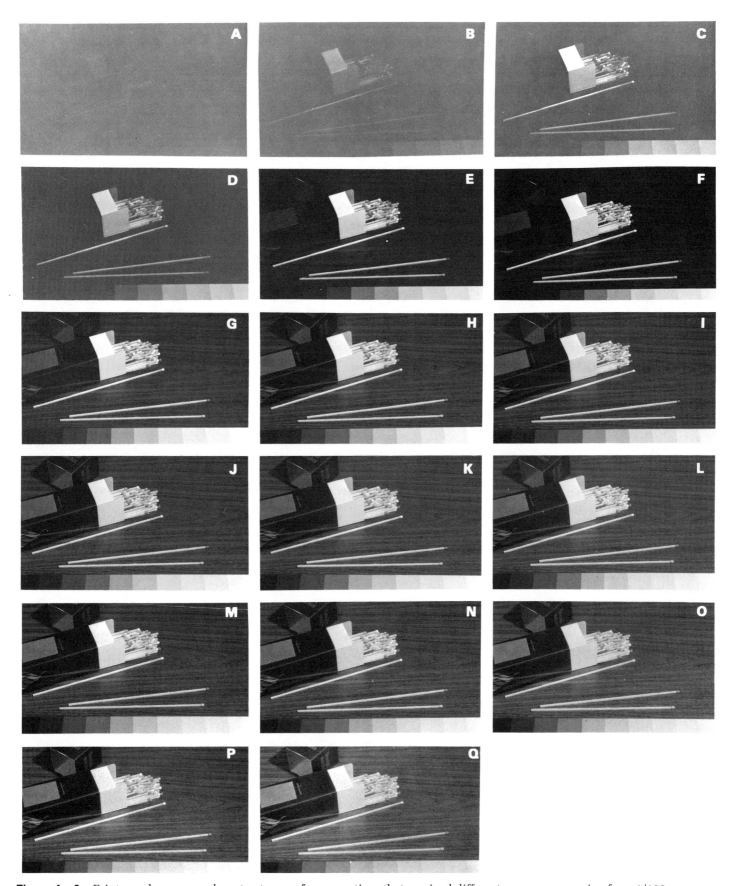

Figure 4 – 9 Prints made on normal-contrast paper from negatives that received different exposures, ranging from 1/128 normal to 512 times normal in 1-stop increments. Print H was made from the normally exposed negative. There is less latitude on the underexposed side (due to a loss of shadow contrast and detail) than on the overexposed side (due to a loss of highlight contrast and detail).

Figure 4 – 10 Variation in overall negative contrast with a range of exposures from 7 stops under normal to 9 stops over normal. Whereas contrast rapidly decreases with underexposure, overexposure first produces a moderate increase in contrast before it decreases at a more gradual rate.

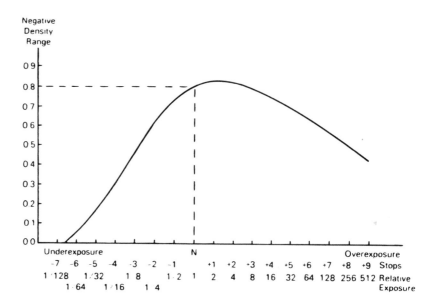

also produces a decrease in image definition, or, more specifically, an increase in graininess, a decrease in sharpness, and a decrease in fine detail. Even gross overexposure of negative films seldom results in a complete loss of detail, although it can result in a partial or complete reversal of tones to produce a positive image, an effect identified as solarization.

Overall changes in contrast due to underexposure or overexposure can be compensated for at the printing stage with black-and-white negatives by using different contrast grades of printing paper, or variable-contrast paper, but local loss of contrast and detail are not correctable. The penalties for underexposure (loss of shadow contrast and detail) occur more quickly and are more severe than the penalties for overexposure (modest change in contrast and decrease of definition), leading to the long-standing admonition, "It is safer to overexpose than to underexpose." Stated in terms of exposure latitude, there is more exposure latitude on the overexposure side than on the underexposure side. These statements apply to conventional black-and-white and color negative films. With reversal films, the exposure latitude is small in both directions.

Exposure Meters

An exposure meter can be defined as a light-measuring instrument that is designed to provide appropriate shutter and aperture settings to obtain a desired exposure effect. A *photometer* is also a light-measuring instrument, but it is calibrated in photometric units such as footcandles or lux for *illuminance* (the light falling on a surface) and candelas per square foot for *luminance* (the light reflected, transmitted, or emitted by a surface). Conversion tables are provided with some exposure meters so that photometric data can be obtained in addition to shutter-speed and *f*-number data. Exposure meters can also be made an integral part of a camera so that the meter will set the aperture at an appropriate *f*-number for a preselected shutter setting (shutter prior-

ity) or an appropriate shutter speed for a preselected f-number setting (aperture priority). Although built-in exposure meters are found mostly on 35-mm and other small-format cameras, view cameras are available with light sensors on the ground glass and with electronic features that make exposure determination more convenient and accurate.

Photoelectric exposure meters were introduced in 1932 with the Weston Universal 617 meter. Later, improved models of Weston exposure meters were marketed at more affordable prices and they became very popular with photographers. Among the features of the meters was a calculator dial that served as the basis for the Zone System, which was conceived by Ansel Adams and Fred Archer in the late 1930s.

The Weston and other early photoelectric exposure meters consisted of a simple electrical circuit containing a selenium photocell and an ammeter. Light falling on the photocell created an electric current that caused a pointer on the ammeter to rotate over a calibrated scale. The calculator dial was then used to convert the scale number to combinations of shutter speeds and f-numbers for specified film speeds. The major disadvantage of this type of selenium-photocell exposure meter is low sensitivity, even when the photocell is enlarged to over 1.5 in. in diameter. Major advantages are that the meters operate without batteries and the photocells have a relatively good balance of response to different colors of light.

Selenium-photocell exposure meters have been largely replaced by cadmium sulfide (CdS) photocell meters, which achieve dramatically higher sensitivity, being some 500 times as sensitive with smaller photocells. Electrical resistance in the circuit, which includes a battery, decreases as the amount of light falling on the photocell increases. In addition to requiring a battery, CdS meters have the disadvantage of responding somewhat slowly to changes in light level, especially when taking a reading in a dark subject area immediately after the photocell has been exposed to a high light level, a defect referred to as meter memory.

CdS meters, in turn, are being replaced by meters that use photodiodes, such as silicon photodiodes and gallium arsenide phosphide photodiodes, which also respond to light by means of a reduction of resistance in an electrical circuit containing a battery. Photodiodes achieve high sensitivity to light with surfaces that are only 1/4 in. in diameter or less, and they respond rapidly to changes in light level.

Reflected-Light Exposure Meters

Reflected-light exposure meters are calibrated to produce the correct exposure when the reading is taken from a middle-tone area in the scene being photographed. Since there might be disagreement as to which tone in a scene containing a wide range of tones is midway between the lightest tone and the darkest tone, a gray surface having a reflectance of 18% (density of 0.74) can be used as an artificial midtone. If one looks at a gray scale that has a white patch on one end (a density of 0.00) and a black patch on the other end (a density of approximately 2.00), a gray having a density of 0.70 should *appear* to be about midway in lightness between the white and the black.

Since typical hand-held reflected-light exposure meters have angles of acceptance in the range of 30° and larger, it is necessary

to hold the meters quite close to small midtone areas or 18% reflectance gray cards to avoid including any surrounding area that could influence the reading. Some meters accept spot attachments to restrict the angle of acceptance, and other meters that are designed as spot meters have angles of acceptance as small as 1°.

A more appropriate name for reflected-light exposure meters is *luminance* meters, since such meters are used to measure other than reflected light, including light transmitted by transparent and translucent objects (such as stained-glass windows) and light emitted by objects (such as night advertising signs, molten metal, and television and computer monitor screens).

Incident-Light Exposure Meters

Incident-light exposure meters measure the light falling on the subject rather than the light reflected, transmitted, or emitted by the subject. The same camera exposure is indicated by readings made with incident-light and reflected-light exposure meters when the reflected-light reading is taken from a suitable subject midtone or an 18% reflectance gray card. If both readings are made with the same exposure meter, and most professional-quality hand-held meters have this capability, turning the meter around when it is in the reflected-light mode and reading all of the light falling on the subject (100%), instead of the 18% that is reflected from the midtone area, would produce a false high reading that would result in underexposure of the film. This is avoided by placing a neutral-density filter that transmits 18% of the light over the light sensor. This neutral-density filter is typically made of white plastic and has a hemispherical shape that appropriately compensates for the effectiveness of light that falls on the meter (and the subject) from different directions. Some exposure meters also provide a flat *cosine-corrected* diffuser that is recommended for use when making photographic copies of flat originals, as distinct from three-dimensional subjects.

Reflected-Light Exposure-Meter Readings

There are a number of different ways of using hand-held reflected-light exposure meters. These include taking an integrated reading from the camera position, taking a closeup reading of a midtone subject area or 18% reflectance gray card, and averaging closeup readings of the lightest and darkest areas in the scene.

Camera-Position Readings

The most convenient method of using a hand-held reflected-light exposure meter is to aim the meter at the scene being photographed from the camera position. The success of this method in obtaining the optimum exposure obviously depends upon the range and balance of the various tones in the scene. Exposure meter instruction manuals warn

the photographer to tilt the meter down when making camera-position readings outdoors to avoid the effect a bright sky would have of inflating the reading and producing underexposure for the main subject. In a similar manner, a reflected-light reading of a document consisting of black type on white paper would be dominated by the large white areas, again resulting in underexposure, whereas a camera-position reading for a portrait of a person wearing dark clothing posed in front of a dark background would yield a false low reading and an overexposed image.

The fact that a large proportion of photographs exposed according to camera-position reflected-light readings fall within the acceptable range of exposures provides evidence that (1) the balance of light and dark tones in most scenes is a reasonable match to the specified 18% reflectance midtone, and (2) black-and-white and color negative films have considerable exposure latitude—at least on the overexposure side.

It is understandable that scenes made up of large areas of middle tones that are not much different from an 18% reflectance tone, such as grass, foliage, and bricks, should produce normal exposures with camera-position meter readings. If a scene is made up entirely of black tones and white tones, however, the proportions of the two tones required to produce an acceptable exposure is less obvious. Rather than equal areas of black and white, as one might expect, the white would have to occupy only 18% of the total area in order for the meter reading to match that from an 18% reflectance midtone. In other words, large white areas and other bright areas such as light sources and reflections influence reflected-light meter readings disproportionately in relation to their size, and precautions should be taken to avoid a false meter reading and underexposure.

Midtone Reflected-Light Readings

Since reflected-light exposure meters are calibrated to produce optimum exposures with readings from midtone areas, such readings will tend to produce more consistent results than camera-position readings, due to variations in the balance of light and dark tones in different scenes. A disadvantage of the midtone method is the extra time required to select an appropriate midtone subject area or to substitute an artificial midtone for a closeup reading. Precautions that should be observed when using an 18% reflectance gray card with three-dimensional subjects are:

1. Hold the card close to the main subject.
2. Aim the card midway between the dominant light source and the camera.
3. Hold the meter close enough to the card to avoid including a lighter or darker background in the reading, but not so close as to cast a shadow on the card.
4. Adjust the angle of the meter to the card to avoid a glare reflection of a light source.

When making photographic copies of two-dimensional originals, however, the gray card should be placed flat against the original, facing the camera, so that the lighting angles are the same for the gray

card and the subject. Since the conventional lighting arrangement for copying consists of two lights at equal angles on opposite sides of the camera, there is no dominant light, as there is for most three-dimensional subjects.

The gray-card artificial midtone is especially useful when photographing small objects, where a conventional reflected-light meter reading could not be made. There are, of course, situations where a gray card cannot be used, including (1) when a subject cannot be approached for a reading, such as a distant scene, and the lighting is not the same at the camera position, (2) when there is insufficient time to use this method, and (3) when the subject itself is emitting the light or transparent or translucent objects are illuminated from the rear.

Brightness-Range Method

The problem of selecting an appropriate midtone subject area can be solved by taking reflected-light readings of the lightest and darkest areas in the scene where detail is desired and then determining a middle value, either on the shutter-speed scale for a given f-number or on the f-number scale for a given shutter speed. For example, if the reading for the lightest area indicates an exposure time of 1/1000 sec. at $f/16$ and the reading for the darkest area 1/15 sec. at $f/16$, the middle value on the scale 1/1000-1/500-1/250-*1/125*-1/60-1/30-1/15 is 1/125 sec. Similarly, if the reading for the lightest area indicates an f-number of $f/45$ at 1/125 sec. and the reading for the darkest area $f/5.6$ at 1/125 sec., the middle value on the f-number scale 5.6-8-11-*16*-22-32-45 is $f/16$.

With meters that indicate light readings in terms of consecutive scale numbers or consecutive exposure value (EV) numbers, 1-2-3-4, etc., the middle value is found by selecting the middle number between the high and low numbers, for example, 18 in the sequence 15-16-17-*18*-19-20-21. Some electronic exposure meters have the feature of being able to average highlight and shadow readings electronically.

Keytone Method

There is no reason why the correct exposure cannot be obtained by taking a single reflected-light reading from a lighter or darker area than a midtone, providing that an appropriate adjustment is made to compensate for the tonal difference. For example, if a reading is taken from a light gray surface or Caucasian skin that reflects approximately 36% of the incident light and no adjustment is made, the exposure meter will indicate half the exposure that it would indicate for a reading from an 18% reflectance surface and it would be necessary to compensate by doubling the exposure indicated by the meter.[2] In a similar manner, if a photographer did not have an 18% reflectance gray card, the same result could be obtained by taking a reflected-light reading from a sheet of white paper (reflectance of approximately 90%) and multiplying the indicated exposure by 5 (90%/18%).

[2] J. Dunn and G. Wakefield, *Exposure Manual* (London: Fountain Press, 1974).

Zone System

The Zone System is based on the belief that a photographer should be able to visualize how selected areas in a scene will be reproduced in terms of print tones and be able to modify exposure and development to achieve desired tone-reproduction effects. The system is based on the Weston exposure-meter dial that had, in addition to a midtone normal arrow, shadow and highlight markers covering the 7-stop range of luminances representing an average scene.[3] Seven stops equals a subject luminance ratio of 1:128.

The visualization process can be facilitated by attaching patches of paper, representing print tones, to the dial with a just-lighter-than-black patch in the shadow position (subject value or exposure zone I), a just-darker-than-white patch in the highlight position (value VIII), and corresponding tones of gray in the intermediate positions. In addition, a paper-white patch is placed 1 stop above the highlight at value IX, and a maximum-black patch is placed 1 stop below the shadow at value O (Figure 4–11).

With a normal-contrast scene having a luminance range of 7 stops, the film would be given the same exposure with (1) a reflected-light reading of the shadow area aligned with the shadow position on the dial (value I), (2) a reading of a midtone area aligned with the normal-exposure arrow (value V), or (3) a reading of a highlight area aligned with the highlight position on the dial (value VIII). Any selected subject tone, however, can be reproduced lighter or darker than its normal reproduction tone by taking a reflected-light reading of that area and then positioning the reading opposite a lighter or darker tone on the dial. When photographing a black object, for example, it may be decided that the detail would be too subtle if reproduced with the normal shadow density (value I), so the reading could be positioned opposite the next-lighter patch (value II), the equivalent of doubling the exposure.

Application of the Zone System to camera-exposure control will be more vivid if it is assumed that reversal color film or Polaroid print film is being used rather than negative-type film, where additional control over the density of the final image is available at the printing stage. Variations in effects using the Zone System can be illustrated with a profile view of a person in front of a window with a bright background and with normal room illumination on the subject. A normal exposure effect can be obtained by taking a reflected-light meter reading of an

[3] A. Adams, *The Negative* (Dobbs Ferry, NY: Morgan and Morgan, 1971), 14.

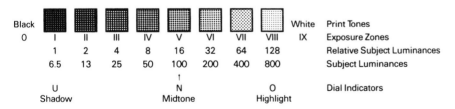

Figure 4 – 11 The U and O positions on the Weston exposure meter represent the detailed shadow and highlight limits of a normal 7-stop scene. These positions correspond to subject values I and VIII in the Zone System. The normal-exposure arrow on the meter corresponds to subject value V.

18% reflectance gray card held in front of the person's face and aligning the reading with the normal-exposure arrow, or by taking the reading from the person's face and aligning it with the patch that matches the person's skin tone (Figure 4–12). To obtain a semi-silhouette, the reading of the face would be set opposite the shadow position on the dial (value I) for just-perceptible detail, or 1 or 2 stops higher (value II or III) for increasing amounts of detail. To obtain a silhouette without detail, the reading would be set opposite the patch representing maximum black (value O), 1 stop below the shadow position.

When photographing contrasty scenes that exceed the normal 7-stop luminance range, ruling out contrast-control procedures for

Figure 4 – 12 A reflected-light exposure meter reading was made of the model's skin and 6 negatives were exposed for subject values VI (normal), V, IV, III, II, and I. (In the original prints, detail is visible in the value I exposure print.)

Figure 4 – 13 A situation where it would be difficult to obtain a dependable reflected-light exposure-meter reading due to the small size and the light tone of the push pin.

now, it would be necessary to make a decision whether it is better to sacrifice detail in the highlight areas or the shadow areas, or possibly a smaller amount in both. As a general rule, with front-lit scenes where shadow areas are relatively small, detail in the shadows is less important than detail in the larger highlight areas. Conversely, with back-lit scenes where the main light is rim-lighting objects, detail in the relatively small highlight areas can be sacrificed more safely.

Limitations of Reflected-Light Readings

Counterbalancing the advantages of reflected-light exposure meter readings are certain limitations and disadvantages. For camera-position readings, decisions need to be made concerning the balance of light and dark tones in the scene. For closeup readings, decisions are required concerning which subject area best serves as an appropriate midtone. Some scenes may not contain an appropriate midtone, and in other situations the selected subject area may not be accessible or may be too small to measure (Figure 4–13). Taking multiple readings for the Brightness-Range Method and substituting an artificial midtone in the form of a gray card require extra time, and in the latter case care must be exercised in positioning the card and the meter to avoid including a shadow, a glare reflection, or a contrasting background. While the Keytone Method and the Zone System offer photographers considerable control over the tone-reproduction process, they require a greater understanding of the compensations required when taking readings from subject areas that are lighter or darker than the midtone and when modifying film development to alter image contrast.

Incident-Light Readings

The basic concept of incident-light exposure meters is simple—hold the meter directly in front of the subject, aim the meter at the camera, and expose the film as the meter indicates. The success of this system is based on the assumptions that (1) the level of the illumination falling on the subject is more important than the range and distribution of tones in the scene, and (2) the meter will automatically compensate for changes in direction of the main light source. Although there are situations where an adjustment should be made to the exposure indicated by incident-light meter readings, the assumptions are generally valid.

Light Diffuser Shape

As noted previously, it is necessary to cover the photocell of incident-light meters with a neutral-density filter to compensate for the difference between the amount of light falling on a subject and the amount reflected, and the filter is normally a hemispherically shaped white plastic diffuser. The basic principle of the hemispherical diffuser is that as the direction of the main light changes from front lighting to

side lighting, less of the subject is illuminated, as seen from the camera position, and less of the diffuser on the exposure meter is illuminated. With the main light at an angle of 90° to the camera axis, half of the diffuser is illuminated, which lowers the reading by the equivalent of 1 stop, which in turn indicates to the photographer that either the exposure time should be doubled or the aperture should be opened 1 stop. With strong backlighting on the subject, little or none of the light from that source strikes the meter diffuser and the exposure is based entirely on the fill light falling on the subject and the diffuser from the front.

A flat cosine-corrected diffuser that can be substituted for the hemispherical diffuser is available for some exposure meters. Although the same reading should be obtained with the two types of diffusers when copying two-dimensional originals with the recommended 45° lighting with two or more light sources, the flat diffuser may be recommended by the meter manufacturer when using the meter to measure light in photometric units of footcandles or lux.

Limitations of Incident-Light Readings

There are situations where incident-light meter readings cannot be used, such as with objects that emit light and transparent or translucent objects that transmit light. Specific examples are a television or computer monitor screen and a color transparency on a transparency illuminator.

In other situations modifications of the camera exposure indicated by an incident-light meter reading may be required, primarily when the main subject is very dark or very light, but also when a special exposure effect is desired, such as a darker-than-normal image for a semi-silhouette effect. Even though it is possible to record the full range of tones from shadows to highlights in normal 7-stop scenes or from the black patch to the white patch on a gray scale with reversal color film (or with negative-positive processes using normal procedures), the contrast is reduced in both the darkest areas and the lightest areas. This local reduction in contrast is acceptable for scenes having a reasonable balance of light, intermediate, and dark tones. When a large dark object dominates a scene, however, more vivid detail is desirable, which can be achieved by increasing the exposure by approximately 1 stop over that indicated by an incident-light meter reading (Figure 4–14). Conversely, local detail can be enhanced in a large light object by decreasing the exposure approximately 1 stop from that indicated by an incident-light meter reading.

Another limitation of incident-light exposure meters is that they cannot be incorporated into the design of a camera to provide automatic exposure control by adjusting the aperture or shutter settings as the light level changes, a feature now found on many small-format cameras and identified by the initials AE. (A 35-mm single-lens-reflex camera was designed with the exposure-meter window on the front surface of the camera body, where it could be used either as a reflected-light meter or, by covering the window with a diffuser, as an incident-light meter, in which case the camera would be held in front of the subject and aimed back at the camera position to take the meter read-

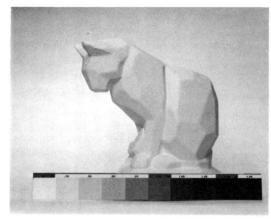

Figure 4 – 14 Although incident-light meter readings (or reflected-light meter readings from an 18% reflectance gray card) produce the optimum exposure for subjects having a normal range of tones as represented by a gray scale, exposure adjustments are recommended for high-key scenes and for low-key scenes. (*Top left*) White object with normal exposure. (*Top right*) One stop less exposure. (*Bottom left*) Black object with normal exposure. (*Bottom right)* One and one-half stops more exposure.

ing prior to returning to the camera position to take the picture. Hemispherical diffusers have also been designed to be placed over the camera lens of any single-lens-reflex camera having through-the-lens metering whereby, again, the camera would be held in front of the subject to take the meter reading before taking the picture.) It should be noted that view cameras having in-camera metering capability, either with a light-sensing probe inserted in the position of the film holder or with sensors attached to the ground glass, are using the reflected-light metering concept.

Electronic-Flash Exposure Meters

Conventional exposure meters cannot be used to determine the camera exposure with electronic-flash illumination since the meters are designed to measure the light from a source of constant intensity rather than a source of rapidly changing intensity and short duration. Electronic-flash meters work on the principle of measuring the total amount of light that falls on the photocell over an appropriately short period of time by charging a capacitor and then measuring the charge. Early models used a fixed time gate, such as 1/60 sec., but the more sophisticated models now have adjustable time gates that can be set to match the shutter speed and therefore measure the same combination of flash and ambient light that the film will receive. Most elec-

tronic-flash meters can be used in both reflected-light and incident-light modes, the same as most hand-held conventional exposure meters. Whereas some flash meters are designed to measure only the flash illumination plus ambient illumination over a short time interval, a number of models of flash meters are now available that can also be used as conventional exposure meters.

In order to use a hand-held electronic-flash meter it is necessary to make a reading with a trial flash before exposing the film. This presents no problem in situations where the distance between the subject and the flash unit(s) is not subject to sudden changes, and time permits. The basic camera control over exposure with electronic-flash illumination is the f-number setting, since the flash duration is typically shorter than the shutter speed. Although this limits control over the flash exposure, since the same amount of light from the flash source will reach the film over a wide range of shutter-speed settings, it also offers the advantage of being able to control the effective lighting ratio between the flash illumination and the ambient illumination. If the correct f-number setting for a given situation is $f/16$, for example, using a fast shutter speed will minimize exposure for the ambient illumination and a slow shutter speed will maximize it. This is an especially useful feature when using electronic flash to illuminate the shadows with subjects photographed at moderate to close distances outdoors with sunlight as the main source.

Many electronic-flash units, both the small portable type and the larger studio type, have adjustable power controls so that the light output can be varied over a considerable range, such as from full power to 1/64th full power, as an additional control over exposure. This allows the f-number to be selected on the basis of depth-of-field requirements rather than exposure requirements. When using multiple flash units, the power settings on the separate units can also be used to adjust lighting ratios.

An alternative to measuring the light from an electronic-flash unit with a preliminary trial flash and a hand-held electronic-flash exposure meter is to use the type of electronic-flash unit that automatically measures the light reflected from the subject with a sensor built into the flash circuit and then *quenches* the flash when the sensor has received a specified amount of light that corresponds to the correct exposure of the film.

Causes of Inaccurate Exposure

When negatives and transparencies exposed according to an exposure meter that is being used correctly are either consistently overexposed or consistently underexposed, an adjustment can be made by using a higher film-speed setting than the published film speed for overexposure or a lower setting for underexposure. It would be better, however, to first attempt to identify the cause of the exposure errors. Some of the possible factors are listed below:

1. Meter variability. Although exposure-meter manufacturers establish quality-control standards that permit little variability of performance on the final inspection, variability does exist, especially among meters that have been used for some time. Exposure meters

that require a battery normally also have a built-in battery tester, which should be used at appropriate intervals. Meter manufacturers' service centers and some camera-repair facilities have the standardized light sources and trained personnel that are necessary to test and adjust inaccurate exposure meters.

Photographers can conduct a simple test that will reveal significant variations in response by comparing a questionable meter with several other meters under identical conditions. Even without comparison meters, the *f*-sixteen rule can be used by taking an incident-light reading or a reflected-light reading from an 18% reflectance gray card on a clear day between 10 a.m. and 2 p.m., where the indicated shutter speed at *f*/16 should equal 1/(the ISO film speed setting), such as 1/125 sec. for an ISO setting of 125. Other *f*-numbers can be substituted for *f*/16 for different sky conditions: *f*/11 for heavy haze or a thin cloud layer, *f*/8 for cloudy bright, and *f*/5.6 for heavy overcast.

2. Inaccurate shutter speeds. Mechanical shutters do not have a reputation for accuracy even when new, but especially after years of use. It is not unusual for a mechanical shutter to be too slow at one setting and too fast at another. Such shutters can be tested, cleaned, and adjusted by trained camera-repair personnel. Electronically timed shutters are usually quite accurate, but a defective shutter should not be ruled out as a possible source of exposure errors.
3. Inaccurate *f*-numbers. There is little reason for photographers to question the accuracy of the *f*-numbers marked on lenses by the manufacturer. While it is true that the iris-diaphragm mechanism can become worn after years of use, this is rarely a problem. What must be kept in mind, however, is that the *f*-number is based on an image distance of 1 focal length, and that whenever the camera is focused on an object at a distance of 10 times the focal length or less from the camera lens, an exposure adjustment should be made by calculating either the *effective* *f*-number or an exposure factor. Variations in light transmittance of different lenses at the same *f*-number should not be a source of exposure errors with modern lenses having antireflection coatings on the glass-air surfaces.
4. Film-speed variations. Plus and minus 1/6 stop is considered to be the acceptable range of variability of film speed at the manufacturing stage, which means that two different batches of film could vary by as much as 1/3 stop, which would be detectable only with side-by-side comparisons of color transparencies. The effective speed of films, and the color balance of color films, can vary over extended periods of time, especially when film is stored under unfavorable conditions.

Of greater importance are the changes in the effective speed of films due to very short and very long exposure times, which produce reciprocity effects, and significant decreases and increases in the degree of development of the exposed film. Briefly, short and long exposure times both reduce the effective speed of most films, and the speed tends to increase with film developing time. Both effects will be considered in greater detail in chapter 5, Films and Film Processing.

Some density differences may be observed between black-and-white negatives exposed indoors with tungsten light and those exposed outdoors with daylight. The differences in film speeds can be

dramatic with blue-sensitive films (for example, daylight 50 and tungsten 8) and significant with orthochromatic films, which also have different published film speeds, but should not be more than 1/3 of a stop with panchromatic films that have a single published film speed. Film manufacturers have made progress in reducing the difference for some black-and-white films in recent years, but it should be noted that exposure meters can also respond somewhat differently to tungsten light and daylight, which complicates the situation.

5. Filters. Appropriate increases in exposure are required to compensate for the absorption of light by any filters used on the camera lens. With color films it is common practice to publish different film speeds when the film is used with the recommended light source without a filter and with a different light source with a filter (such as tungsten film used with daylight with an orange filter). With black-and-white films it is a more common practice to publish filter factors for different filters whereby the *f*-number or the shutter speed is adjusted after the camera settings are determined for the published film speed.

6. Flare light. A light background behind a subject or a light source, such as the sun, included in the picture can produce sufficient flare light to significantly alter the density of the darker subject areas on a negative or color transparency and may require a small decrease in the camera exposure to obtain an image having the optimum density.

Films and Film Processing

5

Film Sizes

View cameras are commonly referred to as large-format cameras. Actually, view cameras have been made in film-format sizes ranging from at least as large as 20 × 24 in. down to 1 × 1.5 in. (35-mm size). For many years the 8 × 10-in. format was considered to be the standard size for professional photographers, but the steady improvement in the quality of photographic films has resulted in the 4 × 5-in. format becoming the most popular-size view camera with both professional and nonprofessional photographers. Even smaller films can be used with 4 × 5-in. cameras by means of reducing backs and roll-film holders, and some modular-type 4 × 5-in. cameras are designed to allow the substitution of larger-format backs.

The relative sizes of various film formats from 35 mm to 8 × 10 in. are shown in Figure 5–1. Although 4 × 5-in. film is only four times wider than 35-mm film, it has approximately 13 times the area, and 8 × 10-in. film has approximately 53 times the area of 35-mm film. In situations where image quality is the most important consideration, large film sizes are preferred. The increased magnification required to print small negatives not only reveals the inherent limitations of the film, but also increases the seriousness of shortcomings in craftsmanship, such as dust and scratches. Photographers who are concerned about obtaining the highest possible quality use film large enough to permit them to make contact prints rather than projection prints, thereby avoiding the inevitable loss of definition and tonal gradation that results from adding another optical system between the subject and the final print image. Also, when reversal color film is used, the film size must correspond to the desired size of the final image, which is commonly specified by the client. When the cost involved in making a large number of photographs is a more important factor than the highest possible image quality, the smaller film sizes have an advantage.

Sheet Film

Sheet films offer certain advantages over 35-mm and roll films in addition to the larger film sizes, such as the convenience of being able to make a single exposure without wasting the rest of a roll of film, and the ability to make exposures on different types of film, such as black-and-white and color, in rapid succession. There are also certain disadvantages associated with sheet films, such as the need to load the film in holders in a darkroom, and when working on location to have a sufficiently large number of film holders available.

Loading Film Holders

The double sheet-film holder has been the most widely used type of film-holding device for sheet film for many years. Other types of holders are available, however, including one that has a hinged back that provides greater convenience in loading and more positive pressure on the back of the film to hold it flat and firmly in position, but that accommodates only a single sheet of film. Grafmatic Film Holders are capable of holding 6 sheets of 4 × 5-in. film. The sheets of film are

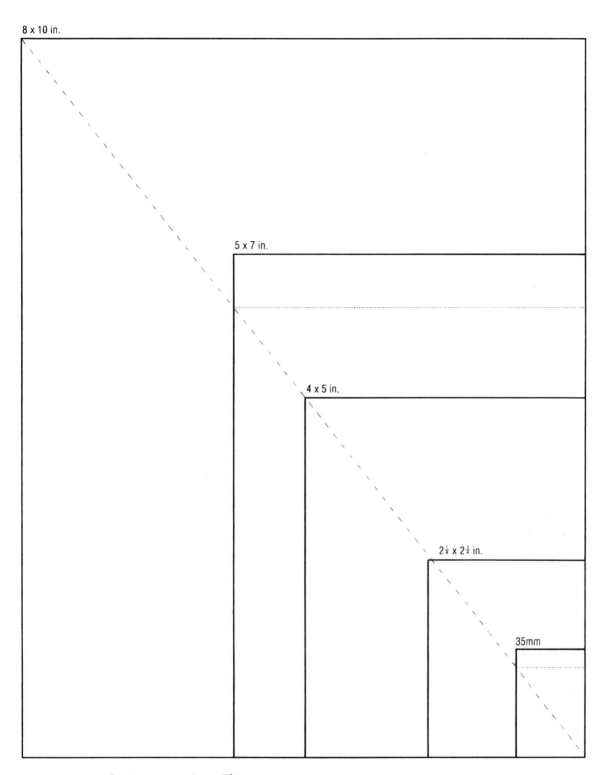

8 x 10 in.

5 x 7 in.

4 x 5 in.

$2\frac{1}{4}$ x $2\frac{3}{4}$ in.

35mm

Figure 5 – 1 Film size comparison. The dashed horizontal lines show the amount of cropping required with 35-mm and 5 × 7-in. negatives when making 4 × 5-, 8 × 10-, or 16× 20-in. prints

loaded into metal sheaths that are then stacked inside the holder. After the front film is exposed, a sliding component moves the exposed film to the back of the stack.

Since it is necessary to work in complete darkness when loading film holders, it is important to prepare the holders and the work area properly before turning off the lights. It is advisable to vacuum all

surfaces in the darkroom regularly and to wipe the film loading area with a damp sponge before loading the holders. Dust on film when it is exposed or on negatives or transparencies when they are being printed causes spots on the prints.

With double-sheet-film holders, the dark slides should be removed and the slides and the holders dusted with a clean brush, preferably an anti-static brush, or vacuumed. One side of the handle end of the dark slides is normally aluminum or white and the other side black. The light side also has bumps or notches that can be felt in the dark to identify that side. It is better, however, to insert each slide in the holder far enough to hold it firmly without extending into the film area with the room light on. It is a universally accepted convention to place the light side of the slide in the outside position when loading the holder and then to reverse the slide when the film is exposed. In this way the photographer knows that when the black side of the slide is visible the holder either contains exposed film or it is empty, and when the light side is visible the holder contains unexposed film. It is also important to identify the type of film being loaded into the holder by making a pencil notation on the white patch on each side of the holder.

It will be more convenient for a right-handed person to stack the holders on the loading bench with the protruding slides on the left end and the box of film that is to be loaded just in front of or just to the right of the holders. Although identifying the emulsion side of a sheet of film and sliding it under the flanges on both sides of the holder are not difficult to do in the dark, this procedure should be practiced repeatedly with a negative or discarded piece of film first with the room lights on and then with the lights off or with the eyes closed. Failure to position the film under the flange on either side will allow the film to curl out of position, producing an unsharp image when the film is exposed, and loading the film with the emulsion side down would be disastrous.

Washing one's hands with soap and water and drying them thoroughly will lessen the chance of depositing a fingerprint on the emulsion that can become a permanent part of the image. The darkroom should be completely darkened before opening any box of panchromatic black-and-white film or box of color film, although appropriate safelight illumination can be used with blue-sensitive and orthochromatic black-and-white films. The emulsion side of sheet film can be identified by orienting the film so that the film notches are located on the right side of the top edge where they can be felt with the forefinger of the right hand (Figure 5–2). After opening the box of film and removing the pack of film from the inner wrapping, the pack of film should be placed crossways in the box with the emulsion side down so that the notched end remains elevated as the pack rests on one edge of the shorter dimension of the box. The pack of film can now be located in the dark without touching the emulsion side. When the top sheet is picked up, it should be turned over and held by the edges in the left hand with the forefinger of the right hand touching the notches on the top edge to make certain that the emulsion side is facing upward.

Transfer the film to the right hand, pick up the top film holder with the left hand, holding the flap open with the left forefinger, insert the film under the flanges on both sides as shown in Figure 5–3, and push the film all the way in. Close the flap, lightly feel for the end of

Figure 5 – 2 Determining that the emulsion side of a sheet of film is facing up.

Figure 5 – 3 Loading a sheet of film into a film holder.

the flange on each side to make certain that the film is under both flanges, and push the dark slide all the way in. If the film holder does not have automatic locks, it will be necessary to turn the lock to prevent accidental removal of the slide.

Film Types

View-camera users have a wide choice of sheet films. Basic categories of films include black-and-white negative films, color negative films, and color reversal films. Special-purpose films within the black-and-white category include high-contrast films, blue-sensitive and orthochromatic copy films, fine-grain films, high-speed films, and infrared films. In addition, Polaroid offers a variety of black-and-white and color instant-picture films in 4 × 5-in. and 8 × 10-in. sheet-film sizes, including a 4 × 5-in. positive/negative black-and-white film that produces both an instant print and a negative that can be enlarged to make conventional photographic prints.

Characteristics of Black-and-White Films

It is useful when selecting films for various types of photography to understand the basic ways in which the films differ from each other, which include film speed, reciprocity characteristics, spectral sensitivity, image contrast, image structure, and exposure latitude. Except for spectral sensitivity, the categories are not entirely independent of each other. When a film manufacturer changes a photographic emulsion to increase the film speed, for example, the changes will likely alter some of the other characteristics as well.

Film Speed

The film-speed numbers assigned to photographic films vary directly with the sensitivity of the films to light and inversely with the amount of exposure required to produce a specified density. Many dif-

Table 5 – 1 ISO arithmetic and logarithmic film speeds.

Arithmetic/Logarithmic
6/9°
8/10°
10/11°
12/12°
16/13°
20/14°
25/15°
32/16°
40/17°
50/18°
64/19°
80/20°
100/21°
125/22°
160/23°
200/24°
250/25°
320/26°
400/27°
500/28°
650/29°
800/30°
1000/31°
1250/32°
1600/33°
2000/34°
2500/35°
3200/36°
4000/37°
5000/38°
6400/39°

ferent film-speed systems have been used in different countries in the past, but the ISO system that is now being used universally by film manufacturers and photographers is named for the International Standards Organization, an organization that includes representatives from all of the major industrialized countries and that approved this film-speed system. ISO film-speed numbers contain two numbers that are written, for example, 100/21°, where the first number corresponds to the arithmetic ASA film-speed system that was formerly used in the United States and the second number corresponds to the logarithmic DIN system that was formerly used in Europe. Exposure meters that have only a single set of film-speed numbers have a label indicating whether they are ASA or DIN numbers.

ISO film-speed numbers from 6/9° to 6400/39° are shown in Table 5-1. Consecutive film-speed numbers on this list (100 and 125, for example) correspond to a 1/3 stop change in exposure, a second higher number (100 and 160) corresponds to a 2/3 stop change in exposure, and a third higher number, which is double the original number (100 and 200) corresponds to a full stop change. Since film manufacturers round all film speeds off to correspond to one of these numbers, it can be seen that two different films (or different batches of the same film) could vary by as much as plus and minus 1/6 stop, or a total of 1/3 stop, and still be assigned the same film speed. It should also be noted that film-speed numbers are based on standardized development of the film, and increasing or decreasing the degree of development will alter the *effective* film speed. Aging of film can also affect its speed.

Reciprocity Effects

ISO film speeds are not only based on a standardized degree of development but also on a standardized range of exposure times—1/10 sec. to 1/1000 sec. for most black-and-white films. In practice, it is possible to make a series of photographs of the same subject with different combinations of *f*-numbers and shutter speeds that allow the same total amount of light to fall on the film (for example, 1/15 sec. at *f*/45, 1/30 sec. at *f*/32, 1/60 sec. at *f*/22, etc.) and the resulting images can be expected to match in density because the film speed remains essentially constant over this time range. When the exposure time is increased to 1 sec. or longer with a low level of light falling on the film, or decreased to 1/1000 sec. or shorter with a high level of light falling on the film, the effective speed of the film decreases. It is not necessary for photographers to understand the theory of why the effective speed of film decreases under these conditions but it is important for them to compensate for the decreased sensitivity of the film by increasing the camera exposure. Rather than publishing adjusted effective film-speed numbers for very short and very long exposure times, film manufacturers normally publish the adjustments required in terms of changes in exposure time or *f*-number from the settings indicated by exposure-meter readings.

In addition to the decrease in the effective film speed with long and short exposure times, there is typically a change in image contrast. With long exposure times the contrast tends to increase, requiring a decrease in the developing time by as much as 30%, whereas with short exposure times the contrast tends to decrease, requiring an in-

crease in the developing time by up to 20%. Since these changes in developing time also slightly alter the effective film speeds, the published corrections take both factors into account.

The reciprocity corrections for long exposure times in Table 5-2 are valid for most conventional black-and-white films, but it is advisable to check the data published for specific films by the film manufacturer. Even though corrections are provided in the table in terms of both *f*-stops and exposure time, it should be noted that the two types of corrections do not produce the same exposure increase. When an exposure meter reading indicates an exposure time of 100 sec., for example, the photographer can either open the lens diaphragm 3 stops (which increases the exposure by a factor of 8) or multiply the exposure time by a factor of 12. The reason the time factor is larger is that the longer (1200-sec.) exposure time produces a larger reciprocity effect than the 100-sec. exposure time with the larger diaphragm opening. It should be noted that newer black-and-white films incorporating T-grain emulsion technology typically require much smaller corrections for reciprocity effects. Kodak T-Max 100 Professional Film, for example, requires only a 1-stop correction or a 2× time correction for an indicated exposure time of 100 sec. and no development adjustment for image contrast. Color films, on the other hand, may require the addition of a color filter to compensate for shifts in color balance of the images.

Reciprocity effects are more complicated with color films because they contain three emulsion layers that can respond differently to very long and very short exposures, thereby producing color shifts in different directions in highlight and shadow areas that are not correctable when making color prints—in addition to a decrease in the effective film speed and a possible change in image contrast. Some negative color films, designated as Type L films, are designed to produce normal results with exposure times longer than 1/10 sec., with others, designated as Type S films, designed to produce normal results with exposure times of 1/10 sec. and shorter.

Spectral Sensitivity

Most black-and-white and color films have panchromatic sensitivity, that is, they are sensitive to all wavelengths in the visible part of the spectrum, although with color films the red, green, and blue primary color components of white light are recorded on separate emulsion layers. All photographic emulsions are also sensitive to invisible

Table 5 – 2 Recommended exposure and development corrections for long exposure times with most conventional black-and-white films.

Indicated Exposure Time	Exposure Time Factor	(OR)	Open Lens Diaphragm	(AND)	Shorten Developing Time
1 sec.	2x		1 stop		10%
10 sec.	5x		2 stops		20%
100 sec.	12x		3 stops		30%

(T-grain films require much smaller exposure adjustments and no development adjustment.)

ultraviolet radiation. Other types of sensitivity include blue-sensitive films, orthochromatic (or blue-and-green-sensitive) films, and infrared-sensitive films. The main advantage of blue-sensitive and orthochromatic films is that they can be handled under safelight illumination. They are used mostly for copying black-and-white images or where the darker reds and lighter blues or blues and greens are desirable, although similar tone reproduction can be obtained with panchromatic film and an appropriate color filter. Even panchromatic black-and-white films can vary in spectral sensitivity. One method of increasing film speed that is available to the manufacturer is to increase sensitivity in the red region of the spectrum, which also causes red subjects to be recorded denser on negatives and lighter on prints.

The relative sensitivities of the red-, green-, and blue-sensitive emulsion layers in color films are controlled during manufacture to balance the films for use with different qualities of illumination, normally daylight (5500 K color temperature) and tungsten (3200 K). Each type of film can be used with the other type of light source by using an appropriate color filter but the daylight film/tungsten illumination combination is less popular than the tungsten film/daylight illumination combination due to the greater loss of effective film speed with the former.

Image Contrast

The contrast of black-and-white print images depends upon a large number of factors but when all other factors are standardized for a comparison of different films, it is found that the inherent contrast of the films can vary over a large range. For some purposes a film that has such high contrast that it records subject tones with either no density or a heavy density is required. Lithographic films used to make line and halftone negatives for photomechanical reproduction are examples of this type of high contrast. Slightly less contrasty films, sometimes identified as contrast process films, are used in view cameras and other cameras to copy black-and-white drawings and documents to maintain the high contrast in the print or to increase the contrast of lower-contrast subjects. Even within the group of films referred to as normal-contrast films, different films can vary considerably in inherent contrast. Traditionally, slower fine-grain films tend to have higher contrast than high-speed films, but photographic emulsion chemists have considerable control over the contrast characteristics. Photographers have less control over image contrast with reversal color films, where the transparency is the final image, and with negative/positive color film and paper, than with black-and-white processes, but certain color films and color printing papers and processes have gained reputations for producing images with slightly higher- or lower-than-normal contrast.

Film Exposure Latitude

Like image contrast, camera exposure latitude depends upon various factors, but with respect to film exposure latitude the largest difference occurs between negative films and reversal films. With normal exposure on reversal color films, a normal-contrast scene (one hav-

ing a luminance ratio of 1 to 128 between shadows and highlights or a luminance range of 7 stops) suffers some loss of contrast in the brightest highlights and darkest shadows. In other words, for critical work reversal color film has essentially no exposure latitude with normal-contrast scenes. For less critical work the exposure latitude is commonly considered to be about plus and minus 1/2 stop from the optimum exposure. With low-contrast subjects, the exposure latitude might be based more on the appearance of the image as being too light or too dark than on a loss of shadow or highlight detail. As noted in chapter 4, when photographing very light subjects it is better to reduce the exposure by 1/2 stop or more and with very dark subjects to increase the exposure by an equal amount from the exposure indicated by an incident-light or reflected-light midtone meter reading, which implies that at least with some subjects reversal color films may have less than zero exposure latitude.

With both black-and-white and color negative films there is considerably more exposure latitude on the overexposure side than on the underexposure side of normal exposure, but photographers who desire to obtain the best possible image quality do not allow the camera exposure to deviate much from the optimum. An extra emulsion layer has been added to some black-and-white negative films to reduce the loss of contrast and detail (or blocking-up) of highlight areas with overexposure. In general, exposure latitude decreases as the inherent film contrast and the degree of development increase.

Image Structure

Image structure refers to the appearance of a greatly enlarged area of a negative or transparency such as the images of object points, lines, and areas of uniform tone. The term *definition* is commonly applied to the appearance of clarity of detail in photographic images. Numerous factors affect the image definition on negatives and transparencies exposed in a camera, including the quality of the camera lens, accuracy of focus, steadiness of the camera during the exposure, film characteristics, exposure level, type of developer, and degree of development. With respect to the film, developer, and degree of development combination, image definition can be subdivided into three more specific attributes—*graininess*, *detail*, and *sharpness* (subjective terms), or *granularity, resolving power,* and *acutance* (objective terms).

Graininess/Granularity

Graininess is the appearance of a random-pattern variation of density in an enlarged image of a uniformly exposed area and is caused by the fact that black-and-white images are composed of microscopic particles of metallic silver that partially overlap at different depths in the emulsion to produce the appearance of clumps. With color images, particles of dyes or other colorants occupy the same locations.

Graininess can be measured by determining the minimum magnification at which the graininess pattern can be detected with a fixed viewing distance, or the maximum viewing distance at which it

can be detected with a fixed magnification. Granularity is determined by scanning a uniformly exposed area of the image with a microdensitometer and then calculating the granularity value on the basis of the small-scale variations of density. To make the granularity values more meaningful to photographers, they are typically divided into seven categories—Micro Fine, Extremely Fine, Very Fine, Fine, Medium, Moderately Coarse, and Coarse. Traditionally, granularity has increased with film speed, but the T-grain emulsion technology used for some newer films has resulted in dramatically lower granularity than in older films having the same speed.

Detail/Resolving Power

The ability of a film to record detail refers to its ability to record small, closely spaced subject elements as separate elements rather than as blended together. This ability can be evaluated subjectively by comparing images made on two different films under identical conditions. The more objective resolving power can be determined by photographing a test target consisting of alternating light and dark bars having decreasing widths and then determining the smallest set of bars, with a magnifier or microscope, that can still be distinguished in the image. Since this number is the resolving power of the lens-film system, it is necessary to determine the resolving power of the lens by examining the aerial image with a microscope and then calculating the resolving power of the film from the other two resolving powers.

Film manufacturers commonly provide resolving powers of films both in lines/millimeter and in descriptive terms, as shown below:

Low	50 lines/mm and lower
Medium	63, 80 lines/mm
High	100, 125 lines/mm
Very High	160, 200 lines/mm
Extremely High	250, 320, 400, 500 lines/mm
Ultra High	630 lines/mm and higher

Sharpness/Acutance

Sharpness refers to the apparent abruptness of the change in density that occurs when crossing an edge such as the image of the edge of a razor blade that is in contact with the film. Acutance, an objective measure, is determined by scanning across the image of the edge of the razor blade with a microdensitometer. It may not always be possible for a person to distinguish between detail and sharpness when viewing a photograph, but if a photographic copy is made of a page of printed material containing type of decreasing sizes, as in an eye-examination chart, the resolving power (detail) capability of the film will influence the legibility of the small print and the acutance (sharpness) capability will influence the appearance of abruptness of change in density of the edges.

Film manufacturers may also provide an *enlargement allowed* rating that takes into consideration all three of the above characteristics, graininess, detail, and sharpness. The attention that needs to be given to the image-structure characteristics when selecting a film varies with the film format size and the intended degree of magnification of the image.

Processing Sheet Film

View-camera users have various options with respect to processing sheet film, including processing in trays, open tanks, light-tight tanks, drum processors, and roller-transport processors, and using the services of a professional lab. Major factors involved in making a choice among the options include the quantity of film to be processed, whether the film is black-and-white or color, cost of processing equipment and chemicals, and time and convenience of use.

Tray processing of black-and-white film is the least expensive of the various options, requiring only four trays, a thermometer, and a timer. Tray processing requires only small quantities of processing solutions, and by discarding the used developer and using fresh developer for each batch of film processed, there should be little variation of development contrast between batches. Tray processing is not suitable, however, for processing large quantities of film. First-time users of this method should begin with a single sheet of film and gradually work up to 6 or so sheets. Moderately larger numbers of films can be developed at one time by those having sufficient experience and manual dexterity, especially with slower-acting developers that require longer developing times. Another disadvantage of tray processing is that the emulsion is more susceptible to being scratched or gouged by fingernails or the sharp corners of the other sheets of film during processing, and careless handling of the film can produce permanent fingerprints. Also, it is necessary to work in complete darkness and to place the hands in the processing solutions. Some photographers are either allergic to or become sensitized to metol and certain other developing agents with the result that the skin on their fingers and hands becomes rough, or even painfully blistered and cracked, a reaction referred to as *metol poisoning* or *contact dermatitis.* It is best to avoid this experience by wearing surgical gloves, which are available in drug stores and are thin enough to preserve the sense of touch, when developing film in trays. The use of print tongs is recommended when tray-developing prints.

Developing in open tanks must also be done in total darkness, but since the sheets of film are first loaded into hangers that are supported by opposite edges of the tank, moderately large numbers of films can be processed in each batch and it is not necessary to immerse fingers in the processing solutions. Agitation consists of lifting all of the hangers from the solutions at specified intervals, rotating them counterclockwise 45° so the solution drains from the lower-left corner, alternated with rotating them clockwise to drain from the lower-right corner. Agitating too vigorously produces uneven development from the flow of developer through the openings around the edges of the hangers, and insufficient agitation produces uneven development due to the flow of the heavier byproducts of development over the surface

of the film. Floating covers can be placed on the solutions when they are not being used to prevent evaporation and oxidation, and replenisher can be added to the developer to extend its useful life.

Light-tight tanks for processing sheet film have grooves on opposite sides to hold the film, with the film being loaded into the empty tank in the dark. Room lights can be turned on after the top is in place. It is difficult to provide the type of agitation that produces uniform development with these tanks and they are not widely used.

Drum processors can be used with the room lights on and are capable of producing very uniform development. Sheets of film are inserted in grooves on the interior surface of the drum in the dark. After attaching the top, solutions can be added and drained with the room lights on. Agitation is provided by rotating the drum at a constant rate. The maximum film capacity of drums is approximately 10 sheets. As with tray development, drums require only modest quantities of solutions so that fresh developer can be used for each batch. The better models, which provide temperature control and motorized agitation, are cost effective for most photographers only if the drums, are also used for processing reasonable quantities of color films and prints, since the prices tend to be in excess of a thousand dollars.

Roller-transport processors, whereby exposed film is fed into one end and the processed and dry film emerges minutes later from the other end, provide the ultimate in convenience combined with uniform development and consistent quality. The high cost of these processors can be justified only by organizations that process large quantities of film, although less-expensive table-top models are available for processing prints.

Since most photographers prefer to process their own black-and-white film, professional labs are used by photographers mostly for processing color film and/or making color prints. Professional labs, as distinct from photofinishing labs, give more individual attention to each order and attempt to satisfy the quality criteria of their customers. The labs commonly provide additional services such as retouching color negatives, airbrushing prints, print texturing, and print mounting.

Tray Processing of Black-and-White Film

Separate trays are required for the developer, stop bath or water rinse, and fixer. There are advantages to using a developer tray that is only a little larger than the film being developed, such as a 5 × 7-in. tray for 4 × 5-in. film, since less developer, which is usually discarded after each use, is required than in a larger tray, and when developing more than a single sheet of film less difficulty will be experienced in keeping the stack of film together in the dark.

After adding the processing solutions to the trays, their temperatures should be adjusted to fall within the recommended range and the darkroom timer set for the time recommended for the developer temperature. A fourth tray should be available for washing the negatives after they have been processed, and if more than a single sheet of film is to be processed it is advisable to place a tray of water to the left of the developer tray for presoaking the film before placing it in the developer.

It is important to arrange the trays, the timer, and the holders containing the exposed film in appropriate positions and to orient oneself with respect to these items so that everything can be located in the dark. Beginners have been known to put the film in the fixer first instead of the developer. It is advisable to put on surgical gloves for processing. Otherwise, the hands should be clean and dry to avoid fingerprints.

Assuming that several sheets of film are to be developed, they should be held in the left hand with the emulsion side up and the notches in the upper right corner where they can be felt with the index finger of the right hand. By staggering the films outward from bottom to top, it will be easy to remove the films from the top, one at a time. If two sheets of film are in contact when they are placed in water or developer, they may become stuck together and be difficult to separate without damaging the emulsion. Immerse the films, one at a time, in the tray of water and let soak for a minute or so. Remove the stack of films from the water, drain for a few seconds, and arrange in the left hand as before, emulsion side up with the notches in the upper right corner and staggered outward from bottom to top. Start the timer and insert the films in the developer one at a time, making sure that each is completely immersed before inserting the next and being careful not to damage the emulsion of the top film with a sharp corner of the film being inserted. After adding the last film, immediately begin removing the bottom film and immersing it at the top of the stack until the timer sounds. If it is important that all of the films be developed for the same length of time, the last film to go into the developer can be rotated end for end so that the notches are in the lower left position; be sure that the same film is on top by feeling for the absence of notches as the films are cycled from bottom to top before removing the stack of film from the developer. After draining for a few seconds, the entire stack should be turned emulsion side down, which will position the last film to go into the developer on the bottom. Slide the films forward from bottom to top in the left hand so they can be removed from top to bottom and placed in the stop bath. The negatives should be cycled once or twice before removing, draining, and placing in the fixer in the same manner. After cycling the films once or twice in the fixer, the room lights can be turned on for the completion of fixation and for washing. The washing time can be reduced from 20 minutes to 5 minutes by rinsing the negatives in water for 1/2 minute after removing them from the fixer and then soaking them in a weak solution of sodium sulfite or other washing aid for 1 1/2 minutes with agitation. Rinsing the negatives in a diluted wetting agent such as Kodak Photo-Flo Solution before they are hung up to dry will prevent the formation of water spots.

Film Development Contrast

Once black-and-white film has been exposed, the photographer still has considerable control over the density and contrast of the negative image by varying the degree of development. The factors that determine the degree of development for a given film are the developer composition and the time, temperature, and agitation during development. The type and frequency of agitation should adhere to the recommendations for obtaining the maximum *uniformity* of development with a given system of developing rather than to alter the *degree* of de-

velopment. Constant agitation is recommended for tray development and intermittent agitation for tank development, for example. Film manufacturers compensate for the effects of the differences in agitation by recommending different average developing times, such as 10 minutes for tray development and 13 minutes for tank development for a certain film-developer combination. For a given type of agitation, time and temperature are the remaining controls. A development temperature of 68°F (20°C) is generally recommended in situations in which the temperature can be controlled, but adjustments can be made in the average recommended developing times for temperature variations over a modest range, as shown in Table 5-3.

The most useful control over the degree of development is the developing time. The effects of varying the developing time can be demonstrated by photographing a scene containing a gray scale—exposing 5 films exactly the same but developing them for different times. If the densities of the gray-scale patches are measured on the negatives and plotted on a graph, a set of characteristic curves similar to those in Figure 5–4 will be obtained. A comparison of the curves reveals that as the developing time increases from 3 min. to 15 min. the densities of all areas of the scene increase, but the increase is larger in the highlight areas than in the shadow areas. Since the difference in density between highlights and shadows, that is, the *density range,* is one measure of negative contrast, it can be said that the negative contrast increases as the developing time increases.

Another method of measuring contrast from the curves is to determine the slope of the middle or straight-line part of the curve, a measurement identified as *gamma.* This can be done by selecting two different points on the straight line and dividing the vertical separation between them by the horizontal separation, such as 1.0/1.4 = 0.7.

Table 5 – 3 An example of recommended adjustments in black-and-white film developing times for variations of developer temperature and type of agitation.

Developing Times (Minutes) for Sheet Films

Tray

(Continuous Agitation)

65° F (18°C)	68° F (20°C)	70°F (21°C)	72°F (22°C)	75°F (24°C)
9	8	7	6 1/2	5 1/2

Tank

(Agitation at 1-Minute Intervals)

65° F (18°C)	68° F (20°C)	70°F (21°C)	72°F (22°C)	75°F (24°C)
11	10	9	8 1/2	7 1/2

Figure 5 – 4 A family of film characteristic curves representing variations in developing time. Typical shadow and highlight exposures are indicated by the vertical lines.

Gamma is a measure of the degree of development or development contrast, since it does not vary with differences in scene contrast, the luminance ratio between highlights and shadows, whereas the density range does. Gamma, however, has been largely replaced by *contrast index,* which is the slope of a straight line drawn between a shadow point on the toe part of the curve and a highlight point located on the upper part of the straight line, a section of the curve that better represents a normally exposed negative of a normal-contrast scene. A valuable attribute of contrast index is that photographers can use different combinations of film and developer to photograph a scene and obtain the same negative contrast by developing the films to the same contrast index.

Some photographers prefer to develop all of their black-and-white negatives for the same recommended average developing time, for the film-developer combination being used, rather than adjust the time for low-contrast and high-contrast scenes, since the differences in negative contrast can be compensated for at the printing stage by using different contrast grades of paper or variable-contrast paper. An advantage of this approach is that the effective speed of the film remains constant.

If, on the other hand, the developing time is decreased to compensate for high contrast in a scene without adjusting the exposure, there is danger of losing contrast and detail in the shadow areas. Thus it is generally advisable to increase the camera exposure when reducing the developing time. The danger of not making an exposure adjustment when *increasing* the developing time to compensate for *low* contrast in a scene is not as great. The shadows will have more density and detail with the longer developing time and there is little danger of losing detail in the highlights, since the scene contrast is lower than average and there is more latitude on the denser overexposed side of the normal range of negative densities.

In situations where it is necessary to underexpose black-and-white film by 1 or 2 stops—when it is necessary to use a small diaphragm

111

opening for depth of field and a fast shutter speed to stop motion, for example—increasing the developing time can compensate for the decrease in overall contrast associated with underexposure and partially compensate for the loss of shadow detail that would otherwise occur. Push proceeding, as this procedure is called, works best with low-contrast scenes, as the increase in contrast produced by the longer developing time may also improve the tonal quality of the image. It is best to run a test with the film-developer combination being used, but an increase in the developing time of 50% is suggested for the first trial. With Kodak Ektachrome Films an increase of 2 minutes in the first development time is recommended for a decrease in exposure of 1 stop.

Some photographers, however, prefer to adjust the film developing times to compensate for variations in scene contrast so that all of their negatives can be printed on one contrast grade of paper, generally because they believe this procedure produces the highest print quality and also simplifies the printing process. For photographers who want to make adjustments in exposure and development for low-contrast and high-contrast scenes but aren't concerned about printing all of their negatives on one contrast grade of paper, the rule of thumb that with high-contrast scenes the exposure should be increased and development decreased, and with low-contrast scenes the exposure should be decreased and development increased, may be adequate. Those who want to strive for greater precision can either refer to a contrast-control nomograph that provides development adjustments in terms of changes in contrast index, or conduct the necessary tests that are part of the Zone System to obtain corresponding information.

The contrast-control nomograph in Figure 5–5 takes into account variations in scene contrast, camera flare, and type of enlarger to provide a recommended contrast index for development and an exposure adjustment. The markers on the scale on the left indicate that when using a *condenser* enlarger the normal contrast index is .42 and when using a diffusion enlarger the normal contrast index is .56. The slanted line to the right represents the subject contrast, covering a range from 5 stops to 9 stops, where 7 stops is considered normal. The contrast index adjusted for variations in scene contrast is found on the center scale by placing a ruler so that one edge runs through the starting point on the first scale (.42 or .56) and the subject contrast (5, 6, 7, 8, or 9 stops) on the second scale. With a normal 7-stop subject the starting contrast index remains unchanged. The fourth scale provides adjustments for four different levels of camera flare; *moderate* would be used for typical scenes, *low* where dark tones dominate the scene, *high* where light tones dominate the scene, and *very high* where direct light sources or bright reflections of light sources are included in the picture.

A straight line through the adjusted contrast index (on the center scale) and the camera flare level (on the flare scale) extended to the scale on the right side indicates exposure adjustments on the right side of the line and the contrast index to which the film should be developed on the left side of the line. It should be noted that when using a condenser enlarger it is necessary to increase the exposure by 1/2 stop with a normal-contrast subject and moderate flare due to the lower contrast index recommended for condenser enlargers. In other words, published film speeds are based on developing the film to produce negatives for printing with a diffusion enlarger.

With the Zone System, subject contrast is specified in terms of the range of *Subject Values*, which are identified by Roman numer-

Figure 5 – 5 A Contrast-control nomograph that can be used to determine adjustments in exposure and development of film to compensate for variations in subject contrast and camera flare with condenser and diffusion enlargers.

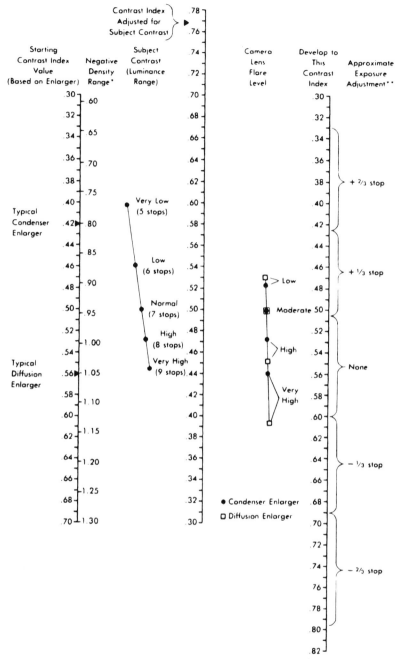

KODAK Films with Long Toe Characteristic Curves

Eastman Kodak Company

**Some film and developer combinations may require more or less exposure adjustment than these average values shown here especially when the adjusted contrast index is less than 45 or greater than 65. Some of the finest-grain developers cause a loss in film speed that must be considered in addition to the losses caused by developing to a lower contrast index.
*These are the typical negative density ranges that result when normal luminance range subjects (7 stops range) are exposed with moderate flare level lenses and developed to the contrast index shown in the left scale.

als, from 0 for an area that is so dark that no detail would be expected in a normal print to X for an area that is so bright that no detail would be expected, such as a light source included in the picture. Subject Value V corresponds to a midtone, such as an 18% reflectance gray

card, and a normal 7-stop scene would contain 8 Subject Values, from I to VIII. Eleven identical Roman numerals are used for a scale of *Exposure Zones* (commonly called Zones) where Subject Value V would normally be placed in Exposure Zone V, but could be placed in Zone VI if a lighter tone is desired in the print (or color transparency) or Zone IV if a darker tone is desired.

With respect to the degree of development of the negatives, development that would produce a negative of normal contrast for printing on normal-contrast paper with a normal-contrast scene would be identified as "N" development. Although the film manufacturer's recommended normal developing time should produce that result, it should be verified with a practical test. The longer developing time required to *expand* a 6-stop scene (Subject Values from I to VII) to produce a negative that will produce a normal print on normal-contrast paper is identified as N+1, which again would have to be determined with tests. To expand a 5-stop scene would require N+2 development. The term *compaction* is used to describe reducing negative contrast of contrasty scenes by developing for shorter times, with N – 1 for 8-stop scenes and N – 2 for 9-stop scenes. Since the density of darker subject tones is affected less by changes in developing time than are lighter tones, it is generally best to place the darkest subject area where detail is desired in the appropriate Exposure Zone. Additional information on the Zone System can be obtained from any of a number of books that have been published on the subject.

Filters

6

Although many photographs are made without using a filter on the camera lens, filters are indispensable for some photographs and can be considered to be a useful tool for improving many other photographs. Filters enable photographers to (1) lighten or darken subject colors selectively, (2) increase or decrease the contrast between different subject colors, (3) obtain more accurate monochromatic tone reproduction, (4) decrease or increase the appearance of aerial haze, (5) alter the color balance of color photographs, (6) increase the saturation of subject colors, (7) eliminate or reduce reflections, (8) make invisible detail visible, and (9) create various types of special effects.

Specific filters are recommended for some situations, such as when using certain combinations of color films and light sources, but in order to take full advantage of the benefits that filters offer it is necessary to have a basic understanding of how filters function. Filters can only remove part of the light (more accurately, radiation, which includes invisible radiation) that falls on their surfaces—they cannot add anything to the incident light and they cannot, for example, change red light to blue light. There are various ways of classifying filters, but with respect to the effect they have on incident radiation, they remove some of the radiation (1) selectively by wavelength, as with color filters, (2) nonselectively by wavelength, as with neutral-density filters, or (3) selectively by angle of polarization, as with polarizing filters. Some of these categories can be further subdivided.

Filters for Black-and-White Photography

Color filters are commonly identified by the color of the transmitted light when viewed with white incident light. Thus a "red" filter transmits the red component of white light and absorbs the green and blue components. Color filters differ with respect to (1) which parts of the visible spectrum are absorbed (such as green and blue for a red filter), (2) the width of the absorbed regions—and therefore also of the transmission bands (narrow-band, broad-band, sharp-cutting passband), and (3) the degree of absorption of the unwanted colors (identified by general terms such as light-yellow and dark-yellow for blue absorption, or by specific transmittance and density data).

Contrast filters are deep or saturated color filters that nearly completely absorb the unwanted colors of light and are commonly used in black-and-white photography to lighten or darken selected subject colors. Photographers need to be able to predict the effect that contrast filters will have on subject colors. One method is to look at the subject through the filter and note which colors are lightened and which are darkened. The accuracy of this process depends upon the film and the eye responding in a similar manner to the subject colors. Although panchromatic film does not respond to different colors in exactly the same way as the eye does, the responses are sufficiently close to make this a useful procedure. This is illustrated in Figure 6–1, in which the subject consists of a wood goblet, green background, and gray scale. For the center photograph, taken without a filter, the white marker was placed on the gray-scale patch that appeared to match the green background most closely in lightness, and that patch is also the closest

Figure 6 – 1 A white marker was placed on the gray-scale step that most closely matched the lightness of the green background before each photograph was made. (*Center*) No filter. (*Left*) A green filter. (*Right*) A red filter. The closest visual matches were also the closest photographic matches.

match in the photograph. The closest match when looking at the subject through a green filter was one patch lighter, which is also the closest match in the photograph on the left, exposed through the green filter. Conversely, the closest match looking through a red filter was one patch darker than without a filter, which is also the closest match in the photograph on the right, exposed through the red filter.

If this experiment is repeated with blue sky behind a gray scale, it will be found that the sky will be recorded lighter on a black-and-white photograph made without a filter than the patch selected when viewing the gray scale and blue sky without a filter, because the film has some sensitivity to the ultraviolet (UV) radiation that is mixed with the blue light whereas the eye does not. However, the patch selected when looking through a yellow or red filter, both of which absorb UV radiation, will be the same as the one that matches in the photograph.

Subject colors that we identify as red, or green, or blue, for example, are seldom as pure as the colors of contrast filters, as can be seen in the photographs of the goblet where the green filter lightened the green background by only 1 step on the gray scale and the red filter darkened the background by only 1 step. On the other hand, it can be seen that very little light is transmitted when red and blue contrast filters are superimposed. Somewhat more light is transmitted through superimposed red and green contrast filters and green and blue filters because these pairs of colors are adjacent to each other in the spectrum, but most of the incident white light is still absorbed.

Another method of predicting the effect that color filters will have in lightening or darkening subject colors in black-and-white photographs is by using a color triangle of the type shown in Figure 6–2. The *additive primary* colors (red, green, and blue) are located at the apexes of the triangle. Red, green, and blue are called additive primary colors because all other colors can be produced by mixing these three colors of light together in different combinations and proportions. Mixing red light and green light, for example, produces yellow light. Blue and green produce cyan, and blue and red produce magenta. These

Figure 6 – 2 The Maxwell triangle can be used to predict the effect contrast color filters will have in lightening and darkening subject colors on black-and-white photographs.

mixtures of pairs of primary colors of light are called additive *secondary* colors. (Cyan, magenta, and yellow dyes and pigments, however, are called *subtractive primary* colors because by absorbing or subtracting red, green, and blue light respectively in different combinations and proportions from white light they can produce colors of any hue, as is evident in photographic color prints and transparencies.) Desaturated colors and neutral colors (grays) are produced by mixing all three primary colors in different amounts and appropriate proportions with both the additive and the subtractive systems.

The color triangle is used to predict the effect a given color filter will have on subject colors by using the rule of thumb that a color filter will lighten its own color and the adjacent colors and darken the other three colors in terms of the photographic print. Thus a red filter will lighten red, magenta, and yellow subject colors and darken cyan, blue, and green colors.

Exposure Adjustment with Filters

Since filters absorb some of the light that would otherwise reach the film, it is necessary to compensate for this decrease in exposure by using either a larger lens aperture or a longer exposure time. The conventional method for specifying the required exposure increase is the *filter factor*. With a filter factor of 2, the adjustment can be made either by opening the diaphragm 1 stop, such as from $f/16$ to $f/11$, or by multiplying the selected shutter speed by 2, for example, 1/60 sec. \times 2 = 1/30 sec. Consecutive shutter-speed settings on modern shutters change the exposure by a factor of 2, the same as consecutive f-number settings. The required change in f-number stops or shutter-speed settings for a given filter factor can be determined by noting where the factor fits in the sequence of exposure increases 2-4-8-16-32-64-128, etc., where a filter factor of 16 would require opening the aperture 4 stops or increasing the exposure time by 4 shutter-speed numbers, or any combination of the two changes that adds up to 4. Intermediate settings can be used for filter factors that do not match any of the numbers in this sequence, such as 12, which falls midway between the 3rd and 4th numbers. Although most shutters do provide intermediate speeds in-between the shutter-speed numbers, it is safer to make fractional changes of less than a whole stop or shutter-speed setting by changing the aperture. A reference list of filter factors and equivalent stops (or shutter-speed settings) is provided in Table 6-1, where, for example, a filter factor of 20 requires an exposure increase of 4 1/3 stops. The list can be extended by noting that each increase of 1 stop doubles the filter factor, whether starting with a whole stop or a fractional stop.

Another method of compensating for the absorption of light by a filter is to divide the film speed by the filter factor. Thus with a film speed of ISO 200 and a filter factor of 4, a film-speed setting of 50 would be used on the exposure meter. It should be noted that film manufacturers sometimes provide adjusted film speeds for popular combinations of films and filters in addition to the no-filter ISO film speeds. A daylight reversal color film, for example, might have a film speed of 64 with daylight illumination and 16 with tungsten illumination and the recommended conversion filter.

Table 6 – 1 Exposure increases in stops and corresponding filter factors. Shutter-speed settings can be substituted for whole-stop changes, such as a change from 1/250 sec. to 1/60 sec. for a change of 2 stops.

Stops Change	Filter Factor	Stops Change	Filter Factor	Stops Change	Filter Factor
1/3	1.25	2 1/3	5	4 1/3	20
1/2	1.4	2 1/2	6	4 1/2	23
2/3	1.6	2 2/3	7	4 2/3	25
1	2	3	8	5	32
1-1/3	2.5	3 1/3	10	5 1/3	40
1-1/2	2.8	3 1/2	11	5 1/2	45
1-2/3	3.2	3 2/3	13	5 2/3	51
2	4	4	16	6	64

Correction Filters for Black-and-White Films

It has been noted that black-and-white films do not record all colors as tones of gray that correspond to the response of the human eye to the lightness attribute of the colors. With blue-sensitive films the differences are obvious since these films cause blue skies to appear white and red colors to appear black on the prints. With orthochromatic films, which are sensitive to blue and green light, the differences are less dramatic but still apparent. Even though the lightness discrepancies are much smaller with panchromatic films, they can be annoying with certain subjects. Blue skies, for example, tend to be recorded too dense on the negative and light on the print because of the film's sensitivity to the invisible ultraviolet radiation plus the film's inherent high sensitivity to blue light. A light yellow *correction* filter improves the tone reproduction by absorbing ultraviolet radiation and some of the blue light. Some black-and-white films and color films have an ultraviolet-absorbing coating on top of the emulsion to prevent additional exposure from the ultraviolet radiation in blue skies. With tungsten illumination, panchromatic films tend to record blue (due to the film's high sensitivity to blue) and red (due to the high red content in tungsten illumination) too light in terms of the print, so a light green filter, which absorbs some of each of these colors, serves as a correction filter. The red sensitivity of some panchromatic films has been increased during manufacture for the purpose of increasing the overall film speed. Use of these films without a filter, for portraiture, may result in unnaturally light skin tones.

Haze Filters

The light from aerial haze, like light from blue sky, contains a large amount of ultraviolet radiation, which causes the haze to appear more obvious in the photograph than it appeared to the eye at the time the film was exposed. A light yellow correction filter will reduce the discrepancy between the photographic and visual effects. Increasing pene-

tration of the haze to reveal more detail in distant objects can be achieved by using filters that absorb more of the shorter wavelengths of radiation—ultraviolet, blue, and even green—by using more saturated yellow filters and then a red contrast filter. Complete removal of the haze can generally be achieved by using a film and filter combination that records only infrared radiation. An increase in the appearance of haze, when this is desired for a pictorial effect, can be achieved by using a blue filter or a filter that transmits ultraviolet radiation but absorbs most of the light.

Filters for Color Photography

When color films are used with the type of illumination for which the films were designed and the exposure times are within the ranges recommended by the film manufacturer, it is generally not necessary to use a filter on the camera unless an effect other than normal color reproduction is desired. Most of the filters that are commonly used when exposing color films can be classified as being one of three types—*conversion* filters, *light-balancing* filters, and *color-compensating* filters.

Conversion filters are used when the color temperature of the light source being used to illuminate the subject is different than that for which a color film was designed. Examples of such mismatches are when tungsten-type color film is used with daylight illumination or when daylight-type color film is used with tungsten illumination. Since daylight has a higher color temperature and is bluer than tungsten light, it is necessary to lower the 5500-K color temperature of the daylight to 3200 K by absorbing some of the blue light with an orange filter (such as a Kodak 85B filter) when exposing tungsten-type film with daylight illumination. Conversely, when exposing daylight-type color film with 3200-K tungsten illumination it is necessary to raise the color temperature from 3200 K to 5500 K with a bluish filter (such as a Kodak 80A filter) that absorbs some of the red light. When it is necessary to use a single type of color film with these two types of illumination, it is generally better to use tungsten-type film because (1) the filter factor for the orange filter with tungsten-type color film and daylight illumination is smaller than the filter factor for the bluish filter with daylight-type color film and tungsten illumination, and (2) the illumination level is generally lower with tungsten light sources than with daylight and, therefore, the loss of effective film speed will be less acceptable with the longer exposure time required with the tungsten illumination. The exposure adjustments required when filters are used with daylight- and tungsten-type films are provided on the data sheets that accompany the film, usually in the form of an adjusted film speed rather than as a filter factor. Other conversion filters are available for changing the color temperature of the illumination with certain other color film and light source combinations.

Light-Balancing Filters

Light-balancing filters also alter the color temperature of light but by smaller amounts than conversion filters. Kodak provides bluish (82 series) and yellowish (81 series) light-balancing filters to respectively raise and lower the color temperature. A bluish filter could be used, for example, to raise the color temperature of household tung-

sten illumination to 3200 K for use with tungsten-type color film, and a yellowish filter could be used to lower the color temperature of the illumination from 3400-K photoflood light sources to 3200 K. Light-balancing filters can also be used with daylight illumination to compensate for variations in color temperature under different conditions, such as the colder-quality illumination on an overcast day or with a subject in the shade on a clear day, and the warmer quality of sunlight early in the morning and late in the afternoon. Sometimes it is appropriate to reverse the direction of change in color temperature to create or enhance a mood effect, such as that of a reddish sunset.

Color-Compensating Filters

Color-compensating (CC) filters are designed to absorb each of the three additive primary colors of light (red, green, and blue) and the three subtractive primary colors of light (cyan, magenta, and yellow). A red CC filter, for example, will absorb the other two additive primary colors, green and blue (which combined form cyan, the complementary color to red). A cyan CC filter will absorb only its complementary color, red. CC filters are used on cameras and enlargers to control the color balance of film and print color images. CC filters are produced in a range of saturations in each of the six hues, with the saturations calibrated in terms of peak density. Thus a CC30M filter is a magenta color-compensating filter having a density of .30 (the decimal is omitted in the designation) when measured by the wavelength of green light that is most strongly absorbed. Filters are available in densities ranging from .025 to .50, but larger densities can be obtained by combining two or more filters having the same hue.

Since the density of CC filters is based on the wavelength of maximum absorption rather than the proportion of white light that is absorbed, exposure corrections cannot be calculated from the density, as can be done with neutral-density filters, but instead are obtained from the manufacturer's data sheet or by experimentation. A manufacturer's data sheet suggests, for example, 2/3 of a stop exposure increase for CC30 filters in all hues except yellow, for which it suggests 1/3 of a stop. When combining two or more filters of the same hue, the densities are additive—for example, CC30R plus CC20R equals CC50R, and CC30M plus CC20M equals CC50M. Combining any two of the three *subtractive* primary hues, cyan, magenta, and yellow, produces the same effect as a single filter of the resulting additive primary hue having the same density. Thus, a CC20M filter plus a CC20Y filter is equivalent to a CC20R filter. Combining two filters having complementary colors and equal densities produces a neutral density, which would not be useful in controlling color balance. A CC20Y filter plus a CC20B filter is equivalent to a neutral-density filter having a density of 0.20, for example.

Filters for Black-and-White and Color Photography

The filters discussed above are used primarily with black-and-white films or color films, rather than both, although red, green, and blue contrast filters that are used with black-and-white films to ob-

Figure 6 – 3 (*Top*) Orientation of particles in polarizing filters causes them to function as light slits. (*Bottom*) Unpolarized light vibrates in all directions radially from the line of travel.

tain maximum darkening or lightening of certain subject colors have also been used on cameras to make direct separation negatives, and on enlargers to make separation negatives from color transparencies for use with dye transfer and other color printing processes. Most filters that are used for both black-and-white and color photography are neutral in color. Such filters include polarizing filters and neutral-density filters.

Polarizing Filters

Polarizing filters appear gray, the same as neutral-density filters, when viewed with conventional white light, and when used to photograph a scene containing only unpolarized light the effect is the same—that is, the exposure is reduced but there is no change in the tonal rendering of the subject colors. The polarizing particles in the filter are all oriented in the same direction so that they function as light slits. Light vibrating in the same direction as the slits is transmitted freely, while light vibrating at right angles is completely absorbed (Figure 6–3). Since unpolarized light vibrates in all directions radially from the line of travel, some of the light is absorbed, but the light that is transmitted becomes polarized. This can be demonstrated by placing a second polarizing filter on top of the first filter. When the top filter is rotated so that the slits in the two filters are at right angles to each other, essentially no light is transmitted and the filters appear opaque.

Rotating a single polarizing filter has no effect on the image when the light reaching the filter is unpolarized. Light from glare reflections on most nonmetallic reflections, however, is almost completely polarized at certain angles to the surface. The angle of maximum polarization varies slightly with different nonmetallic materials, but is close to 35° for most materials. These polarized-light reflections can be almost completely eliminated by rotating the filter until the slits are at right angles to the plane of vibration of the reflected polarized light. This effect can be seen by rotating the filter while looking through it or while examining the ground-glass image with the filter in front of the camera lens.

The effectiveness of a polarizing filter in eliminating a reflection from a glass surface when the reflection is at the optimum angle of approximately 35° to the surface is shown in Figure 6–4. As can be seen in the diagram, a mannequin is located behind a glass plate that is at an angle of approximately 35° to the lens axis. A textured surface to the left of the glass plate produces a reflection on the glass surface that nearly obscures the image of the mannequin when the polarizing filter is rotated so that the light slits are parallel to the direction of vibration of the polarized reflected light (photograph A). The reflected light is partially absorbed by the filter (photograph B) when it is rotated to an intermediate position and nearly completely absorbed when it is rotated so that the light slits are perpendicular to the direction of vibration (photograph C).

A polarizing filter on the camera lens has no effect on reflections on metallic surfaces because metallic surfaces do not polarize light, regardless of the angle of reflection. Placing a polarizing filter over the light source, however, produces polarized light that remains polarized when reflected from metallic surfaces (at any angle), and this

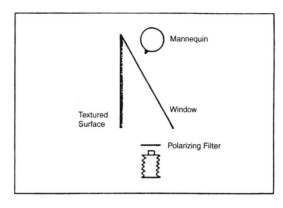

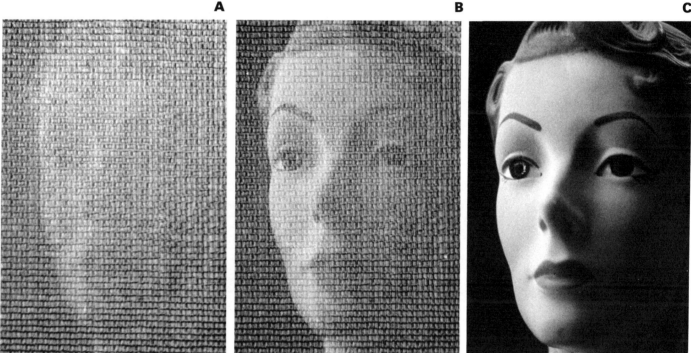

A **B** **C**

Figure 6 – 4 (A) A reflection of a textured surface on a window obscures the object behind the window. Rotating a polarizing filter in front of the camera lens provides control over the reflection, which is reduced in B and effectively eliminated in C.

reflection can be removed by rotating a polarizing filter on the camera lens so that the slits are perpendicular to the slits in the filter on the light source. The effect of a polarizing filter on the camera with respect to eliminating reflections on metal and plastic can be seen in the 3 photographs in Figure 6–5. In the top photograph, normal (unpolarized) light was used to produce reflections on both the metal and plastic parts of the objects. In the 2nd photograph, a polarizing filter on the camera lens removed the reflections from the plastic handles but not from the metallic blades. In the 3rd photograph, a large polarizing filter was placed in front of the light source with the light slits rotated perpendicular to those of the filter on the camera. Even though the reflections appeared the same to the eye from the camera position as in the 1st photograph, the polarizing filter on the camera was able to remove the reflections from both the plastic and the metallic parts.

A polarizing filter can increase color saturation and image contrast with some subjects where there do not appear to be any glare reflections, for example, grass, plant leaves, and flowers. Even though the surfaces of the leaves and flower petals are at many different

Figure 6 – 5 (A and B) A single polarizing filter on the camera lens can eliminate the reflections on the black plastic parts of these objects because the camera angle to the reflecting surfaces is approximately 35°, but the filter has no effect on the reflections on the metal parts. (C) When a polarizing screen is placed in front of the light source producing the reflections so that the reflections on the metal parts also consist of polarized light, the filter on the camera can remove the reflections from the metal as well as the plastic parts.

A

B

C

angles with respect to the camera axis, enough of them are typically close enough to the optimum angle of 35° so that reflections on their surfaces will be significantly reduced, if not eliminated. Polarizing filters are also able to increase penetration of aerial haze to some extent, apparently by reducing reflections on the multitude of small particles in the air that cause the haze.

Whereas yellow and red filters can be used with black-and-white films to darken blue sky, polarizing filters must be depended upon to achieve that effect with color films. The light from blue skies contains polarized light in addition to ultraviolet radiation, but the proportion of polarized light depends upon the section of the sky selected. The darkening effect is greatest when the sun is at a right angle to the camera axis, the position that produces side lighting on the subject when the sun is low in the sky. The darkening effect is weakest when the camera is aimed either directly toward the sun or directly away from it, positions that produce back lighting or front lighting on the subject. When the sun is high in the sky, the darkening effect will be greatest near the horizon. The effect can be seen by rotating the filter while looking through it.

The filter manufacturer's data sheet should be checked to determine the exposure increase required for the polarizing filter being used, but a filter factor of 2.5 is typical, which corresponds to opening the aperture 1 1/3 stops. The required exposure increase can also be determined by taking reflected-light exposure meter readings of any surface of uniform tone, first without the filter and then through the filter, and noting the difference in stops for a given exposure time or by calculating the ratio of the exposure times for a given *f*-number. An even simpler method is to take a reflected-light reading through the polarizing filter of the scene being photographed.

Neutral-Density Filters

Since neutral-density (ND) filters absorb all colors equally, they do not alter the tone reproduction of subject colors, but they provide the photographer with a third control over film exposure (in addition to shutter speed and relative aperture). Neutral-density filters are especially useful when it is necessary to use a large aperture (to obtain a shallow depth of field), a slow shutter speed (for intentional blurring of moving objects), or high levels of illumination (to prevent overexposure). Varying the shutter speed with electronic flash illumination is not a viable exposure control so when the *f*-number must be selected for depth-of-field considerations and other exposure controls (such as adjustable power on the flash unit) are not available, the use of a neutral-density filter may be appropriate.

Another useful application of neutral-density filters is to compensate for the difference in speed of two films that are to be exposed to the same subject. For example, Polaroid instant print films are often used to check the lighting, composition, depth of field, and exposure before exposing color film. If the speed of the instant print film is different than that of the color film, there are advantages in using a neutral-density filter with the faster film to compensate for the difference in speed rather than changing the shutter or aperture setting. Assuming that the speed of the instant print film is two times that of

Table 6 – 2 Exposure increases for neutral-density filters in stops and filter factors.

Neutral Density	Stops Change	Filter Factor
0.1	1/3	1.25
0.2	2/3	1.6
0.3	1	2
0.4	1 1/3	2.5
0.5	1 2/3	3.2
0.6	2	4
0.7	2 1/3	5
0.8	2 2/3	7
0.9	3	8
1.0	3 1/3	10
2.0	6 2/3	100
3.0	10	1000

the color film, a 0.3 neutral-density filter would be used when exposing the instant print film and removed when exposing the color film.

Some neutral-density filters are calibrated in the equivalent number of stops the diaphragm would have to be stopped down to produce the same change in image illuminance or exposure (or the number of stops the diaphragm would have to be opened up to compensate for the light absorbed by the filter) but the conventional calibration is in terms of density, where each 0.1 of density corresponds to 1/3 stop. Densities of 0.3, 0.6, and 0.9 correspond to 1, 2, and 3 stops respectively. Two or more filters can be superimposed, in which case the densities or the change in stops would be added. To obtain an exposure decrease of 1 1/3 stops, for example, ND 0.3 (1 stop) and 0.1 (1/3 stop) filters would be used. If filter factors are used to determine the new exposure, however, it is necessary to *multiply* the two factors. The combined filter factor for ND 0.3 and ND 0.6 filters, which have filter factors of 2 and 4 respectively, would be 2 × 4, or 8, which is equivalent to the 3-stop change resulting from adding 1 stop and 2 stops for the two filters. Corresponding values for neutral density, filter factors, and stops are listed in Table 6-2.

Infrared Filters

Since panchromatic films are not sensitive to infrared radiation, which has longer wavelengths than red light, infrared photography requires the use of a film that has been sensitized to infrared radiation by the use of appropriate emulsion dyes. Infrared films are also sensitive to ultraviolet radiation and all wavelengths of light. Both black-and-white and color infrared films are available, but different filters are used with these two types of infrared films. All infrared filters for black-and-white photography have high transmittance of infrared radiation but they vary in the width of the band of wavelengths transmitted. A visually opaque infrared filter transmits no light and therefore allows only infrared radiation to be recorded. Other infrared filters transmit various amounts of red light, which has the effect of recording reds and colors containing red (such as yellow and magenta) denser on negatives and lighter on prints.

Exterior black-and-white infrared photographs are characterized by blue skies appearing dark or black (because blue sky contains essentially no infrared radiation) and green grass and foliage appearing abnormally light (because chlorophyll is highly reflective of infrared radiation). Infrared portraits tend to have an ethereal appearance due to the unnaturally light rendering of skin and lips combined with a softness that results from the penetrating quality of infrared radiation that may even reveal the darker veins beneath the surface. Infrared film and filters are commonly used not only for pictorial photography but also to reveal detail that is otherwise not visible, which is especially useful in the fields of forensic photography and biomedical photography.

Unfortunately, photographic lenses do not bring infrared radiation to the same focus as the focus for light, so that an adjustment is required after focusing visually with visually opaque infrared filters. Many small-format cameras have an infrared focus mark whereby the distance focused on is transferred from the normal distance indicator

to the infrared focus mark. With view cameras, the image distance after focusing visually should be *increased* by 1/4 of 1%, or 1/400th of the image distance. If, for example, the image distance is 400 mm (15.7 in.), the distance should be increased 1 mm. When using a red rather than an opaque infrared filter, the visual focus can be used but it is advisable to stop the diaphragm down farther to increase the depth of field.

Two different film speeds are published for black-and-white infrared films because of the higher proportion of infrared radiation contained in tungsten illumination—for example, 50 for daylight and 125 for tungsten illumination. The published film speeds should be treated as tentative values, however, due to the differences in spectral response of infrared films and exposure meter sensors, and variations in the proportion of infrared radiation in white light under varying conditions. Bracketing of the calculated exposure is advisable.

Infrared color photographs made with Kodak Ektachrome Infrared Film are positive color images consisting of records of red light, green light, and infrared radiation on three separate emulsion layers—rather than the traditional red, green, and blue records formed on conventional reversal color films. This infrared film is classified as a *false-color* photographic system because the dyes formed in the three emulsion layers are not complementary in color to the sensitivity colors. As a result of the dye colors used, red in the scene is reproduced as green, green is reproduced as blue, infrared is reproduced as red, and blue is reproduced as black since a yellow filter on the camera prevents blue light from being recorded on any of the three emulsion layers (but the green in "blue" sky is reproduced as blue). This false-color system was designed to provide information about subjects that could not be obtained visually or with conventional photography, such as evidence of camouflage and the detection of diseased plants, but it is also used to produce unusual, expressive color images.

Ultraviolet Filters

There are two basic types of ultraviolet filters, those that absorb ultraviolet radiation and freely transmit any of various bandwidths of light (identified as *barrier* or *UV-absorbing* filters) and visually opaque filters that transmit ultraviolet radiation and absorb all colors of light (identified as *exciter* or *UV-transmitting* filters).

All silver halide photographic emulsions are inherently sensitive to ultraviolet radiation and blue light, whereas sensitizing dyes must be added to the emulsions to broaden the sensitivity range to include green light, red light, and infrared radiation. Even when no camera filter is used, only the longer wavelengths of ultraviolet radiation, those adjacent to blue light in the spectrum, escape being absorbed by glass in the camera lens and gelatin in the film. Also, some black-and-white films (such as Kodak T-MAX films) and various color films have UV-absorbing coatings on the emulsions, primarily for the purpose of limiting the adverse effect of ultraviolet radiation in blue sky that results in blue sky being recorded lighter in photographs than it appears to the eye.

Sufficient ultraviolet radiation does reach the silver-halide grains in emulsions, however, so that photographs can be made solely with this radiation—when using light sources that emit a sufficient

amount of it, such as electronic flash units. (Some flash units have UV-absorbing filters on the flash tubes or windows to absorb ultraviolet radiation, which can cause some subject colors to be recorded as different colors than they appear to the eye.)

The recording of images with ultraviolet radiation is referred to as *reflected ultraviolet photography* or *direct ultraviolet photography*. With some subjects such images can reveal detail that is not visible to the eye or on photographs made with light, with or without filters. In the field of biomedical photography, for example, reflected ultraviolet photographs can reveal abnormalities of skin pigmentation because the pigment strongly absorbs ultraviolet radiation. Reflected ultraviolet photography also finds applications in other fields, such as forensics and industrial and scientific research. Since all light must be prevented from reaching the film, it is necessary to use a visually opaque UV-transmitting filter on the camera lens and it may be necessary to take special precautions to seal the area around the filter to prevent light from being reflected from the back surface.

It was previously noted that barrier or UV-absorbing filters are useful in reducing or eliminating ultraviolet radiation when photographing scenes containing blue sky or aerial haze on black-and-white panchromatic films and infrared films. Another area in which these filters are used is that of *fluorescence* photography. When certain materials are exposed to ultraviolet radiation they convert the invisible radiation to longer-wavelength visible radiation. In order to see and to record this fluorescence on film it is necessary to work in a darkened room and to use a visually opaque UV-transmitting filter on the light source. To prevent the fluorescence from being obscured by the ultraviolet radiation that is reflected by other parts of the subject and that would be recorded on the film (even though not visible to the eye) it is necessary to use a UV-absorbing filter on the camera lens. This procedure can also reveal invisible information with certain subjects and is used in the medical, forensic, and other fields. The fluorescence can be recorded on either black-and-white or color film, but color film is commonly used because the color of the fluorescence varies with different materials.

View-Camera Refinements

7

Ever since the first Daguerreotype camera was built in 1839 untold numbers of different types of cameras and different models of the different types of cameras have been designed and built. Even though the earliest cameras were capable of making photographs of excellent quality, many of which have been preserved and are still treasured, photographers ever since have been requesting improvements in their cameras, requests that camera manufacturers have responded to. A comparison of the most sophisticated of contemporary cameras with the simple early cameras would show how dramatic the changes have been. While we should be impressed with the features found on modern cameras, we should not overlook the incremental improvements made along the way and we should also appreciate the ingenuity of many early photographers and camera manufacturers. With respect to large-format cameras it can be noted, for example, that an angled mirror that allowed the photographer to view a right-side-up image appeared on a Daguerreotype camera in 1839. A monorail camera, which is generally considered to be a relatively modern type of camera, was made at least as early as 1870, and a camera with a revolving back, a useful feature found on fewer than 1/3 of the contemporary 4 × 5-in. view cameras, was made in 1886.

Camera Tripods and Stands

Since view cameras cannot be hand held (although technical cameras, a close relative, can), it is appropriate to consider some of the improvements made in tripods and stands over the years. The desirable characteristics in tripods of ruggedness and high maximum height for use with a camera, and compactness and light weight for portability, are somewhat incompatible, but considerable progress has been made in incorporating these characteristics through the use of lightweight metals, multiple telescoping legs, and a geared centerpost. A centerpost not only provides a convenient way to increase camera height with a single adjustment but (on models that allow the centerpost to be inverted) also to support the camera close to ground level. Other refinements include pan-tilt heads that can be tilted in two different directions, level bubbles on the tripod head, reversible rubber (for hard floors) and spiked (for outdoor use) leg tips, quick-release locks on the legs, and a quick-attachment and release device to hold the camera. Tripods are made in a variety of sizes and weights to accommodate everyone, from someone who wants to carry a lightweight tripod and view camera in a backpack to the photographer who is more concerned with stability than portability. Wheeled-tripod dollies are available to make it more convenient to move a tripod and camera about in a studio or on any hard surface.

Professional photographers who use view cameras in studios appreciate the advantages offered by monopost camera stands that allow the camera to be moved quickly from near floor level to considerable heights with little effort by means of a counterweight mechanism. The stands are mounted on wheels for ease of movement, with locks that provide stability, and typically have a tray to hold accessories.

Figure 7 – 1 A flatbed view camera in the open and closed positions.

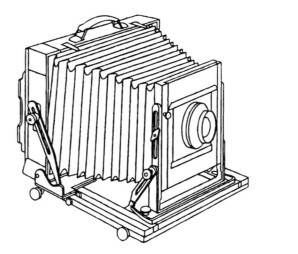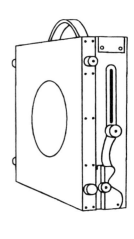

View-Camera Beds

The two basic types of view-camera beds are flatbed and monorail. Flatbed cameras evolved from the interlocking double-box Daguerreotype cameras in an effort to make cameras more compact for storage and travel. Addition of a flexible bellows allowed the lens standard to be retracted into the shallow box body, and the front of the hinged flatbed folded up to close the opening and provide a protective door on the box (Figure 7–1). The addition of a rising-falling front, tilt and wing adjustments, and telescoping tracks to increase the focusing range has enabled flatbed cameras to survive in the face of increasing competition from monorail view cameras. At the present time somewhat fewer than half of the different models of 4 × 5-in. view cameras being marketed are of the flatbed type—but the difference in the total numbers of the two types of cameras being sold is more dramatic.

Monorails

Whereas the beds and bodies of flatbed cameras are typically made of wood, monorails are universally made of metal. A variety of monorail shapes have been used on different models of cameras, including solid cylinder, hollow cylinder, flat, v-shaped, and square (Figure 7–2). The monorails on older-model monorail view cameras were typically an integral part of the camera and were fixed in length. A long monorail made it possible to use longer focal-length lenses and to focus on shorter object distances, but when using short focal-length wide-angle lenses it was necessary to move the lens close to the front of the monorail to prevent the monorail from appearing in the picture, which then caused the back end of the monorail to protrude well behind the back of the camera making it difficult to get close enough to the ground glass to focus the image. Two different models were made of one popular view camera, a wide-angle model with a short monorail and a standard model with a long monorail.

Various innovations have been introduced to avoid the limitations of short and long monorails, including (1) making interchangeable monorails in a variety of different lengths, (2) making a monorail so that sections can be added and removed as the situation

Figure 7 – 2 A sample of different types of monorail beds that have been used on view cameras. Focusing tracks are indicated by arrows.

requires, and (3) making a monorail with telescoping sections, somewhat similar to telescoping legs on a tripod. A side view of a two-section telescoping monorail is shown in Figure 7–3 with a cross-section view of a multiple-section telescoping monorail that produces a more compact unit in the fully collapsed position.

Tripod Blocks

The tripod block is the device that attaches the monorail to the tripod. On some older monorail cameras the clamp on the monorail interfered with movement of the front and back runners, for example preventing them from being placed close enough together to focus the image with short focal-length wide-angle lenses or allowing both runners to be positioned either in front of or behind the clamp. Various methods have been devised to avoid these problems, including (1) hinged clamps that can be removed and reattached at any position on the monorail (Figure 7–4), and (2) designs that eliminate interference between the tripod block and the runners.

Focusing Controls

Since focusing normally consists of changing the distance between the lens and the ground glass, focusing can be accomplished by changing the position of either the lens or the ground glass. Most modern view cameras provide focusing mechanisms on both the front runner and the back runner but some older view cameras and most other types of cameras provide only one focusing adjustment. It is not uncommon to encounter situations where it is more convenient or even necessary to be able to focus with both front and back adjustments, as when movement of one runner is stopped by encountering the tripod block or the end of the monorail. A third focusing adjustment has been provided on the tripod block on some view cameras. Although this adjustment moves the entire monorail and therefore does not change the distance between the lens and the ground glass, it is a useful feature when making closeup photographs where fine focusing by changing the camera-to-subject distance is quicker and more accurate than using the front and/or back adjustment (Figure 7–5). (If the image is too small when this procedure is used, the lens-to-ground-glass distance is increased with either the front or the back focusing adjustment and the image is then refocused by moving the monorail and, conversely, decreasing the lens-to-ground-glass distance when the initial image is too large.) An accessory focusing device that can be attached between the tripod and the camera tripod block is available for use with cameras that do not have this feature.

Figure 7 – 3 (*Right*) A two-part telescoping monorail. (*Left*) A cross-section view of a multiple-part telescoping monorail that provides extra compactness when collapsed.

Figure 7 – 4 Hinged clamp permits the tripod block to be moved from between the front and back runners to any location on the monorail.

Figure 7 – 5 Variations in focusing controls that have been used on different view cameras.

Locking mechanisms on the focusing adjustments to prevent defocusing the image when inserting a film holder are normally provided as standard equipment on view cameras, but improvements have been made in their design. On some earlier cameras the locking knob and the focusing knob were close together on the same shaft in such a way that turning the locking knob could accidentally change the focus. Improvements include separating the locking and focusing controls and, more recently, providing self-locking focusing controls.

When setting up a view camera and when substituting a lens having a different focal length it is convenient to be able to move the runners rapidly to the approximate desired positions before focusing carefully. Improvements in this operation have resulted from the use of coarse and fine focusing controls with different gear ratios and quick-release mechanisms that disengage the focusing mechanism so that the runner can be moved freely.

Linear scales on monorails are another refinement related to focusing mechanisms that are provided on some view cameras. These scales can be used for such purposes as measuring the lens-to-ground-glass distance to determine the exposure factor for closeup photography and placing the runners in appropriate positions for different focal-length lenses.

Depth-of-Field Scales

For many years 35-mm and roll-film cameras have had depth-of-field scales on the lens barrel or the camera body, a feature that is now being adopted by view-camera manufacturers. A typical view-camera scale consists of a circular band containing a scale of *f*-numbers located on the back focusing knob (Figure 7–6). The camera is first focused on the most distant point for which sharpness is desired, and the scale is rotated to the zero setting. The camera is then focused on the closest point for which sharpness is desired, and a mark indicates the *f*-number required to obtain the desired depth of field. To obtain the optimum focus, the focus knob is turned back until a posi-

Figure 7 – 6 (*Left*) A depth-of-field focusing scale on the back focusing knob of a Sinar view camera. (*Right*) One of 4 different scales that are substituted when film formats are changed. — *Sinar Bron*

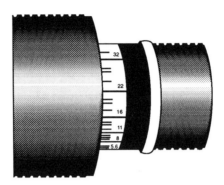
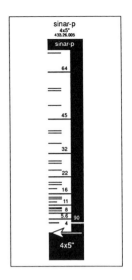

tion 2 stops larger than the specified *f*-number lines up with the indicator mark, which positions the back midway between the near and far focus positions. With view cameras lacking this feature, the optimum position can be determined by marking the near and far positions of the back runner on the camera bed and then setting it midway between the marks, but another method must then be used to determine the *f*-number required to obtain the desired depth of field.

Tilt-and-Swing Adjustments

All modern view cameras have tilt and swing adjustments on the front and back standards, an improvement over some earlier view cameras that omitted some of these adjustments. Earlier view cameras also had mechanical stops on the tilt and swing adjustments that limited the maximum deviation from the normal positions to very modest angles. Most modern view cameras continue the practice of limiting the tilt and swing angles but the variations of maximum angles range from 10° to 60° deviation from the normal position on different cameras, and a number of cameras now have no mechanical stops on the adjustment to provide "unlimited" tilts and swings. In practice, of course, the "unlimited" adjustments are eventually limited by binding of the bellows. Typically, there are also optical and aesthetic reasons for not tilting or swinging the lens or film plane to extreme angles, but most photographers prefer being able to use their own discretion rather than having limits imposed upon them by the camera. One of the major reasons for physically limiting the tilt angle of the back is to prevent the back standard from interfering with insertion and removal of the film holder. Various methods have been used to reduce or eliminate this problem, including (1) increasing the distance between the tilt pivot point and the vertical support, which, unfortunately, also makes it more difficult to place the ground glass close to the lens with short focal-length wide-angle lenses, (2) eliminating the back support on one side by using L-shaped standards, and (3) eliminating the back supports on both sides by using a rocker-panel support at the bottom of the back (Figure 7–7).

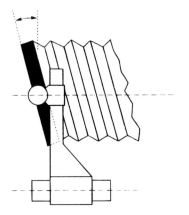 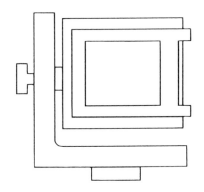 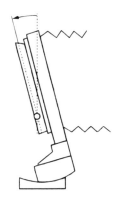

Figure 7 – 7 Three different systems for supporting and tilting the camera back. (*Left*) With supports on both sides, interference can be encountered when inserting a film holder. (*Center*) L-shaped support leaves the right side of the back unobstructed and also provides center tilt. (*Right*) Rocker motion at the base of the rear standard of a Sinar view camera eliminates the need for side supports and also tilts the back around a horizontal line on the ground glass.

Various other improvements have been made in tilt and swing mechanisms over the years to increase the convenience and accuracy of use. Some newer view cameras have self-locking geared adjustments on the tilts and swings, replacing the older procedure of unlocking the adjustment, changing the angle of the front or back by hand, and locking the adjustment, which was especially awkward when it was necessary to simultaneously keep the image in focus.

It is important to have some way of knowing when the camera back is perpendicular to the ground to prevent convergence of vertical lines in buildings and other objects. The indicator on older view cameras was an inverted metal arrow that hung like a pendulum on one side of the camera back. When the arrow pointed to an indicator dot, the back was perpendicular to the ground. Most, but not all, contemporary view cameras have a spirit level on the back to serve this purpose, and some also have levels on the front and the bed.

Most photographers make certain that all view-camera adjustments have been returned to their zero positions either after using the camera or before setting it up for the next use. This operation is simplified on many newer view cameras with click indicators that can be felt as an adjustment is being made without having to look at a visual indicator, but many also have calibrated angle scales for the tilt and swing adjustments and linear scales for the horizontal and vertical shift adjustments with the zero positions clearly marked.

Tilt Pivot Positions

The pivot position for tilting the front and back on early view cameras was typically low and close to the bed, now referred to as a base tilt. Approximately half of the 4 × 5-in. view cameras now being marketed have base tilts, although many of them also have on-axis tilts. Most view cameras have the same tilt system on the front and the back but there are exceptions where, for example, on-axis tilt is used for the lens and base tilt is used for the ground glass. On-axis tilts are generally considered to be more desirable than base tilts because they minimize the amount of refocusing and recomposing required after using a tilt adjustment, but there are advantages to having dual base and on-axis tilts. Two other tilt systems have been introduced in recent years, *asymmetrical* and *variable axis* tilts (Figure 7–8).

A — Axis B — Base

C — Axis + Base D — Asymmetrical E — Variable Axis

Figure 7 – 8 Five variations on the location of the tilt axis.

The asymmetrical system is used to tilt or swing the ground glass so as to obtain a sharp image of a subject plane that is at an angle to the camera as specified by the Scheimpflug rule, where the extended planes of the subject, lens, and film must meet at a common line. With Sinar view cameras having rocker tilts, the camera back tilts around a horizontal line marked on the lower part of the ground glass (see Figure 7–7). After the image of an angled subject plane is brought into focus on that horizontal line, the tilt angle of the back is adjusted until the image is also brought into focus on another horizontal line near the top of the ground glass. Since tilting the back does not affect the focus along the horizontal line of rotation, a sharp image is obtained for the entire angled subject plane. If the photographer prefers to use the front tilt rather than the back tilt to alter the angle of the plane of sharp focus, the angle of rotation of the back is noted on a scale and the front is tilted the same number of degrees, but in the opposite direction, before returning the back to its original position.

Vertical lines on the left and right sides of the ground glass are used in a similar manner with the back *swing* adjustment to change the angle of the plane of sharp focus to produce a sharp image of an angled vertical subject plane. View cameras that have a *variable-axis* tilt system have vertical and horizontal scales marked on the ground glass. The photographer has the freedom to focus the image on any of the lines, on or off axis, after which the corresponding tilt or swing axis is used.

If the swing pivot location is lower than the tilt pivot location on a view-camera back, as occurs with on-axis tilt cameras, an annoying problem identified as *yaw* may occur when the entire camera is tilted upward or downward. Assume, for example, that the camera has been tilted downward to photograph a box-shaped object, and the back and front have been tilted perpendicular to the ground to keep the vertical subject lines parallel and to improve top-to-bottom sharpness. If the back is now swung, the fact that the swing platform is not level causes the ground glass to rotate clockwise or counterclockwise, which in turn causes the object to appear to be tilted sideways in the photograph (Figure 7–9).

Figure 7 – 9 (*Top*) Allowing the swing plane to deviate from a horizontal position produces yaw, a rotation of the ground glass, when the camera bed is tilted and the back is swung. (*Bottom*) Yaw can be prevented by locating the tilt pivot below the swing pivot. Some cameras have dual tilt pivots to provide the advantages of on-axis tilts and yaw prevention.

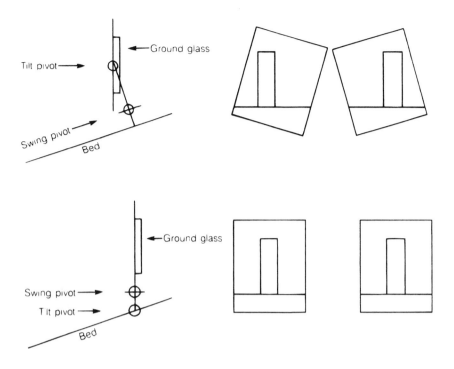

There are three different ways to prevent or eliminate yaw: (1) If the camera in the example above has a revolving back, the back can be rotated so that the edges of the ground glass are parallel to the vertical subject lines. (It should be noted, however, that the bellows on some revolving-back cameras shades the corners of the image when the back is rotated between the vertical and horizontal positions. Cameras that do not have this problem are identified as having 360° or fully revolving backs.) (2) Rather than tilting the camera downward, the camera bed can remain level if the lens is lowered and the back is raised. This assumes that the camera has vertical shift (rising-falling) adjustments on the front and the back and that they have sufficient freedom of movement. (3) The camera manufacturer can provide dual base and on-axis tilt adjustments on the camera back, or with cameras having a single-tilt adjustment, locate the swing pivot above the tilt pivot—as on Sinar asymmetrical-tilt rocker-base cameras.

Ground-Glass Viewing

When a view camera is focused on an evenly illuminated white wall, a circular area of the ground glass that is in line with the camera lens and the eye appears brighter than the surrounding area. Moving the head from side to side causes the brighter area to move in the same direction. Coarse-grain ground glass produces a less obvious image hot spot but decreases the overall image brightness and increases the difficulty of focusing on fine detail. Placing a Fresnel lens (a sheet of plastic that is flat on one side and has concentric ridges on the other) in contact with the ground glass dramatically reduces the variation in brightness of the image (Figure 7–10).

Figure 7 – 10 (A) The basic design of a Fresnel lens, a thin transparent panel that changes the direction of light rays to achieve an effect similar to that produced by a thicker planoconvex lens. (B) A ground glass without a Fresnel lens produces uneven image brightness. (C) Brightness variation is reduced with the addition of a Fresnel lens.

A

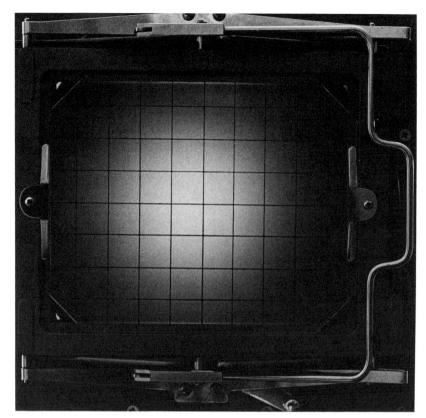

B

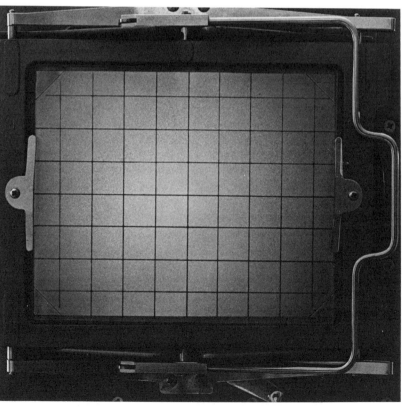

C

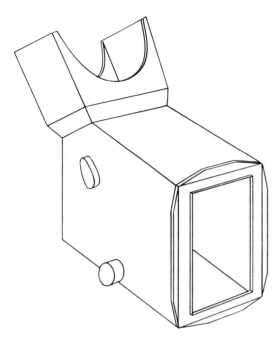

Figure 7 – 11 Binocular reflex magnifier.

Figure 7 – 12 Open corners on a ground glass enable the photographer to check on vignetting by the lens barrel or lens shade.

It is necessary to prevent extraneous light from falling on the ground glass from behind the camera if the ground-glass image is to be seen clearly. A dark cloth, or focusing cloth, draped over the back of the camera and the photographer's head has been the traditional solution, but one that frustrated many of the early photographers, especially when a gust of wind removed the dark cloth. Clips on the camera to hold the front edge of the cloth, a detachable wire frame to support the cloth behind the camera, and small weights inserted in the edges of the dark cloth to hold it in place are innovations that have been introduced to make the use of a dark cloth less troublesome. Focusing hoods offer an alternative to focusing cloths. A variety of different types of focusing hoods have been introduced, including (1) folding hoods that occupy little space in the folded position, (2) rigid hoods that can be detached or swung to one side when not needed, (3) hoods that incorporate a focusing magnifier, (4) hoods that incorporate a binocular focusing magnifier that accommodates both eyes, and (5) binocular reflex magnifier hoods that present a right-side-up (but laterally reversed) image that can be viewed with both eyes through a low-power magnifier that covers the entire ground glass (Figure 7–11).

Some view cameras have open corners on the ground glass to allow the photographer to look through the openings with the shutter open to make sure that light is not being cut off to the corners of the ground glass due to vignetting by a lens shade or vignetting by the lens barrel when tilt, swing, and shift adjustments are used (Figure 7–12).

Various types of markings are used on the ground glass to assist the photographer. These include (1) a cross in the center of the ground glass to identify the center of the image, (2) grid lines that can be used to check the alignment and parallelism of vertical and horizontal subject lines, (3) film-format lines that can be used to compose the image when a smaller size of film is used, and (4) lines used with asymmetrical tilt and swing adjustments and variable axis-tilt adjustments to obtain a sharp image with an angled subject plane (Figure 7–13).

Film Holders

The earliest film holders were actually glass-plate holders. With the introduction of sheet film, film adapters or sheaths were provided that could be inserted in the plate holders and would also serve as spacers to position the film at the same level as the emulsion on the thicker glass plates so that image focus would not be affected. The double sheet-film holders that replaced the plate holders are still popular today and are the only option available when using the larger sizes of sheet films. Improvements in sheet-film holders include features such as a white notation area on each side to record the film type or other data, slide locks, empty-loaded and unexposed-exposed indicators, holders with adhesive strips to prevent the film from shifting when making multiple exposures, a single-film holder with a pressure plate to hold the film in place, provisions for printing data on the film edge, infrared-opaque dark slides, and other improved construction materials.

View cameras have long used a spring-mounted ground-glass frame that eliminates the need to remove the ground-glass as-

Figure 7 – 13 Ground-glass markings on various view cameras include a center cross, grid lines, film-format lines, and asymmetrical tilt and swing markings.

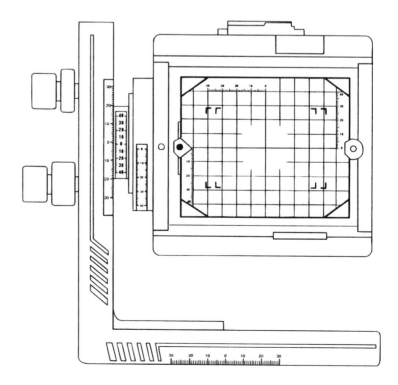

sembly from the camera before attaching a film holder, but the pressure required to insert the film holder and force the ground glass to move back sometimes also moved the camera. Innovations designed to eliminate this problem include mechanical lifting levers that require little effort to open and close the back and a Sinar back that features a fluid-dampened hydraulic back for easy insertion of film holders.

Film holders have been made that hold more than 2 sheets of film, the most widely used being the Grafmatic Film Holder, which holds 6 sheets of 4 × 5-in. film in thin metal sheaths (Figure 7–14). A light-tight slide enclosure moves each exposed film and sheath from the front to the back of the pack, and an automatic counter indicates the number of films that have been exposed. The holder is somewhat thicker than a double-sheet-film holder but some backs can accept the extra thickness and cameras having universal-type backs can use the holder by first removing the ground-glass frame.

Early roll-film holders for view cameras were quite thick and could be used only on cameras equipped with a universal-type back where the ground-glass frame could be removed. A later device that speeded up this operation was a sliding back containing a roll-film holder on one side and a ground glass on the other side that enabled the photographer to shift the back from side to side between composing and focusing the image and exposing the film. Sliding divided backs that produced 2 side-by-side exposures on 5 × 7-in. or 8 × 10-in. sheet film have been popular in the past, especially with studio portrait photographers, for the dual benefits of economizing on film costs and speeding operation between exposures.

Newer roll-film holders have both the film supply spool and the takeup spool in the handle on one end of a holder having the same shape and thickness as a sheet-film holder, and can therefore be used with any type of 4 × 5-in. camera back. The Sinar Vario roll-film holder

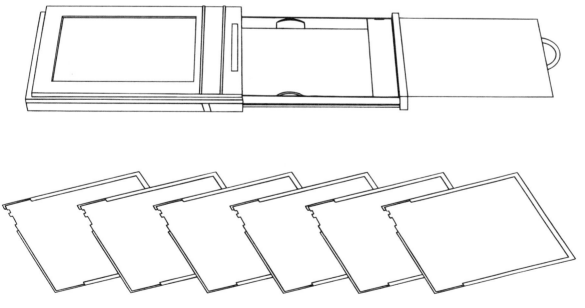

Figure 7 – 14 A Grafmatic Film Holder, which holds 6 sheets of 4 × 5-in. film in thin metal sheaths.

can be adjusted to produce five different picture-format shapes ranging in size from 6 × 4.5 cm to 6 × 12 cm (Figure 7–15).

In addition to roll-film holders, some view-camera manufacturers offer accessory adapters for attaching the camera body of a 120 roll-film or 35-mm single-lens-reflex camera to the view camera, a combination that makes use of view-camera lenses and adjustments and small-format camera film transport and shutter. Photographers who want to use 35-mm film, for slide projection, for example, but who also require control over convergence of parallel subject lines have other options. *Perspective-control* lenses that can be shifted off axis, analogous to vertical and horizontal shift movements on a view camera, enable the photographer to keep the back of the camera perpendicular to the ground to prevent convergence of vertical building lines, for example, by shifting the lens upward to include the top of the building.

Figure 7 – 15 Roll-film holders that are shaped so that they can be inserted in a 4 × 5-in. camera back in the same way a sheet-film holder is inserted. (A) Calumet roll-film holder. (B) Sinar Vario roll-film holder, which can be adjusted to produce five different picture formats on 120 roll film. (C) The dimensions of the five different Vario formats in centimeters.

A device that has all of the tilt, swing, shift, and focus adjustments of a view camera for use with a 35-mm camera body and a view-camera lens is shown in Figure 7–16.

Polaroid film holders that can be used with 4 × 5-in. view cameras are available for individual sheets of 4 × 5-in. Polaroid film, 4 × 5-in. Polaroid film packs, and 3 1/4 × 4 1/4-in. Polaroid film packs, all of which can be loaded and unloaded in daylight.

Eastman Kodak Company offers 4 × 5-in. Ektachrome transparency color film in individual-sheet Readyload Packets that can be loaded into an adapter in daylight for exposure in a view camera. The Mido Cut Film Holder System supplied by Brandless/Kalt Company, Inc., consists of a set of thin reloadable light-tight packets, each of which holds 2 sheets of 4 × 5-in. film, and a camera adapter. This system allows the photographer to carry a large quantity of 4 × 5-in. film in less space and with less weight than with conventional film holders.

Lens and Shutter Controls

For many years it was necessary for view-camera users to set the shutter on the T setting, cock and trip the shutter to open the shutter blades, and move the aperture pointer to the fully open position in preparation for composing and focusing the image. Then it was necessary to stop the diaphragm down to the desired f-number, trip the shutter to close the blades, set the shutter for the desired exposure time, and recock the shutter before exposing the film. A number of innovations have been introduced in an effort to simplify this complicated and annoying routine. One of the first improvements was the addition to the shutter of a press-focus device that enabled the photographer to open the shutter blades with the shutter set at the instantaneous speed that was selected to expose the film. An early version required the photographer to hold the press-focus button in as the shutter was tripped to open the blades and then to recock the shutter to close the blades. A later version provided a separate lever that was flipped one way to open the blades and the opposite way to close them.

Figure 7 – 16 Camera attachment that provides view-camera adjustments with a 35-mm camera.

A self-cocking feature was used on some early shutters in which the shutter was cocked and tripped with a single motion, but the extra pressure required to trip the shutter and the delay between the start of the motion and the tripping of the shutter were considered disadvantages. Automatic cocking of the shutter became more practical with the introduction of electromechanical and electronic shutters, and electronic timing of the shutter-opening duration dramatically improved timing accuracy over that of mechanical shutters.

Another approach to simplifying shutter and aperture operations is to make the settings visible from behind the camera with provisions for controlling the settings and tripping the shutter with a remote device, as with the self-cocking Zeiss Prontor between-the-lens shutter (Figure 7–17-A). Sinar offers a universal behind-the-lens shutter, which can be set and operated from behind the camera (with barrel-mounted lenses), that is available in both mechanical and electronic models (Figure 7–17-B). This shutter can also be coupled with the camera back so that inserting a film holder will close the shutter blades and stop the diaphragm down to a preselected *f*-number, and removing the film holder will open the shutter and diaphragm (Figure 7–18).

View-Camera Bellows

Although the accordion design of bellows has remained essentially unchanged from those used on the early view cameras, improvements have been made over the years, including the use of more durable construction materials. For view cameras that are to be used in a variety of picture-making situations, the bellows needs to be long

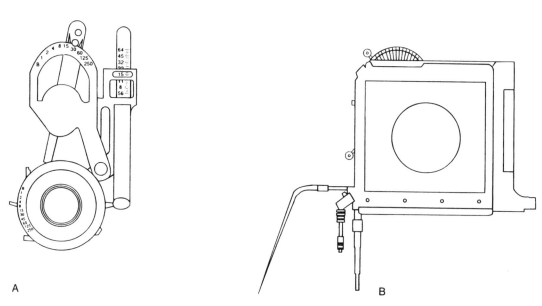

A

B

Figure 7 – 17 (A) Self-cocking Zeiss Prontor between-the-lens shutter. (B) Sinar universal behind-the-lens shutter.

Figure 7 – 18 Automatic film-holder coupling that closes the shutter and stops the diaphragm down when the film holder is inserted and reverses both procedures when the holder is removed. — *Sinar Bron*

enough to permit the use of the full length of the bed without restricting the use of the tilt, swing, and shift adjustments, and yet be capable of being compressed sufficiently for use with short focal-length lenses. Also, the bellows should be flexible enough to minimize interference with adjustments of the front and back and yet sturdy enough not to sag and cut off part of the image light.

Bag-type bellows that are made of soft, flexible material without the accordion pleats are designed for use with short focal-length wide-angle lenses where the front and back standards must be placed close together (Figure 7–19). Some view cameras are designed so that an extension can be added to the bed and an accessory accordion bellows can be added to the standard camera bellows when a very long lens-to-film distance is required, as with photomacrographs where the image is larger than the subject, and with very long focal-length lenses of standard (as distinct from telephoto) design.

View-Camera Lenses

Dramatic improvements have been made in the quality of lenses for all types of cameras over the years. An important improvement that dates back to 1935 is the procedure of applying thin transparent antireflection coatings to lens surfaces in a vacuum. The coating procedure itself has undergone continuous improvement with the result that the coatings on modern lenses are more scratch resistant and transmit a larger proportion of the incident light than the coatings on older lenses. The major improvements produced by the coatings are improved image contrast, less-serious adverse effects from localized flare light, and an increase in the effective speed of the lens at a given *f*-number.

The use of computers in designing lenses made it possible to create new lenses of superior design in a fraction of the time previously required, which, combined with the use of improved types of glasses, has resulted in dramatic improvements in image quality. The improvements include better image definition (especially at large diaphragm openings), larger angles of coverage with both normal- and wide-angle-type lenses, a larger selection of lenses for specialized uses (including lenses optimized for different object distances), better correction of aberrations such as barrel and pincushion distortion, flatter image fields, and less variation in the color of the transmitted light. Corresponding improvements have been made with lens shutters, especially with respect to the increased accuracy of timing, with the introduction of electronic timing with electromechanical and electronic shutters. Some newer shutters have an increased range of shutter speeds, such as 1/500 sec. to 32 sec. (plus time) on a Compur electronic shutter and 1/250 sec. to 15 min. on a Prontor electronic shutter with remote control. Shutter remote control units typically allow the photographer to control the shutter and the diaphragm opening from behind the camera. Some shutters have click stops for 1/2 or 1/3 stop changes in the diaphragm opening, and X-synchronization for electronic-flash lighting is standard on most if not all new shutters for view-camera lenses.

Figure 7 – 19 Bag bellows for use with short focal-length wide-angle lenses.

Lens and Camera-Front Accessories

Shielding the lens from light sources and other bright areas that are outside the angle of view of the lens is more complicated with view cameras than with other types of cameras, due to the effects of using the tilt, swing, and shift adjustments. A lens shade that serves its purpose with all adjustments zeroed may cut off the light to part of the image when the adjustments are used. Vignetting by a lens shade can be detected most easily by looking at the lens through open corners on the ground glass with the shutter open and the diaphragm set at the *f*-number that will be used to expose the film. Adjustable lens shades include a bellows type that can be extended until it can be seen along one or more edges of the ground glass and then retracted until it disappears. A more versatile accessory is a mask having four adjustable blades that can be placed in front of a bellows lens shade (Figure 7–20). Each blade can be adjusted independently to obtain light masking close to all four edges of the field of view.

Various methods have been introduced for holding filters either in front of or behind the camera lens. Although screw-in or slip-on holders for glass filters can be attached directly to the view-camera lens, a common practice with hand-held cameras, view-camera users generally prefer to use gelatin filters, which are available in a greater range of colors and densities, are less expensive, and have less effect on image focus. Holders for square gelatin filters are available that can be attached to the front of the camera, attached to the back end of a bel-

Figure 7 – 20 A four-bladed adjustable mask for use on a bellows lens hood. — *Sinar Bron*

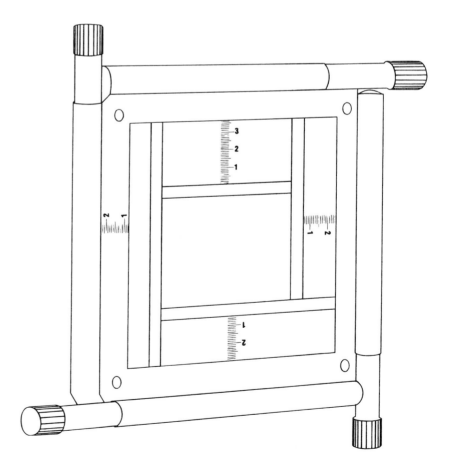

lows lens shade, and are an integral part of a universal behind-the-lens shutter. Some filter holders allow the filter to be easily swung out of the light path or removed from the filter slot when the image is being composed and focused.

A cable release has long been the traditional method for tripping the shutter on view cameras, since it eliminates the need to touch the camera and possibly cause slight camera movement or vibration that would affect image sharpness. Early improvements included extra-long cable releases and pneumatic devices that could be operated by squeezing a rubber bulb on the end of a long rubber hose, both of which allowed the photographer to stand behind or away from the camera when making the exposure. The trend in recent years has been toward the use of mechanical and electronic remote controls that enable the photographer to adjust the shutter and aperture settings and open the shutter and diaphragm for composing and focusing operations in addition to tripping the shutter.

Recessed lens boards have long been used to eliminate the problem with short focal-length wide-angle lenses of not being able to reduce the lens-to-film distance sufficiently to focus the image, especially when tilt, swing, and shift adjustments are used. Recessed lens boards are still useful, but the need to use them has been reduced by the introduction of flexible-bag bellows and consideration of this problem in the design of the camera. One camera manufacturer, for example, offset the swing pivots of the front and back standards on its runners so that the standards could be rotated one way to increase the lens-to-film distance a few inches when the extra length was needed or rotated 180° to reduce the distance several inches with short focal-length lenses.

Film-Plane Exposure Meters

Although hand-held incident-light or reflected-light exposure meters can be used to determine a combination of shutter-speed and f-number settings with view cameras, there are advantages to measuring the light falling on the film instead of the light falling on or reflected by the subject. A major advantage is that film-plane readings automatically compensate for variations in lens-to-film distance that result from focusing on objects at different distances from the camera, so that no extra calculations are required when making closeup photographs. Film-plane measurements also include the uniform flare light that is always superimposed on the image light but that varies in level depending upon the balance of light and dark tones in the scene being photographed, and they detect decreases in the light level when a filter is placed in the light path. When using contrast color filters, however, it is advisable to conduct an exposure test since the film and the exposure-meter sensor may differ enough in spectral response to produce an exposure error.

A type of film-plane exposure meter that can be used with any view camera is one that has a movable sensor probe mounted in a frame having the same dimensions as a sheet-film holder (Figure 7–21). The sensor is then positioned to measure the light level in one or more subject areas, which can be seen on the ground glass. It is necessary to prevent extraneous light from entering the camera through the ground glass (by inserting a dark slide in the holder behind the probe or some

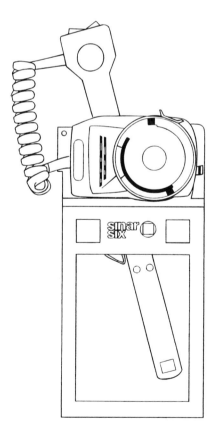

Figure 7 – 21 A view-camera exposure meter with a movable probe to measure the light in selected areas at the film plane.

other procedure) before taking the reading. Sinar also has an electronic metering and autoexposure control system that allows the probe, the meter, and the control unit to remain on the camera so that the probe can be moved into and out of the picture area without inserting a separate frame. The control unit permits either automatic or nonautomatic setting of the shutter speed and *f*-number, and the photographer has a choice of using a single reading or an average of two or more readings. Accurate exposures can also be obtained with mixtures of flash and continuous illumination over a range of exposure times, and the unit can be set to compensate for changes in effective film speeds due to reciprocity effects with long exposure times at low light levels.

A different system for making light measurements at the film plane is available on Arca-Swiss view cameras, which have multiple sensors that are only 1 mm in diameter strategically located on the ground glass. Used in conjunction with a small microprocessor, measurements can be made with any one of the sensors or with selected combinations of sensors. The processed inputs are then displayed on a liquid crystal display monitor, and they are also fed to an electronic shutter that is activated from the microprocessor.

Modular View Cameras

On most older view cameras the only part that was interchangeable was the lens, which resulted in the possibility that a photographer might need more than one view camera in order to make photographs involving different film sizes or the use of both long focal-length lenses and wide-angle lenses. The trend in recent years, however, has been in the direction of making modular cameras that offer greater flexibility in adding, removing, and substituting component parts, especially with monorail-type cameras.

The exploded view of a 4 × 5-in. Sinar view camera in Figure 7–22 shows some of the parts that can be interchanged to alter the characteristics of the camera. The film format can be converted from 4 × 5- to 8 × 10- or 5 × 7-in. with format-changing sets (1 and 2). Reducing adapters are also available to enable the photographer to use 4 × 5-in. film on 8 × 10-in. and 5 × 7-in. view cameras. Two different hoods for viewing the ground glass are shown, a binocular reflex housing kit that presents an upright image and contains dual magnifying lenses that can be swung out of the way (3), and an in-line binocular viewer with magnifying lenses (17 and 18) that would be used with a bag or accordion viewing hood. A 4 × 5-in. metering back with a film-plane exposure meter is shown attached to a runner (4 and 12). The accordion bellows (5) can be replaced with a bag bellows (19) for use with short focal-length wide-angle lenses. The universal behind-the-lens shutter (6) contains a slot for gelatin filters and can be used with the less-expensive barrel-mounted lenses or can be removed when lenses with internal shutters are used. Two other types of filter holders are also shown (7 and 9). The length of the accordion lens shade (8) can be adjusted to obtain the desired effect, or the shape, size, and position of the front opening can be controlled by adding the adjustable four-curtain mask (10). Monorails (11) are available in various lengths that can be attached in tandem to increase the bed length. Also, two bellows can be attached to a multipurpose standard when greater separation is

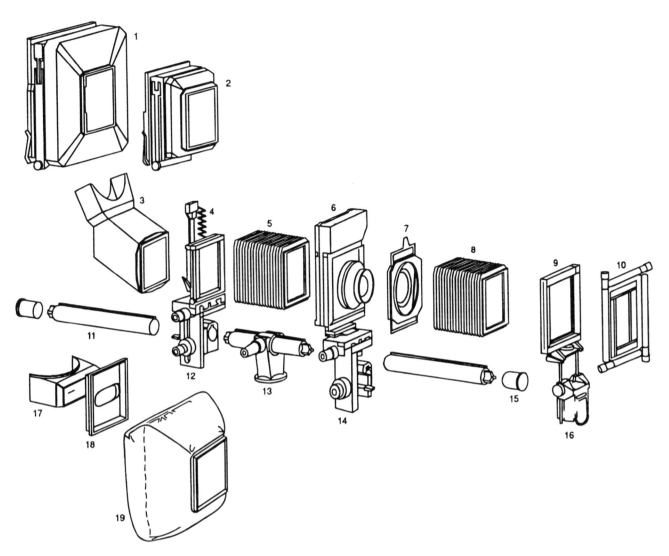

Figure 7 – 22 Component parts for the Sinar modular view-camera system: (1) 8 × 10-in. format changing set, (2) 5 × 7-in. format changing set, (3) binocular reflex housing kit, (4) 4 × 5-in. metering back, (5) 4 × 5-in. square bellows, (6) electronic digital shutter and lens, (7) filter holder, (8) 4 × 5-in. square bellows, (9) filter holder, (10) bellows-hood mask, (11) extension rails (6-, 12-, 18-, and 36-in. lengths), (12) back standard and runner, (13) rail clamp, (14) front standard, (15) rail cap, (16) multipurpose standard, (17) binocular light-hood viewer, (18) binocular viewer board, (19) 4 × 5-in. wide-angle bellows.

required between the lens and the ground glass than is provided with a single bellows.

Electronic Innovations

Electronic features on camera equipment, including view cameras, have been increasing in importance in recent years. The introduction of electronic timing of shutter speeds on electronic and electromechanical shutters has dramatically reduced the variability that has long been experienced with mechanical shutters. Electronic remote-control devices that allow the photographer to select shutter speed and *f*-number settings, open the shutter and diaphragm to examine the image on the ground glass and return them to their original setting before removing the dark slide, and trip the shutter to expose the film, all from behind the camera or another convenient location, make these necessary procedures much less troublesome.

The popularity of electronic hand-held exposure meters has also been increasing. These meters provide digital (light-emitting diode

or liquid crystal) readouts, eliminating the need to note the position of a needle on a dial that is required with analog exposure meters. The calculators on some electronic exposure meters perform other functions as well, such as averaging the readings from two or more subject areas.

An electronic calculator that determines the position of optimum focus and the *f*-number required to obtain the desired depth of field is available as an integral part on some view cameras and can be obtained as an accessory to be used with any view camera. The steps involved in operating the accessory calculator shown in Figure 7–23 are:

1. Focus on the far distance desired sharp and press the ENTER key.
2. Focus on the near distance desired sharp and press the ENTER key.
3. Refocus so that the focus digital readout changes to 0.00 and note the calculated *f*-number on the *f*-number readout. A third number indicates the exposure factor for increased lens-to-film distances with closeup subjects. This calculator is programmed to make the necessary adjustments for different scales of reproduction and it can perform such additional functions as exposure calculations and tilt-and-swing angle calculations.

Electronic Photography

Electronic imaging became a practical reality with the introduction of television in 1945 following World War II but it did not become competitive with silver-halide photography until portable tele-

Figure 7 – 23 Image Analyzer, an accessory electronic device that can be used with any view camera to determine the position of optimum focus and the *f*-number required to obtain the desired depth of field. — *ImageQuest Corporation, Denver, Colorado*

vision cameras and magnetic recording of the images were introduced in the form of camcorders. The original poor image quality gradually improved sufficiently, combined with the convenience and lower cost of magnetic recording, to replace all but the larger-format professional motion picture cameras and film.

Electronic still photography became a reality with the announcement of a still-video camera by Sony in 1981. During the following decade the improvement in image quality still did not match that of conventional 35-mm photography, much less that of large-format photography, but still-video cameras increased in popularity, especially with photojournalists (who could transmit their images great distances in minutes by telephone) and others who appreciated other advantages of the system (such as the ability to retouch and otherwise modify the images using computer programs).

During this same period, electronic rotary color scanners were introduced into the graphic arts printing industry. These scanners produce color separations from transparencies made with large-format cameras that in turn produce better quality photomechanical reproductions in less time than is possible with conventional procedures.

Electronic imaging is now available with some view cameras. This feature makes it possible to display the ground-glass image on a television monitor that can be placed near a setup so that the subject can be arranged and the camera controls can be adjusted without having to look at the inverted image (or erect but laterally reversed image) on the ground glass. The image sensor is a CCD (charge-coupled device) module that is positioned at the film plane. As is shown in Figure 7–24, a number of other options are also available. The analog image can be digitized and entered into a computer where special software programs can be used to retouch or otherwise modify the image, including, for example, combining it with text, graphs, or other images for desktop publications. The computer image can be displayed on a

Figure 7 – 24 Diagram of options available for using the optical image formed in an electronic view camera.

monitor, printed out as hardcopy, or stored on a disk. The image can also be sent to another location such as (1) to an art director's office for display on a monitor, (2) to a workstation for enhancement, manipulation, addition to a layout, and so on, or (3) directly to a printer, for example, to have color separations made for large-volume reproduction on a printing press. The transfer to another location can be made electronically by telephone through a modem, or as is more commonly done when instantaneous delivery is not essential, by physically delivering the computer disk, a procedure referred to as *sneaker netting*.

The detail quality of the final image produced with an electronic camera is limited by the pixel count of the system. The rotary color scanners that are used for volume printing with presses have very high pixel counts that can match the dots per inch of fineline halftone screens. The Arca-Swiss electronic view-camera imaging system shown in Figure 7–25 provides the photographer with a choice of a CCD Sensor Module with a 725 × 625 pixel array or the SC1 Scanning Module with a resolution of approximately 7300 × 4950 pixels. Since the red-green-blue primary colors are scanned in sequence, a process that requires 3 minutes or more to complete, the scanner is suitable for use only with stationary subjects and continuous illumination. Inasmuch as a large proportion of catalog photographs are of stationary subjects and the images are used for photomechanical reproduction in catalogs, the scanning electronic photography system is well suited for use in this specialized field of photography. The CCD Sensor Model provides a real-time image on a monitor screen. The image can then be digitized for computer storage and processing.

Figure 7 – 25 Arca-Swiss Electronic Imaging System, which includes a 6 × 9 M-Line Monolith view camera (*right*) and a choice of a CCD Sensor Module (*top left*) or a CCD Scanning Module (*bottom left*).

Figure 7 – 26 Three pictures made by scanning and digitizing original photographs, modifying the images with a computer paint program, and then photographing the monitor. In the 2nd picture, a line drawing of a fish was also scanned and digitized, and the background was added with the computer paint program. (Originals in color.) — *David Robertson*.

It is also possible to use computer software programs to retouch and otherwise manipulate and use photographic images without CCD sensors at the camera film plane by scanning and digitizing conventional photographic prints and transparencies with relatively inexpensive flatbed scanners and storing the information on computer disks. Some computer software programs allow parts of digitized images to be moved, removed, or replicated; parts of different pictures to be combined; and small sections of the image to be enlarged on the monitor so that undetectable pixel-by-pixel retouching can be used to blend the altered parts. At this time it is not possible to obtain hardcopy prints of the manipulated images that match original photographs in detail, although progress is being made in that direction. The 3 pictures in Figure 7–26 were made by scanning and digitizing photographs, modifying the images with a computer paint program, and obtaining a hardcopy by photographing the monitor image.

Index